MW00945096

CONTENTS

Introduction

JAMES CHEWNING

·····················

THE COAST IS CLEAR

This is a work of fiction. Names, characters, places and incidents either are the product of the authors imagination or are used fictitiously. Any resemblance to actual persons, living or dead, events, or locales is entirely coincidental.

First Edition 2021

The Coast Is Clear

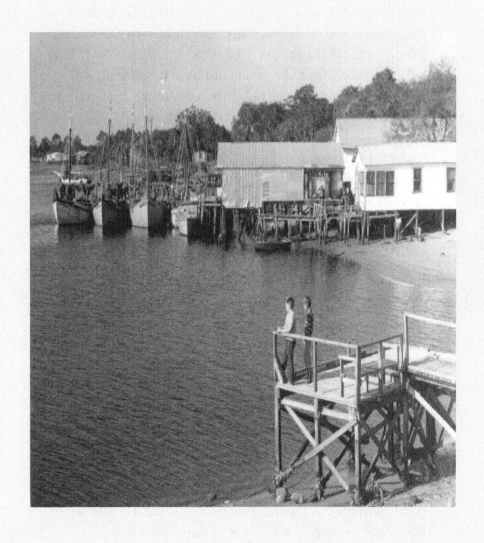

Prologue

"I struggle with the decision every day of my life. Should I have taken my medicine, done the time and not hurt everyone I ever loved, or more so that loved me." Remy awakened to the sound of the rolling thunder across the flats of the gulf. The clouds stacked like folded blankets with a large flesh colored plume above, reaching high into the island sky. The violence to come, now lit by the sunrise over his shoulder as he peered out the kitchen window. The coffee perked filling the room with its aroma, the crystal shaped glass dome of the old tin percolator now hopped and rolled around its axis. He raised the window and felt the pressure drop; the cloud was heading his way. The banana trees that lined the small yard fence swayed lightly at first, and the palm limbs waved a warning of the storm to come. Now he stood infatuated by the change in light as the sun crept around the sphere of the earth and shared its warmth of life, painting a masterpiece before his eyes. Sipping his coffee, he pondered the letter he'd sent, wandering if it was fair to open the wounds he'd inflicted so long ago. Would she show or just ignore the letter? For all he knew she may literally come to kill him. Like he in a way did to her some twenty odd years ago. He thought to himself, "I did set her up financially." Afterall eight million dollars would last her a long time if managed well. His mind was all over the place. As for today, it was the day the plane ticket was purchased for. If she's coming it should be today... Remy walked down government Avenue, turned left at Café Cubano, heading towards the hotel row on the beach. It was only a several minute walk from his small two room place, perched as high as the tree tops on the island. He planned to hang back at the beach club bar at the end of the row. He would sit and watch from there. It was natural for him to be cautious in his line of work. Well x-line of work. The

8

now expatriated American moved with relative ease, but with certain caution that came with the many years of being on the lam. He had decided with anguish he would take his medicine today. Good, bad, or worse… not at all. It would be his death sentence if she didn't show. He felt sweat on his lower back from the nickel plated forty-five tucked firmly in his waistband. He couldn't take it anymore; it was ending today. One way or another. He no longer could take the nightmares, bad dreams and visions he had now more frequently than ever. He sat on the bench with his bare feet in the sand watching the glowing morning evolve. Closing his eyes, he truly prayed for the first time in his life. He asked for forgiveness for what he'd done to her, and what he may do today. Off in the distance the soft deep throated sounds of a Grumman Albatross begin to fill the sky. Remy opened his eyes to the shadows of a sea plane following the shapes of the distant clouds from which it emerged. The large seaplane sank in the sky just above the bay, softly banked towards the island, and slowly sank into its reflection on the steel-colored water…Time to pay he thought.

1.

Mystery on The Plains

The Sherriff stood looking east as the morning sun broke the grip of the cold desert night. The dew droplets fell from the cactus thorns on to the arid desert ground below. The last of the night's crawlers scurried for cover as the night gave way to the dawn. He would have to walk off of the dirt road to get to the crash site. It was some five hundred yards or so down a gradual sweeping grade towards the desert valley. The main site was now nothing more than a smoking heap of aluminum. The black smoke from the burning fuel was only a single plume that slowly twisted into the cool calm morning air. The office had rung him at about 4 a.m. telling him about the call they'd received from a young man on his way home from college for Thanksgiving break. He'd said, he saw a plane come out of the clouds in an inverted dive, plunging into the ground. He stopped beside the highway and watched it burn for some ten minutes or so. There was nothing he could do for the people on board, as it was so far away, and clearly an instant death from the explosion.

The Sheriffs gaze on the quite morning was broken from the popping sound in the distance, from the rotor blades of the federal agent's helicopter. It flew from the south out of El Paso, and only a hundred feet off the ground as it approached the site. It flew east of the crash and banked left, circling it once, then slowly approached the dirt road where the sheriff stood watching.

It touched down on the road, stirring a light dust cloud, nothing more as the night's weather had dampened the desert from an evening shower. The sheriff held his hat on his head while shielding his eyes as he looked away. A few tumble weeds were tossed around as it landed, but not much more.

Somewhere in the islands.

I sat at the bar on the island telling my story to an old salty, sharing the space and time with me.

"You see, I wouldn't blame her if she doesn't show." I said.

I went on, "It all started twenty years ago."

The salty nodded as he sat his beer mug down on the sweat ring covered bar.

"I spent my childhood growing up in the sleepy little coastal fishing village on the panhandle of Florida." I said,

Looking back, I know I was a spoiled daredevil brat, with most everything handed to me on a silver platter. My father was a local commercial crab fisherman, who had some old money. He turned a small-time operation into a very successful business with a lot of sweat and long hour investments. He worked hard every day of his life just to give me the things he never had, or never cared to have. You see, he was just a simple man and was happy with the few things a person needed to make it in this world. I on the other hand dreamed of the "Life of Riley," fast boats, island girls and big yachts.

I think you get the picture. These are the things that got me where I am today, stuck in this repetitive circle of parties on this island.

" It all started about 1977, the year I graduated from high school.

My father had begun to dabble in the shrimping business. He had recently purchased a shrimp boat with the assistance of a government program.
She was a good eighty-five or ninety-feet long and could carry a cargo of twenty-five tons or so." I said.

"My father had carefully calculated my future in his plans, but I had bigger plans.
Hanging out in the local bars as a young man (in a small town like Dead Man Bay) you could get away with underage drinking while frequenting the local dives. In doing so I began to get the feel of the goings on of the local smuggling cliental. I saw how they would throw their money around and brag of how they had made ten grand the night before. This became much more attractive than working your ass off for thirty-five dollars a day for pulling traps, or even the less appetizing job of cleaning them. After they had been out of the water for several days the aroma was unbearable from fifty-feet, much less having to stand at the foot of a mountain of them for twelve hours a day. So, I opted to merge my father's plan with my new-found career. My plans were to get rich overnight, see I only was going to do it one time...but soon found out there is no such thing." I said.

That first encounter at the well-known for its bar flies, divorcées, and kingpins, was at the Crow's Hop. Owned and operated by a local fisherman that went by old Clayton. He was a long time local and ex-convict. The Crow's Hop was your typical backwoods hang out, and boy everybody did. Since the crops were good in Belize, the not so legal tender was thrown around like it had little or no apparent value. I remember that late fall afternoon when my bar buddy and cousin Casey called, and said that the big boys wanted to meet that night to discuss our first

gig. I was really nervous because I'd heard stories about what happened to some of the boys in the past when things didn't go the way planned. I didn't ever want to be in such a position. Casey said he'd be by to pick me up at about seven-thirty. And told me to carry my Colt from now on, because, now things were different.

Casey is an interesting character, he's about six-six, two hundred-forty pounds, and would pass for the lead singer of Lynyrd Skynyrd, and would blow your shit away as he'd soon look at you, but could easily befriend you if there happened to be a cold Busch in it for him. Not your normal stable individual.

I'd heard an old tale that before my time when he was just a young man, that he had shot a man once over half a bottle of Crown Royal. They said the police asked him why he would shoot someone over a half a bottle of liquor. Apparently, his reply was,

"Just a half a bottle of liquor!" You obviously ain't never tried Crown Royal, and furthermore it was way over half full!"

Well anyway, that night just as he'd said, he was there at seven-thirty, rearing to go.

"You ready to go?" he yells out.

"Yea God damn it; I'm looking for my fucking belt!" I said.

I rustled around through the accumulated newspapers and other miscellaneous bullshit scattered about the floor of my rental in the local trailer park. I know it ain't much, but what the fuck do I care, it's only temporary.

I dive into the four-by-four Club of America.

"God damn Casey, you think you could jack this thing up any more than you got it now?" I said.

He replied, "I'm working on it."

The tone of his voice changes as he lines out the plan of the upcoming rendezvous.

Casey said, "Remy God damn it this guy ain't fucking around, he's looking for a longtime commitment from us, so you better be sure this is the life and road you wanna take."

" God damn it Casey if I didn't know that was you driving, I'd swear you was my daddy in a long blonde wig, you fuck!"

"Fine." he replied, "you're on your way to another place and time."

As we drove down the road to nowhere, He fills me in on the scheme of things.

"There is a small freight tender coming from the coast of Belize. She will be carrying a cargo of contraband," He went on.

"She's to be met fifteen miles or so off the coast of Horseshoe Beach on the edge of the shelf, which is as far in as she can come, they don't want to chance running her aground. The coastal side of the shelf shallows quickly as you know. We're to off load the cargo onto, power skiffs, and Prolines, bringing it North, up the coast hugging the shore ever so tightly to avoid detection by DEA. Bringing it in to the mouth of Rocky Creek, quietly but diligently. We will then off-load it onto several tractor trailers that will carry it away. We will have no other contact with it but will profit from it greatly." He said.

He went on. "Needless to say, He had my undivided attention at this point."

14

The ride was surprisingly quiet, and the air whistling through the slightly cracked swivel window was uncommonly warm for this late in the year. The stars were as bright as a lighthouse beacon due to the clear air from the recent rain shower earlier that evening. The planted pines lining either side of the road gradually faded into towering cypress trees with Spanish moss draping towards the ground, their tips pointing in the direction of the ever so slight breeze. We rode for about thirty minutes or so with the sound of Jimmy Buffett playing *"Havana Day Dreaming."* The soft sounds of the steel drum flowed from the speakers in the door panels. I could see the reflection of my nickel-plated pistol from the ambient light of the stereo. It made me think to myself, was I really cut out for this? Would I ever have to use the gun on someone?

Just then Casey said "Hey, there they are."

It was two men standing at the back of a Bronco. It was black with dark tinted windows; the rims were painted with flat black paint as to muffle out any detection of light from any possible source.

We pulled alongside the dark vehicle, killed the lights and stashed our weapons out of sight in our waistbands under our shirt tails.

"I'll do the talking," said Casey, as we stepped from out of the truck.

"No problem," I replied.

The formal introduction from Casey was quite the show. It started with a swig of Jack Daniels, and a line of cocaine from the backside of a pint vodka bottle. The concaved shape seemed to contain the substance until it was all gone... Suddenly I felt as if I

could take on any task dealt before me.

The first name I heard that night would stick in my head for ever, as it would become a household name in the small quiet, and untainted fishing village where I had spent my childhood.

"The name's Trent Clancy," the man said as he put out his right hand.

"Most folks call me Clance," he said as we shook hands.

He was a rather large man standing about six feet two with a broad shoulder build. He spoke with a somewhat deep raspy voice and moved with a bit of a limp. He seemed to favor the left leg. The other guy was quite a bit smaller but seemed to make up for it with his outgoing personality...sort of an asshole. They say first impressions mean everything. Boy, would I find out later that would be an understatement.

"The names Dually, and I don't take no shit from nobody and don't say I never told you so!"

"Nice to meet you, Dually I don't take no shit," I said with a grin.

"Cut it out Remy, he'll shoot your ass, he ain't the sharpest pencil in the jar," said Casey, as he laughed.

"Ok that's enough you guys, we're here to talk business," said Clance.

"Casey we're gonna need a spot plane for the incoming boat. Word is there's a couple of green horns bringing her across. Ever since Chick popped that smart assed Columbian, we're having a hard time finding someone over there capable of navigating a vessel from that distance through the gap." said Clance. "They

seem to keep running into the Cuban Navy."

"Anyway, you guys are gonna need to take off from Horseshoe Beach. The heats on Nathan's dirt strip and the FEDS are all over Cross City airport like white on rice. As soon as you guys get airborne, kill the nav-lights, so it will be hard for those wet behind the ear F.D.L.E. boys to keep up with you. Fly about fifty feet off the deck so they can't pick you up on radar," he said.

"Remy that's where you come in, he'll need your eyes to help keep him flying straight and level. It would only take a couple of seconds to lose track of the coastal lights and crash that fucker.

Don't fly in a straight line, keep moving and changing your headings. This will keep anyone trying to follow you busy.

If you think you are being followed, lead those bastards as far away from us as possible.

We'll be waiting just off Rocky Creek. So, when you find the boat, get a Loran fix on its location and radio it to us immediately.

I'll give you the frequency, and the coordinates they should be at later.

Make sure to misrepresent the numbers by two digits on the top numbers and one on the bottom, one is a three, two is a four and so on, remember we only need the last three numbers, we already know the first two based on where we are on the globe.

This won't totally fool them but if they're listening, and they will be, it will give us enough time to off load and get everyone headed in different directions. They can't catch us all like that.

You guys with me so far?" he asked.

"Sure," said Casey.

Our meeting was relatively brief, but our mission was certainly clear. We were basically responsible for finding this

needle in a hay stack and keeping the Feds off their backs. A little more than I thought I would be signing up for on my first trip out.

Well, what the hell, the way to work your way up to the top is to take the big risks for the big bosses ... No matter how big the risk.

The Jack bottle was passed around for one last swig before our departure.

We all loaded up in our trucks and quietly, but briskly, headed in opposite directions. I watched the tail lights of the black Bronco gradually disappear into the darkness. I began to think about all the possibilities the future held.

Of course, some looked bleak. I tried not to focus on those as they sent a burning sensation through my torso, similar to that one when you were a kid and had done something wrong and you were called out for it by your mother to be punished. It burned so long that I felt I would throw up at any second.

I focused more on the dreams I had always had of owning fast cars, big boats, and that large house with the patio that would hang over the river's edge.

One that everyone would envy, these thoughts made me more at ease with my chosen path.

Suddenly Casey chimes in and brings me back to where we really were.

"You want 'a go across the river and grab a bottle at the Pool Hall?"

"Sure, why not?" I said.

We meandered our way back through the towering cypresses and planted pines, through the cut off at Futch's curve, down Jena Road, and across the old one lane Tourette bridge. We followed the old river road and pulled into Roy's parking lot across from the Pool Hall. I stepped out of the truck and the

warm salty breeze hit me in the face as I peered into the Bay.

" I hear there's not much of an ocean view at the federal prison at Eglin Air Force Base," I said.

The moment was abruptly interrupted from a yell across the street. Someone had recognized Casey, and had summoned him for a drink and some other mischief as I would soon find out.

As we made our way across the polished asphalt aggregate, and down the slope of the banked curve of the road that led to Keaton Beach, about half way across I noticed that the fellow yelling was my uncle TJ. As we approached, he put out one hand to shake and the other around my shoulder, beginning to congratulate me and welcoming me aboard.

"You finally got old enough to make your own decisions, and not have to take orders from the old man aye!"

"Yea I guess," I replied.

My uncle was a retired Navy Commodore and was making a transition into the international import business... of Columbian Gold.

"Come on boys there's a hell of a party going on in there." he said with a bit of a slur.

And followed with, "I paid Marge a couple of grand to stay open for a while longer."

So, we headed towards the door. I could hear the band playing *"Give Me Two Steps"* by Lynyrd Skynyrd. The crowd was getting unruly, as it was about midnight, and most of them had probably started drinking at noon.

I stepped up to the screen door to open it, but it was quickly opened for me by a head first assisted summersaulting unknown

patron.

Casey laughed and said, "Must be one of those hog hunting Tampa WAPs." Never missing a step and continuing into the bar.

TJ followed and I brought up the rear looking over my shoulder at the poor bastard wallowing in the lime rock parking lot. The screen door slammed behind me as I moved through the dim lit breezeway and another screen door, meeting a real pissed off fucker with a busted lip. I could hear Casey making a comment.

"You won that one Eddie Joe, let it go!"

We all headed to the bar where there was an available space to lean due to the recent disturbance. There were several half empty beers on the bar that were quickly removed with one arm sweep by Casey. The bottles clanked against the hardwood floor of the bar, rolling in different directions spilling the last of their contents. I knew that this would result in another eventful confrontation between Casey and some unfortunate, unknowing, out of town bastard. Never the less I made myself at home as did TJ, pulling up a bar stool. TJ ordered us a beer and was quick to spin around to keep an eye out for the previous patron of the over taken bar space, and saw no one at the time with any posturing attitudes approaching. There were quite a few folks standing at the window watching the poor son of a bitch take a few more swift kicks in the gut from Eddie Joe.

"He's a teddy bear till you get on his wrong side" I heard someone in the background say.

"Yea, well He's gotta lot of wrong side to night." said Marge the bartender. "This is the third fight he's been in tonight,

and I warned him, one more time and I was gonna call the Sheriff," as she picked up the receiver of the old rotary dial.

"Remy, go tell Eddie Joe to get in here, he's only got time for a couple more beer, Sheriff Dayle will be here in thirty minutes, so he's gotta hurry and get from here, or they gonna try to haul him away," said Casey.

TJ said to Casey. "Just between me and you, I want to hang around here to watch that fucking show." as he chuckled.

"Ok, I'll be right back," I replied. "But order me another beer." I said.

TJ spoke up, "I'll get you one boy!"

I meandered through the crowd, making my way to the dusty screen door, watching my every step looking left and looking right. For some reason I had a very odd feeling about this. As I reached for the door handle, I heard a loud blast and someone screaming bloody murder. I felt as if a truck had run me down. When I got my bearings back and had come to my senses, I could feel the wire mesh of the screen door pressing against my face. I slowly sat up and removed the tattered door from my body. As I sat up, I could see the unhappy man staggering as he tried to reload his shot gun. Someone off to my right grabbed my arm and drug me from the potential line of fire. It was Eddie Joe

"Sorry," he said. "But there ain't much time for being polite when you got buck shot baring-down on your ass, if you know what I mean."

I turned and looked at the face of the bar where the pellets had stopped. The cypress bar was riddled with tiny holes and one large one in the middle the size of my arm.

"Stay down and don't move," Eddie Joe said.

"I guess that mother fucker didn't get enough the first go around," he says disgustingly as he steps over me heading for the door.

Meanwhile, the dumb ass is still struggling with the reloading of his gun. It was clear he could see that he was about to get the beating of his life. His hand trembled more with each step Eddie Joe took. He began to stumble backwards, yelling at his maker. Nothing he said slowed the pace of the irate giant. Eddie Joe reached out, and grabbed the barrel of the gun, and jerked it from the frightened hollow shell of a man that only wished he had quit while he could live to talk about it. The first blow lifted him from his feet as if there had been a short absence of gravity. He landed on the hood of an old pickup truck, making a tremendous thug, as the air left his lungs. He rolled over to his left, falling flat on his face, hitting the ground like a sack of feed. Eddie Joe grabbed him by the collar of his camouflage jacket dragging him towards the steps of the bar. People began to gather in a semi-circle to watch the vicious beating of the helpless man. Eddie Joe continued up the steps, dragging the man behind him as if he were some sort of trophy. The crowd had become more antagonistic as time wore on. Suddenly, he let go of the man's collar as if nothing had ever taken place, and gently walked into the bar.

He said," I told the fucker to get the hell out of town."

The man was weary and obviously beaten to within a minute of his life. But he was quite a trooper to stand the wrath of Eddie Joe. He could now go back to Tampa and softly lick his wounds. When many days would pass, he could tell the story of the fateful night he made the worst decision of his life to those who might



lend an ear in the local taverns and watering holes. Surely, he will look over his shoulder each time before he begins, because he will carry the memory literally etched in his brain of the massive hand of the unknown.

Casey spoke up as Eddie Joe made his third entry for the night. "Eddie, you sure put the mother fucker through a lot over a pool game."

"Well, that son of a bitch was a cheating, I had to teach 'em a lesson or otherwise he might get the idea that it's all right to fuck an old country boy like myself, out of a hundred-dollar bill, whenever he gets the urge, now we can't have that can we?" said Eddie Joe.

"Well, I bet you before the nights over its gonna cost you a lot more than a hundred dollars," said TJ, with a chuckle as he pulled the sweaty beer mug briefly from his mouth to make the humorous comment.

No sooner had he said that, up rolls the local sheriff.

"Well, looks like my rides here," said Eddie Joe.

"I guess I better go meet ole' Ben or he might get mad if he has to come a looking for me." he said. "See you fellers later." Eddie Joe mumbled as he wandered to the door.

I asked Casey, "Why did he just walk out there and get in the police car without any fight?"

"Well back some time ago ole' Ben and Eddie Joe got into a bit of a struggle and somehow the hammer on Ben's 44 magnum got hit, causing the damned thing to go off and hit Eddie Joe in the foot." he said.

"Word is you could hear that mother fucker a half a mile away when that hot led went through the top of that cowboy boot. Ever since then ole Ben and Eddie have a mutual understanding when it comes to that so-called cab ride." said Casey.

"Let's get the hell out of here, we gotta go down to see the old man's plane tomorrow," Casey said.

We sat our beer mugs on the bar and bid our farewells, heading for the only screen door left standing in the whole establishment. As we made our way across the road to the parking lot, I noticed the salty breeze had picked up a bit. It brought with it the smell of the turtle grass that had recently broken free from the shallow bay, only a brief mile away just around the bend and faintly out of sight, but nearly visible if you close your eyes for a moment letting them adjust to the lack of light. You can see the dim red and green channel marker lights blinking in the far distance and almost make out the south shoreline if you look really hard. Maybe it's your sense of smell you see with and not your eyes at all.

2.

Brown Eyed Girl

I woke up to the stale morning breath of beer that I had drank so eagerly the evening before. My head was resting semi comfortably on a mildewed hunting jacket that I had apparently rolled into a makeshift pillow the night before. My face pressed against the passenger window of the monster truck that had brought me to these unknown surroundings. Through the breath fogged window, I could faintly make out the outline of a face staring at me. I reached up to wipe the fog from the window, but before I could reach it the door that carried most of my bodies hung over weight was quickly jerked open. On my way down I said a prayer, cursed a few bars and clawed the damp morning air. Needless to say, I came to an abrupt stop on impact. Casey began to laugh uncontrollably along with a few others as he handed me a cup of coffee.

"Get up," he said "We're here."

"Where the fuck is here?" I replied.

"At the plane," he said as he walked away towards the seawall and dock.

I managed to pick myself up and brush the damp sugar sand from my back and shoulders as best as I could. I had a really hard time keeping my balance as I followed the wise ass mother fucker that had made me the morning joke.

We made our way down to the dock, crossing a gangway made of old two by four lumber tattered from the sun and Florida humidity. It led to a floating dock of makeshift barrels strapped to an old rickety timber frame, half exposed and half submerged. It rocked from side to side with every step I took, creating a seismic type ripple across the narrow creek surface, disappearing into the shoulder high grass with each blade mimicking the other as the ripples passed through. Beyond the marsh line, a dense grove of palms and underbrush formed a canopy of shade. It blocked the morning sun light, slowing the evaporation of the early dew from its shadow covered landscape.

"This ain't too shabby," said Casey.

Referring to the single engine seaplane perched on a pair of floats.

"Not a bad ride," he said with a note of excitement in his voice.

"You can fly this thing, can't you?"

"Sure." he replied, as he chuckled.

I opened the right door and took a look inside. There was a map lying on the pilot's seat, folded and slightly crumpled. The interior smelled a bit musky from its humid surroundings.

"Climb in, said Casey as he walked around to the other side of the slip.

He opened the door, and slid in one leg at a time, while looking around assessing the wellbeing of the craft. He primed the pump and hit the starter switch. The propeller slowly began to turn, the engine coughed and popped a couple of times, but soon started. The prop began to spin as if it were free of all restrictions. He ran it up, while asking me to cut it loose. He pushed the throttle back as I untied the lines that harbored the anxious craft in its stall. I noticed some girl watching us from the seawall. She was quite a looker, brown hair, short and wavy, long legs and all to go with it. I smiled and nonchalantly waved. I saw her grin as she gave me the finger wiggle girl wave.

"Get in!" hollered Casey, as the plane began to move away from the dock.

I made a leap for it getting one foot wet as I nearly missed the float. I opened the door, climbed into the cockpit and looked over my shoulder to see the girl on the wall. She seemed to be taken with my interest, but obviously amused. I gathered this from her rocking back and forth, laughing, and holding her stomach. I smiled and waved one last time as we made our way down the creek towards the open bay.

"She's quite a gal," said Casey.

"Yea!" I replied.

The floats sliced the water in its path as the engine pitch vibrated our chests. The sun had come out after an early morning shower across the bay. The skies had cleared, and the surrounding palms swayed ever so slightly, with their fronds shuttering from an occasional direction change of the breeze. I could see that the wind was out of the southwest by the small waves crossing the bay from our right to left at a bit of an angle. As we reached the end of the creek, Casey bumped the throttle up

a few hundred RPM, giving it a little right rudder pointing the nose into the wind. As it came around, he eased more power on and said,

"Hold on to your ass Remy Boy!"

The small plane moved across the bay quickly climbing on the step, reducing the drag now and nearing take off. We headed across the bay keeping the nose into the wind. I could hear the water pounding against the floats, simultaneously with the heart in my chest. A moment later, the plane lifted away from the beast that holds it in its grasp, we are free. The wind moved across the torpedo shaped floats and pushed the moisture to the stern, where it drips away, returning back to the sleepy bay below. I looked out and saw the shrimp boats tied to the docks, their weathered hulls and rusty riggings against the skyline getting smaller as we climbed above it all. I suddenly saw the world that we all dashed around on as if there were no tomorrow become less important. It seemed that time had stopped for me. I had never in my life felt this way before. It was then and there I decided that I would fly forever. We climbed about five hundred feet above the bay and began to level off. I shouted through the headset, nearly piercing Casey's eardrums with my excitement.

"Easy on the ears," he said as he squints his eyes.

"Man, this is great ain't it?" I said.

"We're on top of the world Remy Boy," said Casey.

We headed southwest for a few moments as he looked over the instrument panel. He then brought it around to about two-hundred- and ninety-degrees west northwest. We were getting a little wing lift from the cross wind, so Casey made a small adjustment for the lift, as he messed with the radio. I thought to

myself of how I must learn to fly, there could be no greater feeling than being at the controls. Being in charge of your own destiny, where you go, and when you go. I noticed off to the right towards the shoreline I saw a small fishing boat. I wondered to myself who it may be and what part they might play in the big scheme of things. They were just a few frames in the movie of life, a never-ending process of life and death.

"Hey, look!" said Casey, "There at those porpoises."

There was a school of them frolicking and playing with no evident concern for anything going on around them. We dropped down to just above the surface for a closer look at the action. We made a right bank giving me a direct view of the beautiful animals.

They rolled over on their right sides looking back at the strange bird aloft. We hung around long enough to admire their freedom, their poise, and their almost alien existence. It was once said by the great Seminole Indian Chief Billy Bowlegs, "we were only visitors in this world, they were here for millions of years before our ancestors, and they never die," When they leap from the water it is only in preparation for the great one. The great one is their final leap. They become a hawk and fly high and away, flying to the other side."

As soon as they appeared, they disappeared, leaving only ripples on the water and their silhouettes submerging into the shallows below as if they were never there. I'll treasure this encounter for as long as I live.

We leveled off and began a slight assent while watching the ripples from our friends from a distant time. The waves slowly turned into larger and larger circles as the moments passed until they bled into the glassy surface.

"That's what it's all about," said Casey.

I only nodded in agreement.

We continued our heading up the coast lined with sand, pines, and palms that created the beautiful Florida landscape meeting the gulf, with meandering fingers of water reaching into the dense growth, confusing it's beginning and endings. We continued up the coast in silence savoring the moment for what it had been.

"Let's grab some lunch," said Casey.

"Sounds good to me, I could use one of Roy's good ole grouper sandwiches," I said.

I began to recognize the area to my right. It was the creeks I grew up fishing in. I would pole my small skiff in search of the local delicacy, mullet. A shallow water fish that fed on algae and small crustaceans in the mouth of the creeks and on the sandbars.

We crossed Rocky Creek and made our way up to Lazy Island, banking right and hugging the river's edge. We followed the south bank and barely above the saw grass. Looking for boat traffic we spotted our landing area on the rivers surface, lined up, and began our final. Giving it full flaps and pulling the power back to about seventy knots, we gradually and ever so gently eased our floats into the brackish waters below. We coasted down to about forty knots. Casey pushed the throttle back to about twenty percent and we came off the step. We began our taxi to the dock where someone stood waiting our arrival. It was the gentlemen we had met the night before. They stood looking a little out of place in their black attire and dark sunglasses. However, there were a lot of people beginning to look out of place. I ask myself if this was the early stage of paranoia or was it just me being conscious of my new surroundings, that probably were always there. But me not being a part of them, I never

noticed before.

I popped the door and prepared to catch the dock as Casey pointed the nose into the current of the rising tide, making an effort to keep the bird under control at the low speed. He shut the engine down and we slowly drifted up to and against the floating dock. I stepped from the float, picked up a line from the rough surface under my feet and looped it around the front cleat, and quickly moved to the back doing the same.

Casey climbed from the cockpit closing the door behind himself.

"Hell," Clance said to Casey. "What's up with you and Doolittle?"

"Its Dually God dam it!" coming from the mouth of the small guy as he removed his sunglasses and headed down the dock towards us.

Casey gladly met him to see if he really had a problem with the newly appointed nick name. In the distance the voice of Clance could be heard saying,

"You guys cut the shit out, you're gonna attract attention to us!"

"God Damn Clance, I just landed a fucking plane in front of the restaurant full of people, you guys walk out here dressed like a couple of fucking hitmen in those cheap ass sunglasses, and by the way those are about the ugliest god damn shoes I've ever seen on Dually, and your worried about attracting fucking attention!?" He said this as he's waved his arms around in the air and walking up the ramp of the floating dock towards the parking lot, Clance followed quickly behind Casey, he began to talk about tonight's deal. I could tell by the change in Casey's mannerisms, hands in his pockets and nodding his head. I made my way up the gang plank of the floating dock and over towards the restaurant for our

lunch meeting. Dually was right behind me mumbling something under his breath. I looked across the road to see the aftermath of the Pool Hall screen door incident. Marge was standing in the dusty lime rock lot, shaking her head as she picked up the some-odd thousand beer cans. I walked over to say hi and see if I could lend a hand with the splintered shards hanging from the hinges of what used to hold up a door.

"Remy. I don't know why I don't just bar that animal from here." said Marge with a laugh of disgust.

"Well Marge you know that would cause you more trouble trying to keep him out, at least he helps keep all the other rift raff out of here," I stated with an undertone of sarcasm.

"Yea till he gets wasted and starts it himself," she said as she shook her head.

"You need a hand removing the remains of the door, looks a little dangerous with all the sharp splinters," I said.

"That's ok" she said, " Johnny will be by in a couple hours to hang new ones."

"Well, Then I gotta get back across the street to meet those guys," I said.

Marge looked over the top of her bifocals and said. "Remy you're running with the wrong crowd. Does your daddy know you're messing around with this bunch?" she asked.

"Marge Casey's my cousin," I said.

"I'm not talking about Casey. He's been through enough trouble own his own. I'm talking about those other two fellows."

she said.

"Those two, their, just a couple of Casey's buddies down off the Keys," I said.

"Well, they're trouble young man, I can see it loud and clear, you be careful, you hear?" she said.

"Yes Mam," I said as I trotted across the road back towards the restaurant.

I headed for the door at a brisk pace, anticipating the probable conversation soon to take place. My heart raced with excitement and disbelief that what I was about to be involved in was real dope hauling, an international importation of the gold leaf. I walked in and made my way over to the back corner beside the window. The old building had a low ceiling, with its walls lined with a vertical tongue and groove siding in its natural Red Cedar form. Its outer walls were lined with a complete row of windows, framing the picturesque view of the mouth of the beautiful river that led to the open Gulf of Mexico's shallow bay. The guys were just getting their drinks, Casey had ordered for me my favorite, sweet iced tea with two lemons. The menus lay on the table in front of everyone. I picked mine up to look at the common place mat for any coastal seafood restaurant. It was printed on white paper, baring the outline of the state of Florida with the major cities and attractions noted, including the rarely heard of town of Dead Man Bay. There were figures of people water skiing, a picture of the NASA Space Center, and several other icons of the state's history. After studying the menu, as if it would have an influence on what I would order, I had my usual, a fried grouper sandwich and French fries. The others placed their orders with Osteen, and we soon got down to business discussing our place in the new arrangement of the family. I could tell my life was soon going to be quite a ride. After the late afternoon

two-hour lunch, Me and Casey walked across the curved street to the Pool Hall and had a couple of beers. While Casey was engaged into a deep conversation with a local, I grabbed my beer bottle from the bar top and headed back across the street to the parking lot. The late afternoon had given way to the evening. I sat motionlessly on the concrete and sand bag sea wall watching the sun sink into the beautiful Gulf of Mexico. The air was as calm as a sleeping baby, the marsh grass had now turned from its dark green to a shadow of black. The golden orange, mirroring off the water's surface, mesmerized me as I stare directly at it. It's the only time of the day you can do this. I guess that makes me feel like I'm getting away with something. I watched the falling tide leave the river's mouth as if it never really belonged there and wondered if I would see it again. The trailing ripples moved around either side of the cresol pole channel markers glimmered with excitement, but were slowly losing their luster with the setting sun. I wondered if what I had gotten myself into wasn't similar in its lack of appeal with the passing of the time. It seemed too late to back out now, I had to keep my word. I'm really scared for the first time in my life what I might do may not be reversible, but I think it's something I'm willing to chance. All or nothing, it's the only way.

3.

Chase Through the Palms

The time has come. Casey and I make our way down the old rickety dock we had visited the day before. The dark night hampered our ability to balance as we loaded the few necessities for the trip.

I had packed in my satchel a few emergency items, a flashlight, a first aid kit, and some beef sticks, the ones in the red and yellow packaging. You never know when you might need a quick bite to eat. As we sat in the plane going over a pre-flight check list, I noticed the reflection from the street light above. It was glimmering on the small ripples from our floats. It reminded me of my childhood. Me and my sister would go down to the fish house dock to watch the shimmering reflection of the street lights that lined the river road. There were various shades of white and yellow and a few channel-marker lights of red and green. She would tell me they were the head lights of little bugs that ran around on the surface of the water.

We continued our checklist and soon Casey called out "Let's rock and roll." We were on our way. We worked our way down the canal and out into the bay, discussing our plan and all that we would have to do to keep this bird flying straight and level at fifty feet off the deck. The plan had one additional piece of equipment to help us in our nautical related mission. It was a Loran C. A device that gave coordinates, it worked with the use of satellite,

mapping a grid on the earth's surface of oceans, gulfs, and bays.

Casey entered the coordinates as I worked the rudder pedals to keep our nose in the breeze. I focused on the far light out on the point of the rocks at the bays edge, where it met the vast gulf. Casey looked over the instruments one last time before our inevitable departure. The wind blew from the south and a bit heavier than the day before. Giving it a bit of throttle, the floats began to push the waters to either side, causing a fine mist of spray. The mist accumulated on the windshield and made it difficult to make out the dark horizon in the distance. Soon it was blown away as we gained speed and hit the step. Casey never showed any concern as we reached liftoff speed, he was more concerned about being chased by the federal agents. They would tend to monitor the aviation radios and patrol the coast. They were a force, an entity hardly ever showing themselves. A cloak of darkness with someone lurking just out of sight. This was the image I saw in my mind, anyway.

We lifted away from the dark water below, climbed to about a hundred and fifty feet, and leveled off. After cruising for only about fifteen minutes we could see the barge off in the darkness several miles away. It's black silhouette against a dark gray sky. The vessel had weathered quite a journey across the Gulf of Mexico.

It had managed to dodge the possibilities of piracy, and apprehension by the U.S. Customs agents.

It's not always the case in this line of business. Sometimes they never show and are never heard from again.

We made a right bank towards the boat and then leveled back off.

"That's it," he said. "Ok Remy, get on the VHF and give Clance the location."

"Remember to misrepresent them by two digits."

We started to circle them and signal to the vessel below to prevent them from shooting at us. We turned on and off the landing lights in a sequence of two quick bursts and then one

long. They quickly gave confirmation

and we pulled away from the scene to limit the drawing of attention to the soon to be goings on. Holding more to the south and just under radar range, we made our way back towards our original position. We were flying for about ten minutes when all hell broke loose!

Suddenly, the entire fucking sky lit up like a football stadium.

"Holy shit what's that?!" I yelled.

"It's our unwelcome friends from the U.S. Customs and their probably pissed off as usual," said Casey.

They were flying directly at us, no doubt we would end up in a mid-air collision.

I yelled "Casey pull up!"

"Fuck'em, let's play chicken!" he yelled.

They were closing fast!

He gripped the yoke like a sledge hammer.

"Come on you cock suckers pull up!" I yelled.

"Don't worry Remy Boy, they ain't got no balls," said Casey.

Closing with in a hundred yards the low wing air craft pulled up and banked right at about sixty degrees. He then came around and made a diving pass at our dossal float plane. Our headsets filled with the voice of a really pissed off military pilot. You could tell from the direct, clean crisp commands that he was definitely military trained, anyway.

He stated, "Seabird, identify!"

I looked at Casey for some reassurance that we would find a way out of this situation, but only got a smile back. Good enough, I thought.

"Let's play with these guys," Casey said.

"What, Are you crazy?" I asked as he banked her hard left and headed for the tree line.

The Customs plane made several more attempts to communicate with us, to no avail. We continued to the coastline and barely above the water.

Casey put on his night vision goggles and said "ok, it's do or die."

"Let's avoid the latter," I said.

We finally reached the coast and that's where things got interesting.

We were making our way up the nearest creek, skimming the waters glassy surface with a float touching every now and then, and a wing tip nipping at the tops of the marsh grass. The chase was on, hot and heavy. But the federal boys couldn't hang this low at such a slow speed, as it would compromise the control of such a high-speed aircraft. It would become dossal and extremely dangerous, and they knew it. That's what I soon found out that Casey was counting on. The feds would continuously come around and pull up for another pass. They continued this game for about five minutes before there was a chance to make a run for it through the palms that stuck up out of the ground like an impossible obstacle course.

Casey was quite a cowboy when it came to tree top flying.

Meanwhile, back at the off-loading things were going well due to our luring away of the customs boy's.

The water churned as if it were infested with piranha. The rolling of the barge's splashing waves and the singing of the outboards filled the night air. The event was orchestrated with precision. Each off-load boat would pull alongside keeping the motors running, and the crew above would begin to pitch the bails of neatly packaged cargo. They were wrapped in black plastic to protect it from the elements. The crew below would quickly, but neatly, stack the bails one after the other three high and four abreast. As soon as one would finish another would pull in place and start the same process. This would take place simultaneously on either side.

The boats would head for the coast like a string of ants, one right after the other, some making two trips in one night. They would be met at a predetermined location by trucks and additional crew to assist in the off-loading. The operation must be completed before daylight without fail.

The longer we flew the hotter things got. Casey headed right through the middle of a palm grove where there were a few low trees and several missing. It was as if the trees had been cut down in expectance of our arrival. Casey was quiet as he concentrated on every slight move of the airplane, adjusting to keep us out of the trees. As if that were a possibility in such close quarters.

I looked out of his window, only to see that we were flying below the tree lines silhouette and realized we had no place to go but up or forward. The tree trunks at close range were passing us in a flash, as was my life. I leaned forward, looking up through the windscreen, trying to see if the customs boys were still around. I could see their tail beacon as they pulled up and went across the top. This time they continued in an easterly heading until their strobe disappeared across the top of the trees in the near distance. They may have left the chase, but you can bet

they're not giving up so easily. They're bound to give their location and it would only be a short time before there would be company via water.

Seconds after the Feds pulled away Casey reached down and pulled the throttle back to landing speed. He then rolled the flaps to twenty degrees and adjusted for the nosing over with the yoke. We were now in normal landing configuration, except there was nothing normal about this landing that I could see so far.

I asked Casey, "Where are you planning to put us down?" "In the middle of this marsh?"

"Just hold on," he replied.

"Like I have a choice," I said.

"Look, just over that last hump of brush, there's a pond," he said.

I could see from the reflection of the moon that had recently appeared, that there was water in front of us. The only question was how much.

"You gonna try to put it down in that puddle?" I said with obvious doubt in my voice.

"Why do you think this trail is cut through the middle of these palms?" "That's no accident you know?"

Suddenly there was a scraping noise, the floats were skimming across the top of the brush below, but only for a second. After clearing the edge of the pond, like a rock, the plane sank and splashed down in the water.

The landing lights suddenly lit up the pond in front of us in a flash and then went back off.

"Why did you turn off the landing lights!?" I screamed.

Casey replied, "Well I always heard if you turned on your landing lights and you didn't like what you see, then turn them off," and he began to laugh.

I could see the other side of the pond as the brush was closing in, and quickly. Casey removed the night vision goggles from his forehead and flipped the landing lights back on.

"Come on baby slow down, just enough so I can turn you bitch!" Casey shouted.

The engine was at an idle by now as we slid across the surface of the quaint pond. He began to give it right rudder, just enough to start the slight turn, yet not enough to tip it on a wing tip. It was comparable to riding a car on two wheels. No easy task.

I sat quietly not to distract him during this crucial moment.

The plane began to turn just before we reached the other side of the pond.

It was gonna be close though, as Casey talked it through.

"Yea!" screamed Casey as the left-wing tip just missed the limbs of a large pine, hugging the ponds edge as he brought it around applying a little power for control.

"How's that for a kick in the pants?" he said with the excitement of a child in his voice.

"You know I didn't sign up for this kind of shit!" I shouted through the headsets.

"Why didn't you tell me we were gonna be doing this kind of dare devil shit?" I asked.

"Well now would you have come along if I told you, we were gonna do this kind of shit?" said Casey

"Hell no!" I said.

"Well, there you go," said Casey as he turned his attention back to the drifting plane without another thought.

He headed for a make shift dock about fifty yards ahead of us where two guys waited to break our drift. Casey shut it down as one young fellow grabbed a wing tip and walked down to the end of the dock. He pushed his door open, and stepped onto the float, and began to explain to one of the guys how we scuffed the bottom of one float pretty hard on landing. The fellow and Casey were exchanging laughs as he explained to Casey how he knew, as he had witnessed the whole thing.

A loud voice came over the VHF. It was Clance, saying that there were boats on the way and that they had better get moving fast. Casey responded that they were on their way out, threw the mic down, yelled at us and we headed up the trail where there was a truck waiting for us. Casey was jamming some papers in a small duffle bag. He was taking anything that might give away our identity. The two fellows from the dock had stayed behind to cover the plane and would be right behind us. However, they would take a different route out of the marsh. After a couple of minutes hike, we came upon two four-wheel drives, both painted flat black, wheels and all. This was to limit any possibility of detection by reflection of lights. The trucks were lifted for ground clearance, and had large tires made for marsh mud. By the time we had reached the trucks we could hear in the far distance the distinct sound of the air boats on their way. Casey was confident that it would be nearly impossible for the Feds to find the pond, as it was surrounded with palms and dense brush way above eye level. And even if they did, he knew that we would be long gone.

Furthermore, if they found the plane, they only later would find that it had been stolen from across the state from some old guy who owned it and never flew it. He knew that the only way to get to the pond was across a boggy marsh, too dense for even the air boats or by dropping out of the sky. Something he was well versed on. Before the boys knew it, the Feds were nearly on top of them. Casey decided it best to sit tight in the thick brush until they were frustrated and gave up on the search of this area. He turned on the VHF and the police scanner. They could hear the chatter between the boats and the Feds on the main road. It was soon apparent that the trail was cold and that the boats were insistent that the chase plane obviously was mistaken on its coordinates. Before they knew it the sound of the large engines plowing the propellers through the air was fading into the night as the air boats disappeared into the distance.

We joked about the experience as we drove quietly away from the scene with no light but that of the moon. We headed up a narrow road. The road was only two worn grooves in the ground. The dog fennels and wild grass stood high in the middle as if they were a maintained row in a garden, far from it in this muggy wilderness. The cabbage palm's limbs scraped the sides of the truck as we continued. Shortly after, we were passing through a field of planted pines where the ruts turned into sugar sand. I had put on the night vision goggles before we had taken off and I could see up ahead a deer standing in the road. It was oblivious to our presence. I thought for a minute that Casey would have to blow the horn to get it to move off the road, but it heard the truck and slowly stepped off into the undergrowth. I thought of how close we had come to being discovered by the agents, my heart was pounding from the excitement, and the whole feeling of out smarting the law. It was unmatchable, exhilarating!

Things were going well on the other end of the bay. The runners were making good time and were soon expected to arrive

with the long-awaited Belize cargo. Clance paced back and forth at the boat ramp as he always did. It was the things he couldn't control, the things he couldn't see, that bothered him so. This was not uncommon for him. The anticipation sometimes got the best of him. But as always, he would smile from ear to ear when he would see the first of the boats make the bend.

The moon had now cast a haze of light over the creek. In the distance Clance could hear the over loaded boats making their way to the destination. The synchronized engines made a whining noise, obvious to the listener that they were unable to push the boats to a plane. Their bows pushing through the dark water like experienced field plows and the sliced waters rolled to either side into the tall grass. It was as if each blade represented a piano key being softly stroked one after the other in perfect time. The motion seemed almost endless and could easily mesmerize the maker at such a lumbering speed. Each craft's foamy trail was soon to dissipate and disappear as mysteriously as it had appeared. Each boat followed in a close trail, almost parade like, displaying its coastal catch of the evening. The warm night air passed through the hair of the two-man crews as they kept their face to the wind.

When the first boat arrived at the lime rock ramp the synchronization of the well-oiled machine went into action of unloading the cargo of the swollen hulls. Several men created sort of an assembly line and would pass one after the other of the bails to the truck loaders where it would be quickly but neatly stacked in trucking containers. The trucks would soon be on their way to their next stops where the cargo would be distributed to its dealer in the towns large and small, and eventually to its end user. Clance was anxious to get it on its way, for as soon as it left the small coastal town it no longer was his responsibility and he could collect on it in twenty-four hours.

He then would divide up the funds to all those involved at the local tavern over several card games and many drinks. Dually would see that all the boats involved would get a thorough wash

down leaving no trace of its last voyage. This particular grow would tend to lose its seeds easily and leave them lying about the damp decks, not noticeable to the untrained eye. This could be enough evidence for seizure of the craft and in most cases eventual prosecution of its owner. Soon all the cargo had been off loaded and the trucks were on their way. As for the boats, they and the crews were headed back down the creek they had meandered up before, but at a much brisker pace. The crews wanted in no way to be seen anywhere near the scene of the recent goings on. The boats were light and quick, soon distancing their occupants from it all. The sun was pushing the darkness towards the western sky more as every minute passed. The sticky night air slowly turned to a steamy haze, filtering the morning sunlight. Clance looked up the creek watching an old tired gator parting the water with its snout as it swam slowly under the last of the early mornings fog. He thought of how the beast reflected his feeling of age. He was growing tired with the passing of the seasons that forced him further towards the end of it all. The thought didn't linger long, as he began to think of the payoff for his monumental task of the evening. As always, it made him smile as he drove away heading into the rising sun.

4.

No Turning Back

Dead Man Bay, Florida.

Some time had passed since my first encounter with the foreign trade.

I was growing more uncomfortable by the day. There was a bit of talk around the river of the latest haul. It seemed to me that was a bad idea for such scuttle butt to be going around. No one seemed bothered by this, but it was really making me nervous. So, I felt it was in my best interest to leave town for a while, lay low and take a break from the stress of looking over my shoulder.

I had stashed my money in my dad's boat shed out back of the house. It was kept under some life jackets that hadn't seen the water for some time.

As I drove down the road all I could hear was Clancy's laugh as he told me not to spend it all in one place, as he handed me a double hand full of hundred-dollar bills. Some twenty thousand or so, in a brown paper sack.

I decided to head up the coast to Cameron Town, a small oil town in the armpit of Louisiana. My shrimp boat was running out of there and going good as far as shrimping goes. I called ahead to tell the crew to meet me in a few days.

I started the morning with breakfast at the Riverside Oyster

Bar, having grits, eggs, and white toast with lots of butter. I washed it all down with the usual black coffee and a half of a tea spoon of sugar. Some habits are hard to break. I paid my bill and bid Sandy, the waitress farewell for now.

I slid down into the two-tone tan and brown Chevy El Camino, put on my Ray ban aviation sun glasses, started the car and left a lime rock dust cloud in the parking lot as I sped away. Down the beach road and off to Cameron Town.

Meandering through the panhandle of Florida I caught myself thinking of the beauty of the marsh lands and cypress swamps that riddled this coast line. Occasionally I saw the Gulf reach into the long strip of land, take a bite and slide back to where it came from.

Crossing into Alabama I stopped for gas, a snack and to make a call to the Marina to see if the boys had reported to pick up their messages.

I thought of my father, and how he knew this is what he would like to see his son do. That is to make an honest living, be a shrimper and follow in his footsteps to be the fine up standing citizen that he himself was. What the hell I thought, I'll give it a run.

I dialed the number to the marina. The phone rang a couple of times on the other end before a voice came on and said, "Creek Side Marina, this is Johnny can I help you?"

"Johnny, this is Remy from the river, have you heard from Cole?" I asked.

"Hey Remy...yea he said to tell you that he would see you this evening."

"Great, tell'em to hang out till I get there," I said.

"Roger that cowboy, we'll see you tonight," Johnny said.

I hung up the receiver on the pay phone and turned heading back to the gas pump only a few yards away.

It had been a dry week, and each step I took made a puff of lime dust leaving a white film on my brown Dingo's. The old Texaco station signs star was faded more to an orange and less of a red. The green T was now an olive drab lacking in luster. The station had a garage off to the left of the main store. The barn door to the garage was partly open, probably stuck in that position for some time. The paint was unappealing and faded with the passing of time. An old tractor sat at one corner of the tattered building. Kudzu vine had nearly consumed it and its once bright red paint job. As it grows a mile a minute, I am likely the last person to see this old tractor. The rusty tin roof blended well with the trunks of the pines and dead underbrush behind. An old Blue Tick hound lay at the front steps of the general store. Guarding the shade, no doubt. As I approached the front door, the dog cracked open his eyes, and flipped his tail once as if to give approval of passage. I pulled open the beaten screen door, it creaked, and the spring sang a bit of a tune when it slipped over the eye bolt.

I went inside to pay for the gas and get chips and a soda.

"Afternoon" said a voice from behind the counter. I looked up to see a weathered face behind a pair of coke bottle glasses. The body below it wore a pair of aged Dickie overalls, a yellow stained t shirt, particularly around the collar and in the arm pits. The bib of the overalls showed evidence of the tobacco that he spit on the floor. There was a local setting at the end of the counter dressed hauntingly like his friend. The ancient cash register blocked his view of me. He continually leaned to one side to see what was going on. The man put one hand on the old glass cabinet to assist him in standing up. Grunting as he did, he asked Me, "where you from young fellow?"

"Oh, all over you might say," I replied.

"Can't say I ever been there," the old man said.

"It's just over the state line," I said with a grin as I handed the man at the register a twenty.

The old man at the end had a puzzled look on his face as he rubbed his chin.

The man behind the register handed me back a dollar and some change and said "see ya next time young fellow."

I smiled and turned walking back through the screen door, past the old hound that wagged his tail once more in the passing. I opened the door of the car and slid back down into the seat which was still holding the shape of my ass from the previous ride. I sat the plain lay's potato chips on the passenger's seat and my sixteen-ounce cola in the plastic window coaster I'd recently purchased from the Western Auto store.

Looking in the direction of the station as I started the car I saw the hound peeking through his eye lids, wagging his tail again as if to say good bye.

Off once again pointing the car west down the coastal two-lane highway.

Three radio stations and a lot of thinking later I had arrived at the scene of oil boats and muddy canals. The aroma of unrefined fuel blew through the rolled down window on the driver's side as I drove through the time beaten town.

The streets were lined with telephone poles leaning in similar directions from the overload of the wires that were only passing through. Making a left in the middle of town on Dugan Street, I crossed an old creosote coated trestle bridge above the dormant train yard full of history and surely many stories.

The sun had sense set. Leaving a dome of black above, with just a hue of light on the western horizon. The stars peppered the

dark back drop like diamonds spread randomly on a blank canvas of infinity displaying their ever beauty. I often stood and stared into the abyss above wondering what may lie beyond or what may not. Could it be possible that we're alone in this place, this corner of the universe, I thought?

I continued my travels on the tilting pavement, leveling out at the intersections only to quickly drop again. It reminded me of a carnival ride when I was a kid. Up and down, back and forth. The street lights lit the interior of the car briefly, and back to darkness again, time after time at each passing. The sound of a Buffett song, *"Tin Cup for A Challis"* filled the air, it reminded me of the islands and seemed fitting no matter where I was or when I heard it.

There it was, Johnny's Marina was just ahead. Boy I was glad to see it, I thought. The long ride had taken its toll on my sore ass. I parked the car off to the side of the store. Things were quite by this time of the evening, most of the workers left the taverns by ten or so. I could hear a small amount of talk out from the direction of the water, likely a few of the crews were together on one boat having one more for the road.

I could see a figure standing in the distance in front of what appeared to be my shrimp boat. The glow of the cabin lights in the lower portion of the boat reflected on the dark waters of the canal.

"Is that you Cole," I asked.

"Looks like you made good time," Cole said.

"Yea, the roads were empty, and I didn't have a single run in with the law dawgs," I said.

"Want a beer?" said Cole.

"Hell yea!" I said.

I could hear some rustling around down on the boat. It was the deck hand digging in the flake ice cooler looking for the beer that Cole had offered.

"What you been up to Remy?" he asked as he passed me an ice-cold Michelob Light.

"More than I care to admit," I said.

Well, we best just leave it at that," said Jim.

"Yea I guess," I said as I stepped down onto the gunwale of the boat, careful not to slip on the wet fiberglass surface in from the damp night air.

"Come on sit down and let's have a few," said Cole as he headed for the stern of the boat where they had an old fold out card table lit with a hurricane lantern. It was laced with empty bottles and a half full ash tray of Winston butts.

"You ever gonna shave that scraggly fucking beard?" I asked.

"Hell no, that's my flavor saver." Cole went on to explain.

"Remy how did things go with Casey and Clance?" Cole asked abruptly.

"Fine," I said, offering no more.

"How's the shrimping?" I asked.

"Oh, it's pretty good, we got a vat full in about eight hours,"

Cole said.

"That's good," I said.

"Another beer?" asked Jim.

"Yea, I better have several more." I said, as I chugged the ice-cold beer noticing the golden colored fluids brilliants through the side of the amber colored bottle. I heard a cracking noise. It was a fresh one on the rebound being shoved in my face by Jim.
Jim is a jolly type and always joking around.

"Thanks," I said, " your timing is impeccable."

After drinking into the early hours of the morning, and telling large fish stories, we all bid our good nights and Cole blew out the lantern and headed below.
I stumbled to my quarters and climbed into my bunk. My thought divided by recent experiences, including that of the morning I saw the pretty girl on the seawall. I slipped into a trance that being my last awaken thought of the night.

5.

Gulf breeze and Screaming Guitars

The next morning, I was awakened by the clattering of twin diesels. I found the energy to roll out of the bunk and attempt to put my pants on carefully one leg at a time. Holding the rail of the bunk trying to keep my balance. It was a bit of a challenge, I felt to be swaying from left to right, or was that a hangover.

Soon I was top side and pleased that the boat was really swaying. My face was met with a cool morning breeze as I walked up the gunwale holding the rail and taking in the beautiful Fall sunrise. The sound of the clattering engines was only interrupted by the occasional squawk of a seagull.

The gentle breeze was heavy with salt and the smell of the morning low tide. I could see Cole at the wheel and further forward was Jim on the bow securing the mooring lines. Cole steered with one hand and sipped his morning coffee with the other. Without turning his head or taking his eyes off the channel, He asked Me if I would like a cup of coffee. The brilliant red marker filled our windshield and passed us on the left as I poured the coffee into a large white porcelain cup from the Thermos.

"How's the head?" asked Cole.

"Better than I thought it would be," I said.

"What a beautiful morning" stated Cole, "I love everyone I see," He went on to say.

I stared into the burnt orange horizon, mesmerized by its beauty. Off in the distance I could see the silhouettes of a few other boats, and an oil rig towering from the green depths below. We run for a couple of hours diagonally to the coast to what had been a prime shrimping ground for this season.

I could tell we were close from the floating turtle grass on the surface of the bay, and by the brilliant clarity of the waters below the hull. The rattle of the diesels soon ceased, and the boat drifted into the light breeze, idling. Jim undone the hold downs for the trawls and put the wench into action, simultaneously lowering the outriggers nearly level with the surface. Cole signaled Jim to check the tails to see that they were tied and pushed the shifters into gear.

The boat once again moved under its own power. Jim lowered the trawls into the water, releasing more line as we moved forward. He felt them touch bottom and the slack in the line became taught. He tugged on each to see that they were rolling across the tops of the grass flats. After satisfaction Jim headed to the galley for another cup of coffee.

I walked out onto the bow to feel the cool breeze while I finished my second cup. I noticed a small boat some distance from us, it looked like one I had seen just after I had come topside. The boat was mimicking our moves, paralleling us for now.

The morning was gone, and the early shrimping had paid off, we had scored several hundred pounds, but the last drag showed no reason for further attempts today. So, Cole signaled Jim to wrap it up.

I noticed our company was just South of us, I looked with

the binoculars and couldn't make out any faces but could see some figure looking back. I feared it may be customs watching my ever move from now till hell freezes over. I walked back into the cabin and took a seat thinking no more of it, really what the hell could I do anyway, I wasn't doing anything illegal... today anyway.

Cole turned the boat, wind to his back and headed in for the coast. Their work was done for the morning until they got back to the dock. He put it on course and turned it over to Jim. Cole was headed up top to catch a few rays and have a cold soda. He sat comfortably in his aluminum lawn chair, with the sea green and white mesh woven back and forth and around. I joined him with the binoculars, setting on the locker full of rope and bumpers. We talked for a bit as the boats bow rose up and down from the roll of the waves that moved under the vessel. The smell of diesel exhaust occasionally overtook us when the breeze stepped it up a notch.

Jim came out of the port door and motion for me to come down, He held his fingers up to his ear as if to tell me I had a call on the radio. Quickly I jumped to my feet and skinned down the ladder at the back of the cabin and made for the port door of the wheel house. Jim was talking to the marine operator, telling her that I would soon be on the line. I picked up the mic and acknowledged the operator. She came back and told me to stand by for the connection. In a moment I could hear a voice on the p.a. speaker in the wheel house. The sound filled the cabin, it was Clance calling.

"Remy It's Clance are you there?"

"Yea go ahead," I said.

"We need to meet on some business back here tomorrow, and then we're having a big oyster roast tomorrow night down at the beach house."

"No problem." I said. "I'll head out this afternoon, I can be back to the river by Ten tonight."

"That won't be necessary, I'll just send Casey in the bird to pick you up."

"OK?" said Clance.

"Yea, sure, no problem," I said.

"Make sure Cole comes with you," Clance said.

"Roger that, He's right here," I said.

"Good enough, then it's done, I'll see you fellows tomorrow. said Clance." and there was silence on the other end.

I hung the mic back over my head on the clip, looked at Cole and said, "I guess were going to an oyster roast bud!"

Smiling, Cole took another sip of coffee and nodded yes, Cole knew what it meant to be invited to one of Trent Clancy's oyster digs. He was always there, being basically family now. It meant rubbing elbows with the well to do for three counties. Each time his parties had gotten larger and larger. You would see all kinds of officials, the County Judge, the D.A., the Sheriff and a few others, these he kept in his pocket and in turn they kept him out of the slammer. He usually had a well-known band, and an occasional "B" movie actor. Clance loved to surround himself with important people. It made him feel big. He grew up with no father and had very little as a child living in near poverty. His mother was rarely around. He spent most of his life with his grandmother taking care of him. She was a small Indian woman. Her hair was gray, and long. She kept it twisted into a rope,

wrapping it around her head continuously and held it in place with bobby pins. She wore a small pair of horn-rimmed glasses as her sight was failing in her older age. Her wardrobe consisted of a few cotton dresses she had made herself. They were of many different fabrics and colors and she wore them proudly. Her skin was leathered from years of sun and the lines under her eyes were many. She lived to see her Trent reach nineteen. Then the night came, and she left him to face the world alone, no shoulder to lean on, no hand to hold, and no one to give advice or share wisdom. Now she was in another place. He only hoped she knew how dearly he loved her and hoped he had done his best to honor her.

Cole turned to look back at the deck where Jim was washing down before they got in to the canal. He Tapped the horn, and Jim looked up. He motioned for him to come to the wheel house. I walked out onto the bow where he'd sat and began to watch the waves roll off the sharp edge as the boat pushed its way through the green waters of the Gulf of Mexico. My thoughts drifted to another place, in my childhood where I found peace with myself. Remembering all the fun things I had done as a child. I thought of walking the rivers bank at low tide barefoot, dodging oyster shells and broken glass. The mud squeezed between my toes each step. Being careful to stay in the sandier places, they were less apt to sink me up to my knees. I liked to look for arrow heads in the shallows. Keeping a whole collection from childhood, my parents proudly displayed them in a case in the living room. I thought of how I would make bows and arrows from palm frond limbs and palmettos. but most of all I thought of my parents setting down to dinner without me now, I wished I was there.

I watched the green water turn to brown as we neared the canal at Cameron Town. The channel was lined with other shrimp boats, oil boats and an occasional barge. The sun was at our backs, now low enough to cast shadows on the buildings behind the tall riggings of the docked vessels. We slowly worked our way up the canal, the small waves they produced done

nothing to disrupt the dormant giants we would pass on our way
to our moorings. The clattering of the engines increased in pitch
as they were pulled into neutral, and then into reverse. A spin of
the helm and a change of the shifters and the vessel was soon
nudging the dock once again.

Jim tossed a bow line to a dock hand and quickly made his
way down the gunwale to secure the stern as Cole pushed it into
place. The engine soon silenced for now. There was a ringing in
our ears we knew would leave in time.

"Let's clean up and head to Nate's!" shouted Cole.

"I heard that!" said Jim with a giant grin from ear to ear.

They took turns showering, drinking beer waiting on the next
and getting ready.

Soon the sun settled down to the Gulfs surface, appearing as
if it would stop for a minute and then it continued its journey
below the horizon. It left a bloody trail of oranges, purples, and
pinks behind, they melted together painting a beautiful scene for
all who cared to see.

By now everyone was ready and anxious to go. There was
something about the evening, maybe it was the day out on the
water, or the thought of the upcoming days and the events that
they held that put the feeling in the air. It was certainly there, and
they all felt it, even though no one spoke of it. Each knew it
existed.

I was last off the boat locking it down before I stepped off
onto the dock. Cole and Jim were nearly to the marina by now
and were turning and standing, patiently waiting for Me. I soon
caught up and kept pace from then on. We walked straight up
Main Street and turned left at Dugan Street. Walking side by side
speaking about the catch of the day and how we would sell it
tomorrow as the fish market was closed for the evening.

The night was cool, I could feel it through my long sleeve shirt as we walked. I knew the trip back to the boat would be cooler, but it was likely I would feel it less after a hard night of drinking. The street lights lit up the old brick walks of years gone by. The walks led the group only to Nate's and rarely anywhere else. Nate is an old Cajun with a knack for befriending anyone that crossed his path. And decided to spend a life time doing that with crawl fish and beer. He spoke broken English but mostly Creole, but all knew what he meant when he spoke. The bar was an old structure that was a fishery in the early Nineteen Hundred but closed during the war.

Nate spent his life savings on the down payment and with a loan from the bank He's been spreading his cheer since 1945.

He speaks of funny stories to anyone who will listen. You can find him at the bar in his khaki pants, and brilliant Hawaiian print shirts. He walks with a limp; the story is that he was attacked by a tiger shark as a young man diving on the sand flats for wool sponges off the Florida coast. He wears a few of the shark's teeth on a gold chain around his neck that were removed from his leg. He displays them proudly against his gray-haired chest.

The bar had high ceilings with open rafters and fans hanging from above. The worn concrete floors are covered with saw dust. The tables are made of cypress, logged from the nearby swamps by Nate and his boys. The walls were random pine planks and corrugated galvanized roof tin, aged with rust and runs. They were covered with old pictures from years gone by of fishing boats, sunsets, alligators and oil rigs.

He is particularly fond of an autographed picture of Earnest Hemingway. The author had stopped in once in the fifties and made a new friend, leaving the picture behind for the memories.

I worked my way to the well through the thick crowd against the bar. I ordered three beers from a young man that resembled Nate himself. As he put the cold frosty mugs on the counter,

I asked, "you kin to the old man?"

"Yea" he replied, "He's my grandpa, that'll be six dollars please.

I handed him a hundred-dollar bill and picked up the beers and headed for the back room where they kept the pool table. Its bumpers were worn out and the felt faded. Before I could set down the beers, I heard...

"Who da hell bringin in dis Hunda Dolla bill ?!"

I turned, and his tone quickly changed to friendly.

"Remy Boy!" "How da hell are ya?"

"Good, good, I knew that hundred would bring your old ass out the kitchen!" I said, "trade me for this twenty."

Nate quickly obliged.

"Why you so scared of those hundred-dollar bills?" I asked.

"Dey evil Remy, dey be got in a wrong doing way!"

He was right on and didn't even know how right.

"It's just some of that voodoo shit you believe in," I said.

"Maybe so, but I still don't want nutting to do with them," he said as he went to get my change.

We stood around, shot some pool, and drank a few cold beers while we waited for our crawl fish.
Cole talked about the upcoming party down at Clancy's

beach house. Cole was more than excited to say the least.

Nate eventually came back around to give me my change and hung out to talk about old times. He spoke of how he, Clance and the old gang use to turn up the heat in the local bars, the fights were plentiful!

Clance was always up for a good brawl he boasted.

Everyone laughed at the stories as he went on, and on.

After a while the boys polished off a few pounds of bugs and a few too many beers with Nate's help before they called it a night.

They had a big day ahead of them and long ride with the notorious Casey.

So, I paid the tab and motioned for the gang to go. We all bid our farewells and headed for the door.

Nate yelled out "tell Clance not to be such a stranger!"

"I will," I said as I went through the screen door.

Jim and Cole were a few steps ahead of me doing their best to keep one another up right and heading the same direction. It was a comical display and we all laughed loudly. The laughter echoed off the old brick buildings lining either side of the narrow street.

Cole broke into a song from the A1A album of Jimmy Buffett, *"Tin Cup for A Challis."* As he knew it was a favorite of mine. Jim and I soon joined in, knowing it was somewhat out of tune, but felt it was ok for a drunken opera. After a while we all were quiet for a few blocks. As the group made the last bend, we could hear music in the distance. The night air filled with the sounds of blues and the voice of a large black woman. The sounds got louder and the voice clearer as they walked.

"Man, I like that sound!" I said. "Let's go in for a few

minutes." Said Cole, as we approached the bar.

The door was just a hole in the wall of an old warehouse of some sorts. It was an old wooden structure. It was unpainted, and unattractive, other than the soulful sounds that oozed from the walls.

Jim declined and said he was heading on to the boat.

Me and Cole said "OK" simultaneously.

We liked what we heard vibrating the wood slats of the building and ducked in the door propped open with a broken cement block. The floor was worn concrete displaced from years of foot traffic that crossed it leaving a story with each step, some happy, some sad and some ending in death and others in life. But all were an important part in the molding of its history. Cole and I were glad to make our mark with the scuff of another boot. The room was long and slender. A bar placed strategically in the middle, serving from all sides. In the far back we could see a sister draped in red. A large woman and she swayed with the thump of the bass from behind. She held the microphone in one hand and a scarf like towel in the other with which she occasionally wiped her brow. The spot light lit up her face outlining the love for what she did with a glow unmatchable by any I had seen. Her hair had a blue hue from the cheap stage lights above her head. She sang every word as if it were her last and had the small crowd tranced from her display.

Cole had bought us a beer and found a spot at the end of the bar near the stage, so we could view the goings on of the few people on the dance floor. One old man danced by himself to a beat of his own as another couple ground the night away on the opposite side of the floor.

There were two old men at a table near the edge of the parquet wood floor. One wore a Fedora and thick black glasses,

the other dressed like a gangster, a cane in one hand and a Cuban in the other. A plume of blue smoke rose above their heads. The room filled with sounds of soul from *"Mustang Sally."*

Soon the song was done, and the band took a break.

The music in the background was produced by the juke box. It played a disco tune that could be heard on the radio most anytime of the day.

Cole said, "come on, I want you to meet someone."

We headed for the corner table in the back of the room where the band was cooling their heels and talking about the old man who danced by himself. Wandering what his story could be.

The lights were dim, and you couldn't make out exactly what else was going on. But I soon realized I wanted to partake in it. The lead singer was passing around her compact mirror with a little treat for the evenings weary.

She seen Cole and Me as we approached the table and yelled "Cole is that you!?"

"Yea Mavis, it's me" he replied, "don't have no god damned heart attack!"

"Heart attack?" she said "I ain't having no heart attack!"

"I wanta know where them god damned shrimps is you done promised me last weekend!" she said.

I broke in, "you know these guys?"

"I know everybody," Cole said.

"I got'em on the boat, and they fresh too," said Cole.

"You better have!" she said, "now come your ass over here

and join us."

"Come on Remy, you too, now don't be shy." she said.

"How do you know my name?" I said.

"Sugar, I know it all, I know it all," said Mavis, as she stood up and wrapped her arms around me and buried my head between her large breast.
"My names Mavis," she said as she released me.
The bass player laughed as he said, "you got lost in there for a minute boy, you need a drink?" he asked.

"Yes sir," I quickly said. "A strong one."

"Dempsey's the name," he said as he reached out with one hand to greet me, turning to shout over his shoulder to the bartender "hey Donnie, get this boy a Jack and Coke!"

"Got it," replied the bartender.

Dempsey said to me "Cole said you got one of them big ole shrimp boats, is that right?"

"Yea, my daddy seems to think that's the way to make an honest living, but by god it's a lot of work," I said.

Mavis and Cole carried on for a while and they all had a good long laugh.
Mavis insisted that Cole join her on stage for a song as she knew Cole was an avid guitar player.
Soon she had him talked into it, and they headed for the stage.
They warmed up for a moment and then agreed on the Clapton song *"Cocaine."*

Before long the small joint was hopping with excited people as Cole bent the strings on the Les Paul with precision and perfection. I was in awe, as I knew nothing of Cole's musical talents. Mavis sang back up and Dempsey thumped the strings of the bass like they were soon to go out of style. While a young kid played the drums with a chest full of heart.

The bar had filled with the late crowd, they were going off as the song wound down. Without a word, only a look from Mavis they rolled into a soul filled blues tune, Mavis at her best and the crowd at their worst. The dance floor was shoulder to shoulder and the liquor was flowing. She finished the song and the crowd approved with endless applause.

The drums began a beat that sent the crowd into a frenzy, and Cole played the intro to Stevie Ray's *"The House Is Rocking."* He looked at Mavis and launched into the song. The place went mad, people were dancing on the stage, the bar, and a girl danced on the bass amp. He picked the strings apart on the Les Paul. The dance floor rumbled with the excitement. They all hung on every word and every movement he made. Cole could see the hazy hue that hung over the dance floor from the stage lights. It changed from purple to red, and it seemed to pulse with the beat of the drums in the tight quarters of the room. The sweat dripped from his face from the hot lights. Cole finished the song and swung the guitar off his shoulder, sat it in the stand, walked over to Mavis, gave her a kiss. He waved good bye to Dempsey and the drummer as he kept the beat. He turned and walked into the middle of the wild crowd. People were slapping him on his back, applauding him, and cheering. He continued through the madness heading to the door without breaking his stride. Cole turned once and looked over his shoulder, grinned and waved his arm in the air as if to say farewell and to thank his new-found fans. Then he turned back and disappeared out the door into the night.

I waved bye to the gang and waded through the mayhem on

the dance floor. Walking quickly to the front door of the bar. I tried to catch Cole on the street. But He was nowhere to be found. So off towards the marina I went. I knew that Cole would probably be at the boat and if not now, eventually. The fog had rolled off the heated gulf and was making my walk back to the boat a bit damp. The lights from the street lanterns were greatly diffused by the ever-thickening soup.

A voice from behind said "what's your hurry?!"

'How'd I get ahead of you?" I asked.

"I had to take a leak, so I stepped into the alley back there," Cole replied.

"What the fuck was that!?" I asked.

"What?" Cole asked.

"That whole guitar thing, and singing and all, back there with Mavis," I said "I didn't even know you could play the guitar, much less sing and all that," "Those people were fucking going off man!" I yelled with excitement.

"There's a lot of things you don't know about me," said Cole "And it's probably best you never do," he said.

Cole put his arm around my shoulder and said "Let's get back to the boat and get a few hours of rest before that fucking psychotic cousin of yours gets here."

"OK!" I said "But I wanta know more."

"More what?" Cole asked.

"More about where you learned all that wild ass shit on that guitar!" I said.

Cole laughed and said "OK, but another night over some different beers, these have lost their appeal."

We continued our short hop back to the marina and down the wet dock to the boat that lay silent in the waters of the oil saturated canal.

The deck was wet and slippery from the AM fog and I was as careful as a drunk could manage to be while boarding. We said good night, and crawled into the bunks and were soon passed out for the few hours of darkness that was left.

6.

A New Toy for Casey

The next morning, I woke to the nudging of a Louisville Slugger to the rib cage. At first, I thought I was dreaming. Each time I thought I heard laughter. I soon was brought to life from a voice shouting "Get up god damnit, we ain't got all day!" Casey had arrived while we still slept.

"Let's go!" he said. "Clancy's party starts at Seven and I want to get cleaned up when we get back to the river!"

"OK, god damnit!" I yelled, "Stop poking me with that fucking bat, asshole."

Casey laughed and headed for the galley for coffee.

In a few minutes I managed to get out of bed and pull on my jeans. I threw on a faded Margaritaville t-shirt I had from a concert a couple of years back. I went to the galley where Cole, Jim, and Casey were talking about some new Loran equipment Cole had read about somewhere.

I poured myself a cup of coffee and peered through the port hole on the starboard side as I stirred in a spoon of sugar.

I was stunned to see that my crazy ass cousin had managed to land a new sea plane in the canal, and had it proudly displayed, tied to the boat.

"Are you out of your fucking mind!" I said. How did you pull this off without killing yourself ?" "You know this canal is barely wide enough for two shrimp boats to pass, much less try to land a big ass bird like that," I went on.

Casey was silent for a moment, and then calmly said, "Try?... anyway, don't worry I waited till day break, so I could see clearly, and not to wake anyone who might be sleeping in till eight. Anyway, I put it down on the main channel and idled into the circle.

"You're a piece of work." I said.

Jim started breakfast and I went topside to get my bearings and admire the toy that Clance had recently purchased. I wondered how Casey managed to land such a large plane in such a small canal, but I remembered some other flights I had been on with Casey and thought left my mind quickly. The air filled with the sweet smell of the bacon that Jim was cooking below, and the steam rose from the coffee cup in my hand.

The sun cast a dim hue over the canal and the surrounding marsh lands. I thought of how mornings were a special time to me. A new day, another chance to make your mark in the world.

I could hear the boys laughing below at something Casey had said. Shortly after Cole stuck his head out to let me know that breakfast was ready. I stood up to enjoy the morning view for a few more minutes, as I knew it could be my last. Turning my back to the warm sunshine now breaking the marsh line I went below to join the others.

Everyone ate without saying much. Jim's good cooking usually does that to you.

Casey spoke up, "you guys got your shit packed?"

"Yea, we packed yesterday evening cause we knew we'd be too fucked up when we got in from the bar last night," said Cole, as he chuckled.

"Boy ain't that the truth," said Jim.

"Well let's go" said Casey as he stood up from the bench seat of the galleys eating table. Smiling and patting his belly showing a sign of satisfaction for the good breakfast.

Everyone left the table but Jim, he stayed and picked up the plates and cups and then joined the others top side.

By now Casey was standing in the cargo door of the giant twin-engine Albatross motioning for me to toss him the bags. I done so as Cole was going over a few things with Jim that he needed to watch for while he was gone. Jim listened closely to him not to miss a thing.

"Let's go!" Yelled Casey, "we're burning daylight!"

I maneuvered my way onto the floating dock and through the cargo door of the plane. Cole followed shortly after while still talking to Jim as he was boarding.

"Don't worry," I said. "Jim can take care of things while you're gone a few days.

"I know, I know," said Cole, "I just wanta make sure he knows about all the little quirks of the boat."

"He knows more about that boat than you do," said Casey from the cockpit.

"Props clear!" said Casey as he primed the pumps and hit the left starter switch.

the large three blade propeller began to turn. The engine let out a cough, a pop and a burst of smoke. Then it came to life, the blades spinning at a moderate speed. Then the right engine followed nearly identically in its response.

I leaned down and stuck my head into the cockpit. "Wow what a view." The console was covered with instruments from side to side.

Casey reached over his head and pushed the throttles in the direction of the wind screen. The cabin filled with the roar of the engines. I felt the vibration rumble through my head set as we pushed our way down the narrow passage, making the half circle back to the main canal. The sun had since yawned and stretched reaching above the trees reflecting on the waters glassy surface. This made it a little difficult to see in the easterly direction, so we continued south bringing the old boy on the step. It bobbled slightly until Casey pushed it to full throttle allowing the wing floats to escape the grasp of the green gulf. Soon the big Albatross was to a full plane. It was only seconds before it left the smooth hazy surface that merged with the sky in any direction for a hundred and eighty degrees. As we lifted away, we left a wake and a trickle of water rolling from the bottom side dripping back into the calm gulf below. Casey brought it to about 200 feet off the water and began a slight bank, hardly ten degrees towards the east. Slowly the warm morning sunshine filled the wind screen, I felt it on my face, it was heavenly. A glow fell over the cockpit full of instrumentation. Our heading was now One Hundred and Five degrees and altitude One Thousand feet, estimated flight time approx. Two and a half hours. We passed over several oil rigs towering out of the sandy gulf bottom. Their flare stacks ablaze rendering black smoke from the raw fuel.

I began to think of what the outcome of this big to do would likely be.

It was the once-a-year published meeting of the Pins, the haulers and the organizers. It would be the annual company party, so to speak. The once a year they all could be found at the same

place. The meeting of the minds, planning the strategy for the wave of runs to come.

"Hey look at that," said Casey.

It was a large yacht a quarter of a mile south of their heading. It appeared to be moving in the direction of Tampa Bay. Casey pushed the nose over and began a right bank, knifing the wing to accomplish a quick descent.

'Let's look," said Cole.

"I almost forgot you were back there." said Casey.

"Had to get me a power nap," said Cole as he stretched and climbed into the right seat.

We dropped to about a Hundred feet off the water as we made our first pass off to the left of the vessel. Then went around and lined up for another.
We had slowed to about 90 knots and settled down to near 50 feet, just high enough to clear the massive craft filling the wind screen.

"Wow! Look at that," said Casey.

Admiring the 150-foot vessel making its way south.

Cole added. "that's a nice ride!"

Casey added power and pulled the nose up.

"We gotta party to get to!" He said as he banked left in the direction of our previous heading.

Cole went on for a bit more about the yacht.

They all passed the time telling bull shit stories of passed smuggling runs, run ins with husbands, or some type of bar story.

A couple of hours had past and soon we were approaching the beautiful Florida coast. The sun was now over our shoulder lighting up the coast with its golden tones. There was marsh, palms, and pines for as far as the eye could see. What a sight, I thought.

Soon we reached the shoreline, made a sweeping right turn and headed south for Horseshoe Point. This was about ten nautical miles south of where we made landfall.

"Just about there." said Casey. We fell to just above the tree line. He pulled the throttles to slow the craft for approach, as we crossed over the Pepper Fish Keys. A small chain of uninhabited islands surrounded by sand bars. They were covered with Indian artifacts lost during fishing endeavors over many centuries ago. Casey could see the Teepee markers in the distance, it's where we would make our last turn inland before touching down.

As we crossed the marker Casey bled off some more speed as he banked left and lined up for touch down. He gave it a notch of flaps and picked his spot. He trimmed the large bird and adjusted the throttles to compensate. The plane hung in the air for a bit as He pulled the yoke back slowly for the controlled stall as the channel markers slid by. Then it settled into the green gulf water, rumbling as it sank deeper and deeper, until it came off the step. The spray lay a fine mist on the windscreen coming to a drift as he pulled the throttles to idle. The wing floats slapped the water as we drifted towards our tie down.

"Home again," said Casey.

I noticed a familiar face. It was the girl I had seen on the sea

wall some time ago. She was leaning on the railing watching our arrival.

I said to Casey, "there's the girl from the seawall. What she doing here?"

"That's Clancy's daughter," he said.

"His daughter!" Why didn't you tell me?"

"You didn't ask," he said.

"She looks to be interested in someone on this flight and I know it ain't me or Ole Cole," said Casey.

"She's here to see you," He went on.

"How do you know," I asked.

"Oh, I know," said Casey. "You best go over and talk to her."

"She's usually in Gainesville this time of year going to school. She's here for the roast… but she's really here to see you!" Casey shouted through the mic. "She's a Gator girl!" he said in a girly and excited tone.

"Don't worry, I plan to go talk to her!" I said.

There were dock hands ready to catch the plane as it came along side. Casey hung up his headset and headed towards the back. Cole had the cargo door open and was talking to a dock hand, someone he obviously knew. Cole stepped onto the dock continuing his conversation with the hand as Casey and I followed him out.

"What about the bags?" I asked.

"Don't worry about 'em, the hands will tak'em up to the room for you." Casey replied.

"OK," I said, as I nonchalantly walked towards the girl down the dock.

She had a small build; her legs were well toned and tanned. Her hair was brown and barely to her shoulders. She had large brown eyes and a pretty smile. The light breeze fluttered the fringe on her cutoff jeans. She wore a bright yellow tank top which she filled out very well. She watched me out of the corner of her eye, as if I wouldn't notice. She kept looking back out at the soon to be setting sun. As I got closer, she began to smile slightly. She knew what I was up to. I grew nervous as I got closer, what would I say?

"Hi, how ya doing?"

"OK," she replied.

"I'm Remy, "I said.

She smiled nicely and said, "I'm Lucie."

I was in love, hooked, finished, done. I felt a feeling I had never felt before and didn't know what to do about it.

We talked a while and got past the awkward moment of meeting. We talked for more than an hour as we watched the sun sink into the orange gulf, the hot ball of fire extinguished by only the liquid gold that swallowed it whole. I got up the nerve to reach down and hold Lucie's hand. We both felt a hot streak run through us. I never wanted to let go.

I noticed someone under a tiki hut watching us from a distance for a short time, I soon realized it was her dad. But he turned and walked on after he saw that we had spotted him observing us.

"So Clance is your dad, how's that for shooting myself in the foot?" I asked.

Lucie laughed, "he's not gonna say anything to you, don't worry," she said.

"It's more what he may do to me that concerns me," I said, "not what he might say."

"Oh, stop it, it's really OK," She continued trying to convince me as we walked up the dock to the large patio that overlooked the bay.

Quite a few people had shown up by now. The fire pit was blazing, the radio was playing in the background and the bar was open. The band was setting up on a sizable stage just right of the large glass entry to the house.

"I hear your dad always has a big band every year," I said.

"He's got some band that plays a lot of that Caribbean music, they're just breaking out, they've got a song on the radio now or something like that," Lucie went on.

We walked over to the bar to get a drink. I could hear Casey and Cole laughing about something, probably me I thought since they were looking in our direction. I turned back to see Lucie leaning against the bar, one foot off the floor flipping her flip-flop back and forth. The breeze was blowing her dark hair on one side, she brushed it from her face and took a drink of her beer.

The warm glow from the flame of the tiki torch enhanced her soft complexion, what a moment, I stood and took it in for a while. The more I watched the more I fell. The spell was broken with the introduction of the bartender to me. We shook hands and the tender passed me a beer. I turned back to face the crowd as Lucie talked on with the bartender. So, I decided to wander over across the dock where the boys were hanging out. It seemed that the crowd thickened by the passing of every moment. The night was hot, and the beer was cold, the crowd would surely frenzy. The limousines, corvettes, and foreign jobs were starting to line up down Coconut Palm Road for as far as the eye could see. It was an old historical street in front of the waterfront mansions that stretched for several acres facing the secluded bay.

Cole and Casey were knocking them back like the bartender had called last call.

"Hey Remy Boy, looks like you and Lucie are hitting it off pretty good," said Casey.

"Let's go find Clance, he wants to see you," said Cole.

"Oh shit, here it comes!" I said, "He's gonna have my ass over that daughter of his."

"No, he just wants to chat about some upcoming import schedules, and the part you'll play," said Cole.

"Oh," I said with a sigh of relief.

We walked towards the back doors and entered to the left in a small side door and continued down one level. The walls were a pristine white with large nautical art pieces sparsely displayed. Cole opened a large heavy wide and tall door, almost resembling that of a vault. It led down a hall and through another similar

door. We were now deep in the middle of the house but underground. Through one last door that opened to a large room. The walls were covered with and unfinished natural pecky cypress. The room was spherically shaped with the constellation painted in detailed covering the dome shaped ceiling. The perimeter was lit softly but evenly. The walls displayed large highly detailed pictures of sea planes, sail boats, and shrimpers, all in a tropical setting. The waters a brilliant blue and the backgrounds covered in lush green vegetation. Clancy posed in each, appearing proud of each craft as if it were his own child.

"Come on in boys," A voice said from out of sight. "Close the door behind you Cole," he said. Then the wall slid open and out walked Clance in a white sports coat and white shoes. He was smoking a cigar; his beard had thickened since I last saw him. He offered us all a snort of coke. It was in a candy dish as if it were part of the decorations of his office.

Cole and Casey dove on it like a couple of magpies fighting over a piece of bread. Clance laughed as I stepped in and divided it up for everyone.

"Remy, I heard you and Casey had quite a run in with the feds on our last endeavor," he said.

"Yea, it scared the shit out of me, I thought we were goners for a minute. Until old Casey pulled that rabbit out of his hat at the last second." I stated. I was referring to the trail through the palms and ditching in the pond that night.

"Pretty neat trick, ay?" said Clancy. "But don't let anybody fool you, Ole Casey practiced that one quite a few times before he got it right."

"Damit Clance, you weren't supposed to tell him that, now he won't believe I'm a superstar!" said Casey.

"Well, it took you a long time to be the half assed pilot you are right now," said Clance, jokingly.

"Let's get down to business," Clance said as he pulled down a wall map of the coast line of Florida.

They all were very familiar with this coast line.
And then he pulled down a map of the coast of Central America, this was a less known land by most of them in the room except for Cole. He had spent some time in Tampico, and up and down the tip of the Yucatan.

"You guys are heading for Belize, the land of milk and honey, the land of opportunity... Casey, Daughtry has his finger on a DC3 from some old Navy buddy, she supposed to be in pretty good shape from what he says. You need to speak to him before he leaves the party tonight to see where they're gonna bring it... He mentioned something about trying cow creek, on the road to nowhere to see if it can be brought back there on your return," Clance rambled on.

"You should visit the area and make sure it will be suitable for the run," he said.

"You will need to meet a contact on next Thursday night at the pool hall... He'll be a Spanish fellow...you'll know 'em when you see him. He'll have details about the dirt strip you will land on, and direction to the ridge when you reach the coast, and some things to look out for and avoid along the way. His name is Jorge Alverez."
"Cole, you need to make sure we got plenty of fire power on board...One of the Gonzales boys has been ousted from the family power in Belize making things a little unstable at times. There's a bit of a tug of war for power right now." Clancy made

it clear as he made eye contact with Cole.

The briefing went on for about a half an hour and then we were somewhat dismissed. Everyone hung around for more candy and drinks.

Clance stated that he needed to get back up topside to be a good host. So, everyone meandered back down the hall carrying on about this and that as Clance pulled the door shut behind us.

7.

The Oyster Roast

I opened the big glass door and the warm gulf breeze blew across my face. I immediately could smell the familiar marsh lands with the mixture of black jack oak burning in preparation for the oyster roasting. Ah, I love it I thought.

I noticed three large faded silver wash tubs full of the best Apalachicola oyster's money could buy. Covered in mounds of flake ice. I scanned the thickening crowd looking for my new love. I spotted her across the patio setting on the railing talking to a girl in a sun dress slightly fluttering from the breeze. I walked in their direction passing a table filled with all kinds of condiments, and tons of hot sauce. the corner of the white table cloth flipped in the stiffening breeze. I heard an old fellow strike up a conversation with the cook attending the fire. They spoke in a Cajun tongue and appeared to know one another from their friendly gestures. One noticed that my beer was low and reached down into an ice tub and pulled out my flavor, handing it to me as I walked by. We exchanged smiles and I kept walking. The patio made a half round at the fire pit and was lined with a tumbled brick sitting bar on one side. All the seats were taken. The flake ice from the neck of the beer melted from the warm evening air, running down the knuckles of my left hand falling a drop at a time to the plank wooden floor below. Leaving a trail

from the fire pit to the bar.

I walked up to Lucie. She turned and put her arms around my neck, pulling me close to her face.

I thought the drinks must have loosened her up a bit because she kissed me with little nervousness noticeable. I was ecstatic, and my blood rushed hot. I had never felt so in my life. Is this love I feel?

"What did you, daddy and the boys talk about?" she asked.

"Oh, just business talk about our next job," I replied.

"Where are you going this time?" she asked.

"I probably shouldn't say," I said.

"It's quite OK, I know what my daddy does for a living, it's no secret at the dinner table," said Lucie.

"South America," I said.

"Oh, daddy's going for some big fish," said Lucie with a big grin on her face.
"You could say that," I said.

"Well, be careful, will you?" said Lucie.

And that was all the talk of the future endeavor. she quickly changed the subject and we walked hand in hand over to the fire pit.

By now the band was playing and the crowd quickly getting into the music. People were dancing all around. There was no real order to it, people danced wherever they stood. Now the fire was just right for the oysters and Tom had a batch going, Ray bans on his head, he wore a red button-down fishing shirt and a

gold crab encrusted with a large emerald in its shell, that hung from a laced gold chain. He was quick with an oyster knife, and a witty son of a bitch too... he could shuck 'em faster than three people could eat 'em.

Lucie spoke a few words in the Cajun tongue, asking Tom to pass a few their way. He smiled, and he nodded reaching into the fire with his hand covered only with a wet mesh glove, grabbing a couple with one quick sweep. He opened them in a flash, dropped 'em on an aluminum tray and slid them down the bench to where we sat.

"How dat?" he said

"Great," I replied.

I picked up an oyster, slid it onto a Saltine cracker, grabbed the closest hot sauce bottle I could find and doused it down till it was orange.

I ate it in one gulp making a hand gesture to Tom indicating my satisfaction.

"Man, that's good!" I said.

"Oh yea." Lucie followed as she swallowed.

We both reached for the Michelob Light, taking a big drink to wash it all down.

The night passed so quickly. We danced, held hands and sealed it with an occasional kiss. The band played a few slow songs at the end of the night. We danced some more and watched the crowd slowly thin. Until only the bartender and Cajun Tom were left. Casey and Cole left earlier with a couple of girls.

Clance had said good night to the last of the other guest and told us he was headed for bed.

Lucie suggested we go down to the plane floating in the canal. She said we could spend the night on the plane. I was hoping she'd ask me to stay for the evening. We walked without talking at all. When we reached the plane, I held open the rear cargo door as she stepped down into the hollow fuselage. I followed with a bit of nervousness and certain excitement pulling the door closed behind me.

I reached over my head and turned on a dim light, it had a bit of an orange tint and was soft on the eyes. Lucie grabbed a couple of sleeping bags from the hold in the back and spread them on the drop-down bunk. I sat down on the edge of the bunk and she followed without a word. Slowly she began to kiss me each becoming more passionate and seemingly a bit aggressive. I liked it though. I reached over and slowly slid my hand under her shirt moving it up until I felt her soft warm breast in my hand. My heart began to pound, nearly out of my chest. Lucie raised her hands over her head and pulled the brightly colored tank top off and dropped it in the darkness around our ankles. I could see from the dim lit cabin what I was caressing with my hand. Her tanned breasts. The light accentuated them. She pulled my shirt off, unbuttoning it one button at a time slowly working her way down. Then she stood up and slid out of her shorts dropping them on the floor with her shirt. She wore no panties and no tan line below the waist and her body was hard and muscular. I nearly lost my breath. She stood there with her hands over her head swaying her hips back and forth as if to taunt me, smiling lightly.

"Do you like what you see?" she asked.

"Yes, I do." I said.

She pulled me up from the bunk and kneeled and undone my jeans and helped me out of them. I slid My hands down from her small waist to her warm ass. We worked our way to the bunk and

laid down, embraced and intertwined, her legs wrapped around me, we began to make love. The humid night made it hot and sweaty. We made love until we were exhausted. We lay naked uncovered and fell asleep in each other's arms. It was early morning by now and we slept as one.

8.

Pounding heads

Cole began to rub his eyes trying to focus through the swollen lids. Lying flat on his back, he could barely make out the figure that stood over him. He could hear laughter but didn't immediately recognize the voice. He thought of how the sound echoed through his head like a fucking drum. The cocaine, beer and champagne were more than his body could tolerate any more at this age. Casey continued to laugh as he set a cup of coffee down on the night stand.

"Man, you look like fucking warmed over death," he said to Cole.

"Yea, well I feel twice as bad, you ought a be on this side of these eyes," said Cole.

"No thanks, this side is a lot fucking funnier!" he replied.

"Where'd the girls go?" asked Cole.

"Those bitches left two hours ago," said Casey.

"Anyway, get your dead ass up we gotta get down to the

river and start packing for our latitude change next week," he went on.

"OK," Cole said as he tried to stand up holding his head.

Cole slowly moved for the patio door that opened to the terrace hanging from the second floor. His cup of coffee in one hand and balancing with the other. He sat down on the natural thatch colored wicker chair. It was weathered from the many rises of the morning sun. Today being just one more. The morning rays split the towering palms on the eastern islands in the distance.

It's now October and the mornings are cooler than past months. Cole began to think of his mother. She'd always wanted him to attend college rather than choose the life that would turn an honest hard-working man into a bandit at heart. She often reminded him of how his father had gone down. It was over a bad deal in the Cayman Islands. His contact double crossed him, shooting him in the back as he boarded his boat to head for the mainland. He was picking up a pay-off for recent run that Clance had put together and executed flawlessly. The contact took the money and set Cole's father a drift as he lay face down on the deck. You see that's why Clance kept Cole under his wing, He kind of felt obligated to Camron, Cole's dad.

When He didn't show and was a day overdue Clance and the boys went in search of him. They found him about half way between the islands and the keys. He'd caught one in the back, it had grazed his spine and paralyzed him from the waist down. Not to mention he'd lost a lot of blood. Cameron had seen the morning sun rise and he managed to pull himself up just enough to reach the wheel, steering it in the direction of the Keys. When Clance reached him, Cameron made him promise to take care of Cole no matter what. Clance made that promise as he watched him die in his arms.

The two were the best of friends and Clance vowed to even the score for the slaying of his friend.

"You are thinking about Cameron again?" Casey asked as he walked out on the terrace, a cup of coffee in one hand and the other tucked in his jean pocket.

"Yea," he said. I miss him… he was my good buddy," he said in a quiet voice. He spent a lot of time with me, taught me how to play the guitar. Man, he could play an electric guitar. People loved him wherever he went. He never had enemy one. People would stop him on the street just to let him know how good he was the night before on some stage somewhere."

Cole stood against the rail of the terrace as he paused for a moment. The memories began to flow. He held back the tears that seemed to always appear after a hard night.

He turned and walked back into the bungalow, grabbing his shirt off the back of an old rocker as he headed for the doorway. He walked down the stair case putting it on, buttoning it as he descended. Opening the front door he yelled back to Casey, "let's go, we got plans to make, don't we?!"

Casey didn't say a thing he just followed and closed the door behind him. Cole was already in the Vette as Casey walked down the gravel drive. The crunch of the gravel seemed louder than normal this morning. He cleared the long hair from his face as the morning breeze fought his every attempt. Casey opened the passenger door and slid his tall six-foot three frame into the seat, looked at Cole and said, "what are you waiting for?"

Cole started the Corvette and revved the engine, slammed it in reverse and dumped the clutch showering the steps of the bungalow with gravel. He turned the wheel hard left and swung

the front of the car around. When it came to rest it was pointing down the cobblestone back street that had led him to his destination the night earlier. He threw it in first and lit up the tires. Then second causing it to fishtail a couple of times letting up as he reached the end of the street. Made a hard right and stepped on the gas again. The palms lining the street began to look like a picket fence. Casey hadn't said a word, he knew Cole would be fine in a few minutes. Before long Cole eased off the peddle and the car coasted to a more relaxed pace.

"You want some breakfast?" Cole asked.

"Yea let's stop at Taylor's, "Casey replied.

"What about Remy Boy?" Cole asked.

"I'm sure he's just fine… bet he's dining with the boss's daughter this morning," said Casey.

The winding road shortly produced the hole in the wall where they'd chow down. It was, a building made from weathered cypress slats perched halfway on land and half on creosote poles well above the tide line of the river. The dock was lined with shrimp boats, and an old sponge boat wreck lay on the bank across the river. It had been there as long as either could remember. Behind it was an island that backed the marshlands beyond, they played on it as kids. The local tale was that there was an old Indian man that lived there years ago. Occasionally he would come out and trade his jewelry for goods and then disappear as mysteriously as he had appeared.

The island was covered with under growth and red cedars, palms and pines towered above it all. None of the kids had ever seen him but certainly believed in his existence.

Horseshoe Beach, FL

Meanwhile back at the beach house Me and Lucie were having breakfast. Clance had slept in, as he would usually do after a good party night. He often stated that he was no spring chicken anymore and needed all the rest he could get. Especially since he hung around such a young crowd.

We finished eating and stretched out on the couch watching TV. I laughed at the episode of Gilligan's Island. "Never have figured out why they took so many clothes on a three-hour tour," I said rubbing the sleep out of my eyes. "I need to check in with Jim and make sure the boats OK."

"There's a phone in the roll top desk there." said Lucie as she pointed over her shoulder without looking away from the TV.

Sipping on a spicy Bloody Mary I walked to the desk and sat down in the hardwood chair. Fiddling with my wallet, looking for the number to the marina in Cameron Town I picked up the receiver and cradled it on my shoulder. Finally finding the number I began to dial on the rotary phone.
The attendant on duty answered on the other end of the line.

I gave a message for him to relay to Jim. I asked him to have him call back at this number in the next hour or two. I hung the receiver back in the cradle. Lucie slipped up behind me and began to kiss me on the neck and rub her hands on my chest.

"You better cut that out your dad might not like it if he walks in on you loving on me like this."

"He's down stairs asleep, He's not gonna catch me." She said as she headed back to the kitchen where she began to wash the breakfast dishes.

I tilted my glass up to finish off the last swallow of the Bloody Mary. The humidity from the glass dripped onto my chin and ran down my neck during the attempt to get every drop of the drink. As I sat leaned back in the old chair I noticed through the haze and pepper specs that coated the bottom of the glass, was a picture that hung above and to the right of the desk. In it was Clancy standing next to a well-known drug trafficker from Belize; it was the infamous Manuel.

9.

Come Back Home

Dead Man Bay, Florida

Things were heating up at the river. The south American contact had arrived a few days earlier. He'd introduced himself to Eddie Joe one evening at the pool hall. Needless to say, He was nursing his wounds at the motel, and was pretty pissed off to boot. Clancy had sent someone over to check on him to see if he was OK. Beyond a few scrapes, bruises and a black eye he was just fine. Casey and I had split up for a couple of days. Casey went to check on things at home and I went to see my parents. For me these visits became harder each time. My dad had heard through the grape vine who I was hanging around with and the direction I was headed. This saddened the old man, although he never gave up on me. He'd often try to convince me to move back home, to no avail. I thought it was only, so the old man could keep his thumb on my whereabouts. My mother was only glad to see me each and every time. She'd never discuss anything to with my dealings and would only smile when I would talk about the girl I'd met.

"I finally spoke to Jim; everything is fine with the boat." I told my dad.

"Jim's been spending the usual amount of time at Nate's, the boy from the Marina had to go find him there the other morning when I was looking for him." I went on.

"Use to be he would only eat dinner there but now Miss Mammie's got 'em eating breakfast and every other meal there. And when he ain't there miss Mammie's a bringing Fried chicken to the god danged boat." "I told Nate he'd better look out before long he'd be moving his suitcase in."

Mr. Remington only laughed for a second and then took another sip of coffee.

We all talked over breakfast for a while and discussed the finances of the boat. Mr. Remington kept a close watch on the boat, after all, his name was on the note that the government held. It was a special arrangement that had been made for the commercial fishing industry. After breakfast was done and finances finished, I said my good byes. Each time my mother wept as she watched her grown baby walk away. And each time like the one before the old man held her tight fighting back his own tears of love for his son. And each time he wondered would it be the last time he'd see him.

10.

The "Shaken Not Stirred"

Horseshoe Beach, Florida

Lucie spent most of her time working on that bronze tan of hers lying beside the pool in the hot humid Florida sunshine. The sweat beaded up on her thighs as she sat in the lawn chair facing the canal. It was a little warmer today even though it was getting into the fall but there had been several days perfect for tanning. Today was one of those days. She sipped her Bloody Mary as she listened to the AM station out of Tampa Bay. She was expecting Remy any time now. She watched the pelicans on the dock setting atop the poles warming their wings. The tide was low, and the muddy marsh aroma filled the warm air. It was a smell that became enduring from growing up on the coast.

"Hey there little girl," a voice said.

Lucie rolled around in excitement thinking it was Remy, but it was her dad.

"Oh, it's just you," she said.

"What's with the warm welcome?" said Clance.

"I'm sorry daddy, I just thought you were Remy," said Lucie. "He supposed to be here in a bit."

"I been wanting to talk to you about him," said Clance. "You seemed to be pretty attached to him from what I can tell."

"Yea daddy I do like him a lot," she said.

"Well, you sure you know what you're getting into?" He asked.

"I do, daddy," she said.

"You know what kind of dangers involved with men like that, right?" asked Clance.

"You mean like you daddy?" she asked.
He knew this conversation was done and said," Just be careful, alright?"

"OK daddy," she said with a light smile as she looked up at him standing beside her chair.

"I'm sure he'll be here soon. I spoke to Cole and he said he saw him at the river, and he's coming to meet with us today." Said Clance. "So, hang in there little girl," he said as he walked away towards the beach house.

Lucie looked away as she took another swallow of the Bloody Mary from the tall sweaty glass.

It wasn't long before I arrived just behind Cole and the rest of the gang. I walked over and kissed Lucie on the top of the head. She jumped up in surprise and threw her arms around me.

"Wow what a reception I should stay gone for a couple more days if it'll get me this kind of greeting," I said.

"I missed you baby," she said.

"I missed you too."

"How's the parents?" asked Lucie.

"Their fine, daddy's always on my ass and mom she's just glad to see me."

About that time Cole leaned out the back door and yelled, "hey lover boy, get your ass in here we got business to attend to."

"I better go before Cole gets too anxious," I'll see you afterwards."

"OK babe," said Lucie standing, then leaning on the rail, as I walked away, looking over my shoulder.

Lucie sat back down to tan a while longer. She finished the drink while watching some clouds build over the gulf horizon.

All the men met in Clancy's office down stairs. The meeting didn't last very long but was very informative of the plans of a latitude change. The boys were given specific instructions for their next three days, starting immediately. They were to depart in the afternoon of the next day. Thus, their arrival would be under the canvas of darkness. The next several nights would be dark ones with no moon to reflect their existence. This is where Cole's flying experience would pay off or prove fatal. As they would land merely by firelight in the over grown foliage of South America. Specifically, Belize. For now, Cole would meet and

stay with the plane that was arriving this morning. Casey and I would finish some last-minute business in town. We'd catch up with Cole in the morning on the Old Road to Nowhere.

This morning the name "Road to Nowhere" seemed to have a more profound effect on me. It seemed to be trying to tell me something. It spoke through the roar of the large Mudder tires. It spoke to me in broken meanings. Each mile that passed the sound became fainter with me becoming more comfortable with what I now had become and where I was.

The sound soon became only rubber against asphalt. I no longer heard a thing it said, nor did I care as my heart beat faster with excitement. The beating drowns out the road's words of wisdom, muffling it with anticipation. The beast had won again.

As we made the last seeming never ending turn, we could see the long morning shadows of the plane setting on the end of the highway. There it sat like a proud eagle with its wings spread draping well beyond either side of the road. Cole stood off to one side of it with his AK47 over his shoulder and his thermos top full of coffee in his right hand. The steam rose straight into the air, not trailing at all as it was a calm October morning. Cole wore an Army green flight suit; it was his favorite as he said it brought him luck as well home safe each trip before. I noticed it had several bullet holes. I supposed I could strangely see the luck in that... He wore a black ball cap with gold embroidery letters on the front that said "D.E.A.". It showed the humorous side of him. His dark eyes sat in the shadow of the brim and were not visible through the plume of steam from his coffee as he held the cup close to his mouth.

Casey pulled the truck down into the ditch on the shoulder of the road. He opened his door and said with excitement, "Let's rock and roll!"

I only smiled as I opened my door and stepped out onto the

steep slope of the built-up grade of the road. Which made one last slight bend and headed south through the middle of the marshlands for several more miles disappearing into the hazy horizon. This is known to the locals as the airport. Casey had a few words with Cole while I unloaded our gear and stashed it in the plane just inside the cargo door. We'd soon taxi and head Southwest for the big adventure. Someone would soon be by to move the truck out of view from the occasional sightseer. I stepped back looking up at the large wingspan of the aircraft, taken by its size. The large propellers stretched out like arms of giants. I was in ah.

The DC3 was painted military gray with an emblem of a martini glass with a sword through an olive and the words, *"Shaken Not Stirred"* were painted in black just under the glass. Cole put his arm on My shoulder as he walked past. I stopped and looked at him.

"You ready for this ride Remy Boy?" Cole asked.

"Hell yea!" I replied.

"Well let's get this bird airborne," said Cole.

Casey walked by and said, "Let's roll boys."

Cole and I followed him climbing into the cargo doorway. Casey pulled the door closed and dogged it. He showed Me the assortment of artillery spread about the cabin strategically but secured, as Cole went through the preflight checklist. Then We joined Cole in the cabin. Casey took the right seat and I sat in the jump seat that dropped down out of the sidewall of the aisle. I got situated and strapped in. After priming the pumps Cole hit the ignition on the left engine. The large propeller slowly comes to life. Rotating until it fired and spun on its own. He followed it with the right engine. It coughed and bellowed a puff of black

smoke from the giant exhaust. He leaned it up a little, then it was alive. He warmed them and then ran them up to take off RPMs. In the meantime, everyone adjusted their headsets and made themselves comfortable as possible for the long flight ahead. Cole pulled the throttles back to just above idle. Then he released the left brake with his foot and gave it right rudder adding a burst of power to the left engine. The colossal bird broke from its hold and slowly began to roll, turning to the right at the same time.

As He brought it around, he scanned the panel, all looked well. We taxied for a moment until the plane sat flat and level on the Old Road lined up for takeoff. Cole locked the brakes and ran both engines up a bit. The hollow cabin began to rumble. The wings began to rock in synchronization with the engines. The propellers batted the thick southern air making the distinctive popping sound that Cole so loved to hear. Each time his heart raced with excitement like the time before. And each time Casey would do the same thing just before taking off. He would salute out the window as if he was on the deck of an aircraft carrier to someone that was not standing there, reach down and turn on the eight-track player that he'd quickly rigged into the headsets. And each time they'd hear, *"That Smell!"* Then Casey would Look at Cole and give him the same swinging arm signal for takeoff from a flight deck. It was always the same. Cole played along each time never saying a word. He'd pop the brake, quickly check the travel of the yoke for free and clear and push it forward to hold the nose down. The big bird gained speed, the wing tips lifted erect and the tail left the ground. Cole could feel it getting light as they reached lift off speed. He held it down a moment longer since he had four miles of pavement in front of him. The music blared, and Casey sang along as he scanned the humid, palm riddled horizon. I sat smiling, now knowing there was no turning back. The bumping of the wheels abruptly ceased. We were airborne. Cole pulled back on the yoke rotated for climb out and Casey pulled the gear up. The gear made a bumping noise from the hydraulics as they retracted into the wells, leaving the bottom

third of the wheels exposed.

I watched the landscape below shrink away as we climbed to about two thousand feet and leveled off. Cole banked slightly right to a heading of one hundred and ninety-five degrees south southwest. He knew he had to miss the Cuban waters before he turned to his last heading for the coast of Belize. That would be a bit of excitement we could do without on this leg of the trip.

We may still see a gunboat or two hanging on the edge of their territory like a shark on a reef. But should be safe from any confrontation with the Cuban Navy.

"Hey Remy boy, pour us a cup of coffee!" shouted Casey as he removed his headset and began to clean his sunglasses.

"Roger that," I said, as I got up from the jump seat heading back to what was left of the galley in this big bird with its modifications for this voyage.

Cole studied the chart that had been passed to them from the contact. There was a spot circled in red that supposedly marked the location of the dirt strip some thousand feet above sea level in the jungles of Belize. It was believed that it would be marked with a bonfire lit just shortly before their expected arrival. Just to the side of the circled strip was some Loran coordinates to help them pin point their destination in the dark.

I tapped Casey on the shoulder and handed him his coffee and then Cole his. I then grabbed a cup for myself and sat back down, maneuvering the headset with one hand. We passed the time talking about fishing and such things. Only interrupted by an altitude change. We dropped down to just under five hundred feet and refined our heading to 198 degrees. Cole said this would be our heading for the first 400 nautical miles, getting us to a safe enough distance from Faro Roncali, the western end of Cuba. He went on, we should be there just before nightfall. With the nice

weather we would be able to clearly see the light from the oldest light house in Cuba.

I looked down at the nickel-plated Colt strapped to my left leg, putting my hand on it. I thought how I hoped I never had to use it…ever.

Cole carried two nine mils in a double shoulder holster. He kept an extra clip for each nearby, a 32 in the zipper pocket on the leg of his flight suit and a Derringer in the back of his waistband for small emergencies.

The sun had now crossed over Our heads from left to right. It blazed the horizon it soon would overtake.

We'd all had a sandwich in the early afternoon but was thinking of something more substantial for dinner. If things went as planned, we'd be able to get something to eat in a small village down the hill not far from the strip. The cargo would not arrive till tomorrow late, so we had a little time to kill. Apparently sometimes the strip would be happened upon by the federales' with no notable pattern. So, the cargo couldn't set around waiting on a ride.

We lumbered along at about one hundred and sixty knots for a couple of more hours. Listened to the entire *"A1A"* album and shot the shit to pass the time.

"There it is," said Casey, as he pointed in a south easterly direction.

I could see through the windscreen, the light appeared and then disappeared in the shadowy gray distance.

"That's it," said Cole. "We are nearing our turn."

"Bring her around to a hundred and nighty-three degrees," said Cole.

Casey started the slow turn south, not to overshoot his mark, he eased out of it. Watching the compass needle move around the floating sphere, he leveled the wings just before he reached one nighty-three.

"Now start looking for the Punta Molas Light house on the tip of Cozumel, the island just off Playa Del Carmen, it should be just right of dead ahead," Cole said.

Casey said, "It may be a few minutes before we can see it at this low of an altitude. We should sneak over the hump soon," He was referring to the curvature of the earth that blocked our view of the light.

A few minutes passed as I stared into the now dark gray on our left that chased the light across the gulf to our right. The bright blue waters have now turned to a dark steel with a strip of gold against the horizon filling the cockpit with a warm glow. I looked over my shoulder to a fuselage filled with radiant shafts of light gleaming through the seven passenger windows. What a heavenly sight.

Looking back through the windscreen I quickly spotted the light house light in the far distance. The dark gray had now given way to a near black and a lightless hatch was soon to close over our world. We were about eighty nautical miles off the point of Mexico. The light house on Playa Del Carmen was quite clear now and getting brighter with our rapid approach.

Soon the coastline began to appear in the windscreen off to the right. It was nothing more than a dark line in the darkening evening. Off in the far distance towards the east, a thunderstorm was forming. The darkening clouds bled into the gulf leaving no visible horizon, only telegraphing their vicious tall thunder heads each time the lightning struck within. backlighting their angry shapes.

Casey pulled back on the yoke to climb back to gain altitude.

We'd dropped down some four hours earlier to avoid radar. In a moment we crossed the point on the beach and checked the Loran coordinates to see if we were close. It appeared that we were a quarter of a mile north of the ridge. The sun had sunk way behind the mountain some time ago. We banked left a few degrees and leveled back off.

"There it is," he said as he pointed to the glimmer in the line of blackness topped by a faint strip of a soft orange.

At the end of the runway was a small bonfire, and strategically placed torches of some South American sort on either side of the strip.

"Looks short," Cole calmly said.

"Yea, but it ain't nothing we ain't done before," responded Casey, as he leveled the wings and headed out over the river that wound just South of the ridge away from the strip, where he set up for final approach.

Casey banked an brought the ridge back into our view. The approach fire was clear with nothing more than pitch black below the ridge. We'd have to come in low as we weren't sure of the length of the strip. We'd needed to just clear the tree tops and drop in just past the fire.

Casey called the commands to Cole as he maintained control of the yoke as the plane lumbered along.

"Full flaps," he said loudly as he pulled back on the throttles a little at a time watching his airspeed.

"Drop the gear!" he shouted as he compensated for the swirling winds that shot up the ridge face.

"Gear down!" shouted Cole.

I could see right through the middle of the wind-screen, the

gap was smaller than we'd anticipated. I could tell by the way Casey started cracking jokes about crashing. He did this whenever he became nervous.

I stated my observation to the two of them that it appeared as if there would not be enough runway left at the other end for the roll out.

Casey said, "Remy boy we got to get it on the ground before we worry about running out of dirt!"

Now we were crossing the tree line and Cole pushed the yoke to keep the nose down compensating for the force of the updraft at the ridge. The landing lights were exposing the palms as we barely cleared their tops. All of a sudden there was a huge bump and lifting and falling of the plane from the gust of wind. Just then everything was quieter. Casey pulled back the throttles and the large DC-3 sank to just above the ground and glided like a pelican above the surface of the gulf. Cole eased the yoke forward to get it on the ground as quickly as possible. The plane bumped as the gear touched down and the cabin began to rumble. The plane slowed and then the tail touched the ground once, but then was off again. We'd slowed to about 65 knots as we passed the last row of torches. The landing lights shown into the darkness less a distance than would be needed to stop at our current speed. It made Casey uneasy to say the least. He made another joke as he applied all the brakes he could, without locking them up on the dirt strip. Soon the big bird rolled to a stop and everything was quite except the idle of the large engines. Just ahead the landing lights shown on a thicket of trees. Casey sighed with relief.

Then out of nowhere a jeep appeared, driven by a dark-complexioned man. He circled the jeep in front of the plane and waved for them to follow.

Casey looked without a word… paused for a second and then applied power bringing the plane to a slow roll. The large engines

rumbled the cabin once again until it broke loose from the rough turf below.

"That must be Demetri," said Casey.

"Fits the description," said Cole.

The big military gray plane blended with the darkness as it bounced along until we were in a small area. Apparently cleared from the brush just for our arrival. The wing tips nearly touched on each side as Casey held the left brake and spun her around. Then he chopped the throttles once again and began shutting her down from left to right. The large propellers slowed to a kicking halt one after the other.

Cole opened the cargo door very cautiously with one hand on his pistol hanging from his shoulder holster. He was met with cheer from the man in the jeep.

"Ola amigo," he said. "My name is Demetri, I am here to show you around tonight while we wait on …shall we say …your cargo, yes?"

Cole stared for a second and replied, "Yes."

"And what is your name funny man?" asked Demetri.

"Cole, nice to meet you Demetri," he said.

"Who's blocking the fucking door, what's the hold up here!" said Casey as he forced his way past Cole.

Cole looked at Casey with a bit of a glare, as he stepped down from the plane's deck.

Casey stuck out his oversized hand and nearly shook Demetri's teeth out of his head. "How the fuck are ya?" he said.

"I am the fuck good," said Demetri as he chuckled.

"So, where in the fuck is the liquor and the women?" asked Casey.

"The liquor is de fuck at de bar and so is de women," said Demetri with a big grin.

"Well let's get the move on God dammit, they ain't gonna wait for us all night!" said Casey.

I laughed out loud, as I loved to watch him in action, he was smooth, suave and knew how to be the center of attention in any setting.

Your plane will be covered by my men and we will get de move on... Yes, Mr. Casey?"

"Yes, Demetri we will," said Casey as he put his arm on his shoulder as the two walked for the jeep chatting like old pals.

Cole and I followed behind the two and then we all loaded up in the jeep heading off into the land of unknown. We were entering an unforgiving darkness filled with uncertainties and surprises. Many have come, and few have returned as it's told back home in the bars and the night spots that line the banks of the marsh lined river from which we all were members of the social structure that made it what it is today.

Down the dark winding road, the jeep bounced heading in search of a seaside memory on a beach far from home.

We drove for only about fifteen minutes before the soft warm glow of the lanterns appeared in the window openings of the thatch shanties that lined the beach with no real form or organization of thought of their locations. Their yards divided by belongings, colorful blankets on lines, some rickety fences that had intentions but never came to pass. There were Panga skiffs across the road that divided the huts from the beach line. Head high palms fought for position along the road side. A stack of lobster traps here and there with beach grass hiding the lower ones.

As the coastal breeze flipped the ends of the palm fronds that made up the roofs of the primitive structures, we could see people going on about their lives. Mothers holding babies, children playing in the sand, and old men leaning back in their chairs on the front stoops sharing a warm drink with a friend or neighbor. It seemed as if time has stopped here and people just existed.

I thought to myself how this life must be, growing up learning to survive on the land and the sea, only to dream of other places and never to visit. It almost seemed to be a silent hell. I guessed you could only want it if you had experienced it, seen it, or lived it. These people looked as if they'd never done any.

Shortly we pulled into a drive that led right down to the beach we'd driven past for several miles. At the end of the drive sat an open sided thatch hut, in the middle was a bar made of weathered logs and handcrafted pieces of drift wood. Off to one side was a small kitchen room with a fire pit just outside of the door. Around the bar sat a couple of people having beer and oysters. There were several pretty girls dancing barefoot in the sand to the beat of a Rastafari band only several feet away.

"Party!" yelled Casey as he jumped from the jeep as it rolled to a stop.

The rest of the crew followed. Behind the bar stood an older

gentleman with a long gray beard that hung to his chest and his hair kept neatly in a ponytail. He wore a tank top and cargo shorts from LL bean. A gold chain hung around his neck with a large gold propeller. It was a well-known symbol to smugglers of a brotherhood and the involvement in international trade of ganja.

Demetri began to introduce us all as business associates of the Gonzalez family. The bartender began to smile and shook hands with each of us as if we were some types of royalty.

"You like cerveza yes?" asked the old man as he passed out several beers.

"You grab a stool and I fix you something to eat," he said.

"What you boy's wanting to eat, lobster, shrimp, oysters?"

"Lobster all around," said Cole.

Casey and I nodded as we pulled our beers away from our mouths.

"Lobster it is!" the old man said as he turned and headed for the cook house.

I sat staring off across the gulf thinking of Lucie. I often found myself doing so whenever I found an unoccupied minute in my mind. The distant storm blew a warm salty breeze strait into my face as I looked north up the beach. I reminisced about the night me and Lucie spent together on the seaplane on the other side of this great gulf, far from where I sit tonight. I wished she could be with me, but I knew that wasn't possible, the danger was great. This life I'd chosen puts me in a state of uneasiness, but the excitement far outweighs the feeling.

11.

Daddy's Little Girl

Horseshoe Beach, Florida

Lucie stood holding the railing of the deck staring out across the Gulf of Mexico watching the moonlit water dance from the westerly breeze. All She could think of was Remy. How she missed him so.

Clance stood several steps away watching her.

"What are you thinking so seriously about?" He asked her.

"Nothing daddy," she replied.

"Oh, come on I know when something's up … it's Remy huh?"

"Yea, I really thought it would be no big deal, him leaving and all," she said. "I thought he'd be like all the others, but he's not, I think I love him daddy," she went on.

"That's a big step, love and all," Clance said…." Are you sure?"

"I don't know, he's all I think of day and night," she said.

"I guess time will tell," said Clance as he put his arm around her and pulled her close holding her tight as the two of them watched the darkness beyond the moonlight.

"When will they be back daddy?" asked Lucie.

"Tomorrow night," her father replied, "late tomorrow night."

"I can't wait!" said Lucie as her face glowed with excitement.

They stood for a while without talking. Each with their own thoughts,
Lucie with the thought that she couldn't stand being away from Remy. And her father thinking of how he wished all his life she could find a normal man with a normal job and normal life style. But he knew he couldn't forbid their love as he was responsible for her choice in a way. After all she'd only seen this kind of life style. She couldn't possibly live any other way and really be happy…or could she?
The excitement of loving a modern-day outlaw was portrayed as a romantic thing. Clance thought to himself …the irony of it all. He'd spent his entire life trying to provide the best life for his daughter, so she could live happily and respectfully. For it to only turn out that she would end up with a man that had chosen the life style he'd tried so hard to lead her away from.

12.

Nate's in Cameron Town

Things were fine in Cameron town. Jim continued to hang out on the boat and eat dinner with Nate and his wife most every night. He wandered when he would see the guys again. It had been a week and a half almost since he'd heard from anyone. So, he decided he better call the river and see if anyone had seen or heard from them. He walked over to the pay phone in the back corner of Nate's just past the pool tables and beside the bathrooms. The smell of beer hops filled the air and the crunch of peanut shells under his rubber boots echoed in the hall. It was early in the evening on this Sunday. The place was busy as there was a football game on, it was loud, and beers were flowing.

Jim picked up the receiver and dialed the number. It rang a couple of times on the other end and then he heard, "Hello."

"Hi, Miss Remington is that you?" he asked.

"Yes, it is, Can I help you?" she said.

"Yes mam, this is Jim out in Cameron town on the boat."

"Well hello Jim, how are you? Is everything OK?" asked

Miss Remington.

"Oh, yea I'm just looking for Remy, have you seen him lately?"

"Yea he stopped by a couple of days ago but then he said he was meeting Cole and Casey down in Horseshoe at Clancy's place."

"Well, I'm sure I'll hear from him soon, I's just trying to see when he was heading back this way. I didn't want to make a three-day run without knowing if he was coming back right away," Jim rambled on.

"Well, if I see him again, I'll tell'em you were looking for him," she said.

"OK, I'll talk to you later…Oh tell Mr. Don I said hello," said Jim.

"Will do," she said and then the line went dead leaving only the hum of a dial tone.

13.

Overloaded

Belize, South America

The night had been a typical beach bar experience, lots of beer, some great food, a little dancing, and back to the campsite where we'd left the plane earlier.

There were a few of the girls in tow that we'd picked up for the night. It was about two AM in the morning when we all headed for our secluded spots to be alone or to be with someone. I chose alone, and I couldn't understand why but I was sure it had to do with Lucie.

The moon had slid down behind the tree line and the darkness engulfed the rain forest. It was so dark when you closed your eyes you couldn't tell the difference. Off in the distance I could hear a group of Howler monkeys squalling as they danced in the canopy above. Cole had climbed back into the **"Shaken Not Stirred"** and was doing a bit of dancing with his new-found beach friend. As was Casey in a makeshift hut at the edge of the forest.

I could hear the crackle of the campfire as it grew smaller with time. And I grew sleepier by the moment, soon to be oblivious to the conscious world and all its troubles.

It seemed only a short time had passed before I was awoken by the sound of the squawking of a Yellow-headed Amazon in the nearby trees. I slowly opened my eyes to a beautiful sunrise. It must be what heaven looks like beyond our world, I thought to myself. This kind of morning is God's way of teasing our soul with a glimpse of serenity, I thought. His pastel paintings against brisk morning skies. They were the most wonderful shades of purples and pinks I'd ever witnessed. I got up and stretched for a few minutes, and I noticed the distinct smell of the bonfire on my flannel shirtsleeve as I walked over to the fire woodpile to collect a piece to add to the smoldering coals. I stirred the coals until I found an orange ember, and then added the wood.

Fanning the coals until there were flames above the fist sized rocks that circled the ashes of yesterday and the fire today. I began to work on a pot of coffee, as I knew of a couple of swollen melons that soon would need some caffeine nursing and I was their only hope.

Soon enough the cargo door popped open and out crawled a half-naked native girl with her makeup smeared and her hair a strew. Cole wasn't far behind zipping up his lucky flight suit with satisfaction on his face.

"Remy boy" he said, "did you sleep good?"

"Oh yea, just not long enough," I said.

"Is that coffee?" the girl asked.

"Yea, would you like some?"

"Please," she quietly said.

I poured her a cup as she sat down beside me on the slat

115

wood bench crafted from pieces of tree limbs and split firewood.

"Remy meet Carmen, Carmen, Remy," said Cole.

"Nice to meet you," she said.

"Hi," I replied.

Cole poured himself a cup of coffee, loaded it up with a ton of sugar and walked around the nose of the plane.

"What are you looking at?" I asked.

"Oh, just checking out our ride making sure it's ok," "After all it is the only way we have out of here," he said.

"Good point," I replied.

Soon we could hear Casey moving around in the hut along with a bit of moaning.

"Cole looked up at me and said, "Can't tell if he's getting a blow job or if he's got a bad hang over."
Everyone laughed out loud around the fire.

A while later he walked out of the hut swung open the bamboo door, stretched and said.
"Ginger, Maryanne, let's join the skipper and his little buddy for breakfast."
A few seconds passed and out came the two hottest girls you ever seen. It was a couple that we'd seen at the beach bar the night before. They'd shown up later in the night. Boy were they hot, I thought.
They said good morning and quietly disappeared into the shadows of the morning.

"That's not the same girls you brought with you," I said.

"I know, right'" Casey said with a big grim.

It wasn't long before they heard the roar of a Jeep. Demetri and an unknown figure were headed across from the other side of the field. Cole felt uneasy immediately, grabbing for his nine-millimeter keeping it tucked out of sight inside his flight suit. The jeep pulled up to within about fifty yards of the camp fire and stopped. Demetri turned off the engine, the two of them could be heard arguing about something in Spanish. Cole wasn't sure of every word, but he could get the gist of the conversation. It was about money, not enough money.

The passenger was complaining about getting shorted on the deal, the best that Cole could tell. The two got out of the jeep and headed in our direction. Cole patted his nine, so I could see. I looked over towards the hut, but Casey was nowhere to be seen. Cole whispered to me to go to the plane slowly to see if Casey was there, climb in and stay by the cargo door with your hand on the AK, "And don't take your eyes off of me," he said out loud as I was walking away.

I stepped up into the plane and Casey grabbed my arm and quickly pulled me in.

"Take your post Remy boy, I'll be out removing the wheel chocks in case we gotta split soon," said Casey as he quickly jumped to the ground from the doorway.

Demetri came over and began talking to Cole about the apparent problem. It's pretty typical in this type of trade industry for the providers to try and shake you down at the last minute for whatever they can get.

But Cole wasn't going for it, He told Demetri, a deal's a

deal. Things stand as they are, or we bolt." And then turned and walked towards the plane, leaving Demetri talking to the strange dark-skinned man.

Cole walked around the tail of the plane where Casey was clearing the chocks and told him to get the plane ready to load, or haul ass, whichever comes first. Then he went back to Demetri and the man and told them they had one hour to produce the goods or be stuck holding the bag, because this plane departs in an hour. Then he turned cautiously, watching over his shoulder and walked back to the door of the plane and stood, waiting for their answer. Cole also had a real concern that some other Calypso cowboys might try to make a move on this deal. That's another group of smugglers, or bandits that feed off the rest of the school. They've been known to steal planes and kill the crew. Then take the load to some other remote place and stash it until they can work another deal. He stood a few minutes and then Demetri came over to speak to him.

"OK it's all good now, I've promised to make it up to him on my next deal," said Demetri.

"Good, then let's get this show on the road," said Cole.

"Very well, I will go and bring the goods now," said Demetri, as he walked towards his jeep.

"OK, ... Casey have this baby ready to roll at a second's notice," said Cole.

"It'll be ready," Casey yelled from the cockpit, as he checked the fuel levels from the tanks being filled last night by Demetri's crew.

Cole was getting anxious, he paced back and forth beside the

plane. I hung close by the door, armed and ready as I would be the only fire power support if it all went south. Cole had since set me up with a flak jacket and extra clips for the AK.

The way it was to all go down, was several trucks would arrive with the contraband. There would be a few men on each truck, a couple of off loaders and a gunman atop. They'd back up to the cargo door of the plane and begin to pass the bails one by one. Meanwhile Casey would have the engines idling in preparation for their quick departure. I would stand guard as Cole directed the off loaders where to and how to stack the bails on the plane for proper distribution of weight. Cole never liked to allow the potential enemy onboard, but it was really the only efficient way to get loaded quickly. He just never lets his guard down. This process would take place several times until the last truck was unloaded. Cole would jump down and clear the area making sure the plane wouldn't hit anything on the ground that Casey couldn't see, and then climb back aboard while Remy covered him. If it had only gone that smooth.

It started off as planned. Except for the light drizzling rain. The cargo had been being loaded for about a half hour when all hell broke loose, they seemed to come from out of nowhere, contraband pirates! Men who lurked in the shadows waiting for the mother lode to arrive. They'd pounce on the deal swooping down like a hawk on a frightened rabbit in a wide-open meadow. Unfortunately for them, they weren't dealing with frightened rabbits. The gunfire started right away. Cole was laying down a spray of led giving the loaders some support while they finished their job. The loaders couple of gunmen joined in as well. After all it was to protect their investment too. I thought, it's amazing how two somewhat opponents will join forces in a time of such confusion.

Casey luckily had started the engines moments earlier. He ran them up for warming while Cole and the gang kept the pirates at bay for the moment. I covered Cole from the cargo door while

He kept them off the crew. My job was to cover Cole and keep the pirates from boarding the plane. At best we would be out of a ride back to the other coast, and at worst …dead if they were to make it aboard. The loading was nearly done now. They worked like a group of busy ants, ducking as they tossed each bail in the doorway of the plane.

It was time to roll for the dirt strip. I signaled Casey and He pushed the throttles to almost half to break away from the dead still. The nearly twelve thousand pounds of dope held the plane to the ground. The plane sluggishly bounces and rolled from side to side. Cole was running for the door when I spotted a rogue off to the right coming up on the tail. Cole never seen him coming. I raised my rifle and took a careful aim above Cole's head. The man behind him was closing fast and Cole had a confused look on his face as he ran towards the rolling plane. In all the commotion he couldn't figure why I would be pointing a gun in his direction. And then it hit him…literally. The hot piece of shrapnel ripped through the leg of his flight suit tearing at the flesh and tendons in his right leg. Cole's leg collapsed, and he fell violently to the ground. I saw his life flash before him through the sight of the rifle, or was it my life? I asked myself, could I do this? I had to save Cole. I let out a blood curdling scream as I squeezed the cold wet trigger releasing a burst of fire.

Flames shot in four directions as the bullets passed through the cooling tip of the rifle. The man on the receiving end flew in full stride as he left his last foot print in the wet muddy ground. He fell just short of Cole. Cole was bent down and hobbling on one leg towards the slowly rolling plane. I yelled for Casey to stop as I jumped from the doorway and ran to his aid. I threw Cole over my shoulder and held the AK under my other arm firing aimlessly in the distance at anything that moved.

By now Casey had the plane stopped and I ran like hell bouncing Cole on my shoulder. Cole screaming with every step. A couple of the thugs seen what had taken place and were now

baring down on us as we headed for the door. I began to scream at Casey to go! He got the plane moving just as I reached the door. Led began to pelt the side of the big bird. I threw Cole in the door, my feet dragging in the mud, just as Casey pushed the throttles over the top. I managed to pull myself in as the plane's fuselage rumbled with a deafening roar of the engines. The plane quickly came to life and began to bounce across the muddy field. The rain began to come down a little harder now. Cole rolled over as I stepped across him to close the cargo door. Suddenly I became too comfortable with my surroundings, under the circumstances. The rainwater was hitting me on the forearm as I reached out to pull the door closed. The water ran down my arm and rolled from my fingertips being blown away by the prop wash. The water dripped from my hair running down my face as I pulled the door closed just before the two men arrived. I latched the door and screamed to Casey to push it to the wall as I fell back next to Cole. We could hear the men outside pounding on the wall of the plane and yelling in Spanish, as they fired rounds from their pistols into the side of the plane. The darkness of the fuselage was lit by three shafts of silver misty light from the bullet holes in the cargo door. One just over my right shoulder, the other two well above. The sound of the men was soon drowned by the large engines as the plane rumbled to life. Casey squared up with the dirt strip and pushed the throttles to full, the *"Shaken Not Stirred"* came to life as the tail lifted from the ground. The plane built more speed as I worked my way to the right seat to help Casey get it airborne and out of harm's way. Cole worked on supporting his leg with the lining of a duffle bag.

Casey asked Me "Where the hell have you guys been?"

I replied, "chasing your ass!"

"How's Cole doing?" asked Casey.

"I think he'll make it… he took one in the leg," I said.

"Let's get this bitch in the air!" yelled Casey.

The heavy plane stayed on the runway a lot longer than it should have. This was beginning to concern us as we drew closer to the tree line. Casey gave it 10 degrees of flap and began to talk to the plane.

"Come on baby you can do it, just one more time that's all I ask." He'd began to almost whisper to it in a soft voice.

I sat listening for any command I may need to follow to help him.

"Keep your hand on the throttles to full forward, can't afford any bleed off! he yelled.

I put my left hand on the pair of throttles and Casey covered my hand with his right hand and held the yoke with the other.

"Hang on Remy Boy, this is going to be the ride of our lives!"

I flipped the PA and told Cole "Grab a hold of something tight!"

Casey held it on the ground to build all the speed he could muster. Then just before we reached the end of the strip he pulled back on the yoke and the big craft shuttered and slowly climbed, but barely enough to clear the tree line. The landing gear nearly brushed the tops of the trees as we floated off the cliff losing air speed, even with the shallow climb. Casey pushed the nose over and the windscreen filled with the lush green swollen rain forest. The over loaded plane plunged for the tops of the swirling trees below. Luckily, we had a thousand feet between us and the spot

where the plane would hit if we failed. We increased air speed as we slid through the air down towards the beach about a mile away. Casey pulled on the yoke but couldn't get any response alone.

"Help me Remy boy, pull on the yoke, pull!"

I grabbed the yoke in front of me and together we pulled in an attempt to recover the large craft from the long dive. The yoke shook violently as we struggled with all our might. It just wasn't responding. The beach below was blurred by the wet wind screen. I could make out a thatch hut or two and the line of the brilliant blue water against the sand. It felt like a roller coaster ride, my stomach was in my throat and plenty of screaming was going on. It seemed that the only likely difference was that we might not get off this ride. Just as I'd completed the thought the nose began to rise. First, we saw aqua blue, then a brilliant golden sky as we barely cleared the tops of the huts by only a couple of hundred feet. The same ones we'd driven past the night before. The plane lumbered along, engines whining at full capacity, as Casey cleaned it up, retracting the gear the he'd not made time for earlier. We'd began climbing slowly, absorbing the heavenly view before us. The dark rain clouds were over our shoulder sinking into the rain forest that nearly consumed us only moments before. We banked left slightly and set our course. We were headed home.

I felt I'd best go back to check on Cole, but found that he'd managed to get nearly to the cockpit as I undone my belts.

"How are you doing buddy?" I asked as I knelt to help him into the jump seat.

"I'm alright for a shot mother fucker," he replied and chuckled.

"You had me worried, how bad is it?" asked Casey.

"I stopped the bleeding; it was a clean shot above my Knee. Appears it didn't hit any vital arteries," said Cole.

"You mean like your dick!" shouted Casey as he laughed.

"Yes, like my dick Casey you fuck!" He replied.

"How's the bird holding up?" asked Cole.

"Doing fine, short of a few bullet holes…so far," Casey said.

I spoke up and offered to do a damage check in the rear. I ducked out of the cockpit and began to check for anything that might appear suspicious visible from inside. It was really difficult to see over or around the bails of black plastic wrapped marijuana. Everything appeared in order, from what I could manage to see for the time being.

I sat down near the cargo door looking at the bullet holes near the latch. They were in a diagonal pattern. Must have been that of the man I'd taken down, his last rounds I remembered them pelting the plane as I took cover after shooting him. The thoughts started pouring through my head. I thought of how I'd just taken a man's life. I wandered did he have children and a wife waiting for his safe return, what was his name, and many other thoughts similar. The cold raindrops from my wet hair rolled down my face mixing with the tears I now shed gathering on my chin and falling to their death, like the man I'd just shot. I was disgusted with myself for the terrible thing I'd just done. I hated what I'd become. But I had no choice.

Dead Man Bay, Florida

The road to nowhere

The late evening had turned into night. The anticipation of the boy's arrival was eating away at Earl, and it showed with every pass of the pacing back and forth across the end of the road. Things were in place and had been now for an hour or so. The tractor trailer lay in wait up the pavement just a piece or so. The road was lined on both sides with trucks parked diagonally pointing their low beam headlights on the road in intervals of about a hundred feet. There was a half dozen or so on each side. A thunderhead lay just off the coast some several miles. It appeared as if it wouldn't hinder the operation for now anyway. Jesse stood still looking south across the flat marsh peering deep into the darkness that engulfed everything beyond his sight. Occasionally lifting his binoculars, he scanned in the direction of the horizon looking for any sign of them. He took a drag off the unfiltered Camel. His face glowed each time from the orange tip. The night breeze brought ashore the salt air that stuck to his skin. Jesse looked at his watch and then took another drag. The sweet pungent smell of the cigarette drifted across his right shoulder and into the faces of the other onlookers.

"Their overdue by a half an hour," he said to Earl.

"I know, it could be a head wind, or maybe they got a late start or something," Earl said as he continued to pace, smoking a cigarette of his own.

"You gonna wear the soles off your God damn boots if you keep that up," Jesse stated.

"Can't help it… it's what I do to control my nervous tension," he said.

"Well, how's that working for you?" said Jesse as he laughed.

"Oh, shut the fuck up," said Earl as he tossed his cigarette on the ground and walked away towards a group of the off loaders.

Jesse stood and continued to stare into the night never breaking his lock on the blackness in the distance.
Minutes passed but seemed like hours and then He thought he heard something familiar.

"Hey quite down over there!" he said to the group of men that was playing around getting a little loud. They were only passing the time no one meant any harm.

"Earl, come here!" he said.

Earl had forgotten the remark Jesse had made earlier as if it never happened. Trotting over to the end of the road, with his boots striking the paved surface in even notes, echoing into the marsh… he asked, "What's up?"

"You hear that?"

"Hear what Jesse?" he asked.

"That, That right there!"

"Yea, what is it?"

"What is it? it's them!"

"You sure?"

"Damned right, I'm sure. Everybody take your places, here they come!

Every man scrambled to the places they were to wait until the plane was on the ground.

The first sign of light shown in the darkness. The flicker was faint and blurry like a weak star in the distance. It became more visible by the seconds passing. The large Pratt and Whitney R-1830's was more-clear now, and it could be heard that there was a problem with one.

Jesse and Earl struck the caps on the four flares and lay them across the end of the road attempting to give the guys a baring to set up for the approach. Earl ran down the middle of the road signaling for them to all turn on their headlights. Turning and looking back; the onshore cross wind swirled his shoulder length hair as he watched the plane quickly approaching. The lights were getting brighter and doubling in size by now.

Casey was going to make one pass to size up their situation. Even with the miss firing engine it was safer than trying to touch down on the poorly lit strip. The brightness of the flares was nearly blinding just before they crossed the approach end of the road. He maintained his speed but came across only fifty feet off the deck. The rumble of the large engines was deafening to the men on the ground. Earl darted to one side of the road as he thought they were coming down on top of him. The big bird ripped across him as he took cover. Then as fast as it had approached it flew away pulling up and banking left out towards the Gulf. He brought it around for another approach. He lined it up and eased the throttle back on the left, and nursed the missing right engine as to keep it from shutting down. Corrected the crabbing affect the out of sync engine had on the fuselage with a

little right rudder, Casey began to give it flaps. Pulling the landing gear lever, the plane nosed slightly over and began to sink to the earth below. Only a hundred feet off the ground and a quarter mile out the right engine sputtered at the lower rpms. He was quick to the throttle and eased on the power and eased on the rudder. The plane sank further and further, He was now just short of the approach end of the road and only a few feet above the ground. Just as he crossed the row of flares, he eased the throttles back to idle and maintained tension on the yoke. The landing lights lit the weathered gray pavement below them. The ground effects on the large wings could be felt even with the heavy load. But this time it lasted only a second. The wheels chirped, and a moment later the tail wheel settled onto the road. He applied the brakes carefully, he wasn't worried, we had as much roll out room as we needed on the nine-mile stretch of abandoned road to nowhere.

The plane came to rest on the warm pavement. The long weeds on either side of the road swirled from a mixture of the prop wash and the onshore gulf air. As soon as they stopped Casey was out of his seat opening the cargo door.

With one swift swing and leaning out of the door he said, "Here's Johnny!"

The ground crew all laughed as they quickly assisted Cole out of the plane and began the off load. Casey and I stood near the tail gate that Cole sat on while someone looked at his leg. Jesse looked over his shoulder with deep concern while he was being worked on.

Jesse asked, "you OK Cole?"

"Yea I'll make it, I just took one in the leg before I caught this flight," as he turned his attention towards Casey.

"Yea you almost fucked around and missed it," Casey said with a chuckle.

"I spoke up. "Yea, you give a whole new meaning to catching a flight, we chased your ass for three hundred yards before you stopped to let us on."

The boys all talked while the semi-trailer was loaded with the contraband. Soon the task would be complete, and the doors would close. The truck would be on its way to another place and time.

Jesse would take Cole to be patched up, Casey and I would take the ***"Shaken not Stirred"*** around the bend just up the coast to a private strip where it would be out of sight for a while. As well as some maintenance and repairs.

In a flash it was all said and done. The truck was loaded, doors closed and, on its way, driving into the night's abyss. All the workers had since driven away in their pick-ups. Cole was off to the local doc. And Casey and I were now just pulling up the gear as the big DC3 rumbled into the darkness.

14.

A Cold Steel Nine

Dead Man Bay, Florida

My new-found profession allowed me to do things that pleased me greatly. Flight lessons were first and foremost. I loved to fly and spent hours and hours working on my pilot's license, single engine, multi-engine and then float planes. I was relentless, it nearly drove Lucie crazy, me being gone all the time. Flying had become my life. I had owned several single engine planes including a new version of Cessna's Muskrat, a float –plane. Me and Lucie finally went on lots of trips to the Bahama Islands in my new ride. Oh, how I loved to make that trip. We would stop off in the Florida Key's coming and going. Lucie loved the shopping; I had a passion for island places. I loved to meet new people. I'd hang out at *"Sloppy Joe's"* until they closed the place for the one hour a day to clean up.

We spent hours in the warm southern sun lying around on the beaches doing nothing until the boredom set in. Then it would be off sailing for the afternoon. Lucie looked forward to sailing, she'd fallen in love with the breeze. She often joked that if she could get her arms around it, she would dump me for it. On one of our Keys trips I just up and bought a 36-foot sloop for Lucie. I

surprised her with a bill of sell while we sailed up the Atlantic coast to Deer Key for the day. Life was good for us. Money was no object. The only worries we had, was where to go next, what's for lunch and who to visit. The only obvious next step for us was marriage. Which soon came to pass.

It was a small but lovely wedding. Lucie had the roses she'd dreamed of as a small girl. The cake was way too big for the few guests. It was three tiers high and solid white with, of course…roses. We were married at sunset, my favorite time of day. It was as wonderful of a day as you could get.

We went to the Caymans for the honeymoon spending two weeks in white sand drifted beaches backed by vivid green palms. It was a good get away from the day to day of the river life.

Back home now and adjusting to the married life. It was grand for us both. I would continue to work in my new-found industry. Using the shrimp boat as a front. And Lucie would live the life as a wife of a well to do international trade executive. At least that's what we called it. Just when it seemed to be the perfect life… all hell broke loose.

It was a hot August morning that I woke up to the cold steel of a nine-millimeter barrel pressed firmly against my face. There were men in ski mask and someone was yelling for me to get out of bed. One of the men grabbed me and threw me onto the floor. Another grabbed Lucie and yanked her up on her feet exposing her bare ass from under her t shirt.

She screamed at him to "let me get some clothes on, you bastard!"

They ignored her until they had me cuffed and setting on the

end of the bed. A tall red-haired fellow entered the room shortly after things sort of calmed down. He introduced himself as agent Maveric of the FDLE.

"You been up to a lot of shit Remy Boy, and we know all about it," He continued "you are going away for a long-time boy," as he slapped the arrest warrant in my hands cuffed setting in my lap.

"Get him dressed," he said to one of the masked bastards. "Then put him in my car, I'll be delivering him personally to Tallahassee."

I put on my pants after one of the agents checked the pockets, while the other held a gun on me. Then I put on a favorite Gator shirt and a pair of top-siders with no socks. I was shoved out the front door into the yard and into the back of a black Trans-am. Coincidentally one that I'd seen around the river a few times in the last month. I could only yell at Lucie to call her dad. And the door slammed me into silence isolated from the outside world. The agent slid down into the driver's seat started the engine and sped away. Some other agent's cars followed leaving Lucie standing on the front steps crying uncontrollably.

Horseshoe Beach, Florida

The phone rang down south at the beach house.

"Hello," said Clance.

'Hello, daddy it's me… they came and got Remy this morning, what am I gonna do?!" said Lucie.

"Slow down honey, who got Remy?" asked Clance.

"The federal agents!" she said.

"What did they say they were arresting him for?" asked Clance.

"They didn't exactly say, just that he'd been doing a lot of stuff and they knew all about it!" she went on.

"Are you OK baby?" he asked.

"Yea, just scared," she said.

"Ok let me go so I can call the lawyer, don't worry I'll have him home by dark sweetheart," he said to her.

"Ok daddy, thanks I love you," she said and then hung up the phone.

Clance put the receiver in the cradle and sat down at the old roll top desk and began to flip through his rolodex looking for a number.

Lucie called my mom and dad to let them know everything that had happened. She didn't want them to hear it through the local coconut telegraph. Word travels fast in a small town like Dead Man Bay.

She also called Cole and Casey who would come over later to talk about what had happened. They figured they would be next. She sat on the sofa and began to cry; she didn't know what else to do. This could be the beginning of the end of them. This scared her so.

Later in the afternoon Cole and Casey stopped by to see how she was, and to get details of the earlier events.

"Did they say what they were arresting him for?" asked Cole.

"No, but I'm sure it had something to do with the couple of small time deals he'd put together on his own. I told him he shouldn't get too greedy fucking with those inexperienced fucker's down south, or it could cost him… big," she said.

It was silent for a moment. There were looks exchanged, and Casey stood and walked to the window with his thoughts he wasn't sharing for now. Cole sat and sipped a warm glass of bourbon. Lucie went to the kitchen and poured herself a diet soda and joined Cole at the table. Casey pulled the curtains back with one hand and broke the silence with "well we'll know soon enough, here comes Remy Boy up the drive now."

I lumbered up the steps looking like I'd had a hard day. My hair oily and flat, and sporting a five O'clock shadow.
Casey opened the front door and Lucie nearly flattened me as she ran out and threw her arms around me.

"Are you ok ?!" she asked as she hugged me.

"Yea just tired and hungry," I said as I kissed her.

After the warm reception everyone went back inside to the kitchen. Cole sat back down to his bourbon at the old oak table. It was a gift from Clance. He'd had it made somewhere in New England in a small wood shop off the beaten path. He'd had a special inlay of roses put at each end, and ornate carvings on the upper legs. The roses were Lucie's favorite flower. It showed throughout her house.

"I need a drink," I said as I walked up to the bar at the kitchen.

"Me too," said Lucie.

Casey, without a word reached for the bourbon carafe and three of the crystal glasses off the globe bar setting in the corner. He was having one too. He poured the drinks and freshened up Cole's while he was at it.

They all stood or sat, whichever each preferred. No words were exchanged for the moment. Each thought their own about the situation at hand. Casey and Cole's were similar, as they both knew that this could jeopardize the whole operation, they'd all worked hard and long for. The lifestyle was addicting, and they knew living any other way was not an option for them or anyone else in the tight knit family.

I knew I needed to distance myself from the rest of the group. I'd have to get myself clear of them, fading into the landscape of another latitude. I knew this would take some time and some assistance from Clance and a few other contacts in foreign places. But for now, life would have to appear to go on as usual. I'd drive past all the same old people on all the same old roads. I'd eat at all my favorite restaurants, drink in all the same old bars I'd grown up around. I would admire the sunsets over the river's edge that I'd seen my entire life, now knowing their days were numbered, at least for me.

Weeks passed time slipped along as usual. I got bored and decided to head back out to Cameron Town to hang out on the shrimp boat for a couple of weeks until I had to be back for a court appearance. I packed my bags and said my good byes to Lucie who would stay home this trip giving me a little room for thought. I headed out the front door with my bags over my shoulder and started down the dusty lime rock road towards the

private strip at my uncle's only a quarter of a mile away. Lucie
wanted to go but she didn't want to crowd me at a time like this.
The tears welled up in her eyes as she watched me through the
window, as I turn the corner and out of sight. I continued up the
road thinking of the inevitable time I faced in prison. I felt alone.
I walked for a few minutes with no one passing by. Just the sound
of the palm meadow patches inhabitants. I could hear the sound
of a red headed woodpecker pounding on a palm well above the
others. Then my attention was drawn to the sound of an old white
Ford pickup coming up the road. I could hear the sound of the
off-road tires against the well ridden road. The sound grew closer
by the second. I turned and looked over my shoulder. It was
Nelvin, my uncle.

He stopped at my side and said, "Where you headed Remy
Boy?"

"Cameron town," I replied.

"I'm headed to the strip for the moment, you need a ride?"
he asked.

"Sure," I said. As I walked around the front of the truck.
Opening the passengers-door, I threw my bags on the seat,
climbed in, and slammed the hollow door of the pick-up. He
eased off the clutch and the old truck shuttered… he commented
about how he needed to have the clutch looked at sooner or later
to stop the vibration… and began down the rough dusty road.

"What's in Cameron town?" asked Nelvin.

"I thought I'd take a break from the local party scene and
clear my head before the hearing next month," I said.

"I guess that makes good sense to me," he said.

Within a minute or two we were in front of the rusty tin roof hanger that was more of a barn than a hangar at all. It was nestled in a small group of scrub oaks. The grounds were covered with palmettos as far as the eye could see. Stretching all the way to the marsh flats where the long pencil like needles tapered to an eye piercing point. They were as thick as a Kansas wheat field.

"Ok, here you are boy, take care of yourself," Said Nelvin.

"Thanks," I said, "I will."

I dragged my bags from the seat of the truck, closed the door behind me and headed for the plane under the shelter. I stared for a moment and then turned to watch the old truck disappear as quick as it had appeared leaving only the thick smell of exhaust and a trail of white dust.

I thought of how I'd left Lucie crying on the steps wanting to go with me. But I felt I needed to weather this trip alone. It was something I couldn't explain it was just something I felt.

I opened the cargo door of the big twin and tossed my bags in. Then I began to do my preflight. I picked up the pace as the breeze blew my hair around. There was a small thunderstorm brewing off the coast, I had known about it from checking the weather report earlier. It didn't concern me too much as the storm had stalled to a mere five knots. It was still seven or eight nautical miles off shore. I felt I still had time to get off the ground and get around it before it made landfall.

Facing into the building breeze, I pulled the wheel chocks. I climbed in and pulled the door closed behind me and latched it tight. starting with the left engine first, warming it at just above idle. Then followed the same procedure with the right. After the warm up I eased the power on and broke it loose from the concrete pad. The props slapped the air in unison as the plane rolled towards the strip. The wind had picked up and had moved

the front a half an hour in shore sooner. Drops of rain appeared on the windscreen as I turned onto the strip. Now the wind was swirling on the marsh tops like a well-choreographed dance. For a second, I thought I might need to wait it out, but then a ray of sunshine popped through the clouds and gave me a sense of reassurance, and I continued anyway. I reached the end of the strip, applying the left toe brake spinning the plane around heading it in the other direction. Locking the brake, I began the run up of the engines, one at a time to check all vitals. All looked good, so I synchronized the RPM and applied power. Releasing the brakes, the plane lunged forward and began to roll. I slowly pushed the throttles to full and the twin came to life. The big engines rumbled, and the plane hopped down the strip. I looked at the instruments and then through the windscreen. By now the rain was lightly misting the windows forming drops only to be blown down the fuselage. The plane was building speed and was nearly to the halfway point when I noticed out of the corner of my eye, someone standing at the end of the taxiway... It was Lucie, one arm across her waist and the other waving goodbye as I passed. I thought for a split second to continue, but I chopped the throttles and rolled the plane out to the end of the strip and turned it around. I headed back to the taxiway where she stood in the drizzling rain, stopped the plane, killed the engines and popped the door. Lucie ran towards me as soon as the prop slowed to its last round. She climbed in the cockpit, me helping her in, she threw her arms around me and held on.

"I know you want to be alone," she said, "But I can't bare being away from you, I need you!" she cried.

"I'm sorry, I can't stand being without you either," I said. "I just get a little selfish once in a while and tend to forget about others, try to forgive me."

"I will," she said as she wiped the rain mixed tears from her

wet face.

She began to passionately kiss me. I returned the loving gestures as I slid my hands up her legs and under her wet tank top caressing her cool rain-soaked breast. We fell in the nearest seat and kissed for a moment with passion and heat. The rain was heavier now, and a sheet of water covered the wind shield as the grape size drops pelted the walls of the aluminum shell of the plane. Lucie raised her arms over her head removing the red rain drenched tank and tossing it aside. She moved one hand down to undo my jeans while caressing my face with the other. She slipped out of the wet shorts and spread her long silky legs across my lap. My pants off now, I set the seat as far back as it would go as she pressed against me until I was deep inside of her. We made love for a while; the body heat steamed the windows to an opaque. The rain continued as we lay in each other's arms until the sun slipped down under the clouds in the western sky.

15.

Plane for Sell

Mobile, Alabama

I rubbed the damp morning dew from the windowpane and peaked in through the glass. I could see the shadowy outline of the plane against the white walls of the hangar. The airfield was out behind. There were three-grain towers off to my right about half way between me and the main office building. It was an old house that had been turned into the grain operations headquarters. The old structure was made of a dilapidated lap siding. It hadn't seen the end of a paintbrush for some time. The windows had a build-up of years of neglect and were barely translucent. The old silos stood together like three sad soldiers, heads hanging, returning from a long deployment.

Off in the distance stood an old windmill that had seen a better day. The blades were rusty, and one was missing. A bird's nest occupied the top rung of the framework. The backside of the dirt strip was lined with a random row of pines; their tips were pointing faintly to the northeast from the brisk morning breeze.

" Well, I don't see anybody," said Lucie.

"He said he would be here at nine this morning," I replied. " Maybe he's up at the office, I noticed a truck when we crossed overhead for our base turn before we landed. I'll go up and take a look."

I turned and headed towards the office, making it about halfway when I heard a voice come from the corner of the hangar behind me. A man's voice, it was raspy and deep.

He said, "could I help you?"

I stopped in mid stride, turning on one foot as I looked over my shoulder.

"Yeah, we're here to pick up the commander, I'm Buddy Ray and that's my wife Lucie there peering through the front window."

The man said they call me Denny, I kind of run the shop and handle the maintenance on the bird for old man Dixon.

"Is he around this morning?" I asked, "He said to meet him here at nine."

"He ought to be along in a few, he doesn't get around as fast as he used to since that hunting accident," The man said.

"What kind of hunting accident?" I asked.

"He got shot by one them their city slicker boys from over in Atlanta. Son of a bitch said he thought he was a deer. Thing is I never heard of no deer wearing an orange vest," The man said.

"Well good morning to you pretty lady," He went on as Lucie walked up. " Well, I'll be in here getting this baby ready

for you, I got some coffee on if you and the little lady want some, just come on in and help yourself now."

The old boy turned and went in the side door of the hangar.

"Thanks," I said just as the man pulled the door closed behind him.

"You want some coffee?" I asked Lucie.

"Sure," she said.

We headed for the door that the middle-aged man with the worn-out overalls had gone through. The old spring on the door sang as I pulled it open. The hangar was well kept inside, not a conclusion you could draw from the outside. I saw my new baby setting perfectly centered in the middle of the old structure. It was a well-kept 1958 Strike Commander, white in color with burnt orange and gold stripes to accent its lines. Off in one corner I could see a pair of ATC three wheelers, Honda 110's. They had a layer of red Alabama clay on their underside, dried to a crusty shell. There were old air plane posters on the south wall from years past, one of Howard Hughes standing on the wooden wing of the famous Spruce Goose in Long Beach Harbor, California. There were several old wooden propellers of different styles mounted to the hangar wall as if they were hunting trophies from some back-wood's turkey shoot. Well above the other posters was an old enlarged picture of a Corsair faded from years gone by.

The breeze whistled through the spaces in the large hangar door with a whipping effect, stirring a pile of dead brown oak leaves into a small tornado just outside of the hanger door. It disappeared as mystical as it had appeared. I stood facing the wall of history, while Lucie poured us a cup of coffee and made small talk with old Denny. I stared in amazement at all before me, soon

Lucie joined me, nudging me with her right elbow and handing me a steaming cup of morning brew, she said "what are you so intrigued with up there Remy Boy?"

"Oh, just the past," I replied.

About that time, I could hear the spring on the side door from the distance across the room. It was a man in his late fifties. He wore all khaki clothes and red wing brand boots, buckskin in color. He sported a straw fishing hat with the emerald green sun visor sown in the front portion of the brim. The hat was aged, and had a permanent sweat stain around the perimeter. He had a rather thin build and stood well over six feet in height.

" Good morning the man said," as he limped closer to where we stood.

"Good morning," I replied.

"I'm Buddy Ray and this is Lucie my wife. (I had to give an alias so this transaction could not be traced later).

"Pleased to meet you both, my names Robert Dixon. Most folks around these parts call me Zero, it's an old war nickname."

"You were in the war asked Lucie? "Yes, ma'am little lady I flew Corsairs off of a flat top in the Pacific Ocean, during World War two, shot down more Japanese Zero's than any other combat pilot in the entire fleet. That's why they call me Zero."
"So anyway, you folks here to pick up old Betsy?"
Referring to the airplane he continued with,
"She ain't the fastest thang but she's sure reliable. Kinda reminds me of the misses," he said as he chuckled.
"You want 'a let's take her around the block?" He asked.

"Sure," I said.

Mr. Dixon looked at Denny, and began to ask if it was ready, but before he could get a word out Denny spoke up and said, " yes sir she's all ready to go."

"OK then let's get the door open and push her out, and we'll be on our way!"

"We began our roll for take-off. The plane bumped across the hard pan clay runway. I was already taken by how well the bird handled after the initial low speed over steering was passed. Shortly we were airborne. I pulled the gear up and climbed to about a thousand feet, leveled off and began to bank right to head for the nearby coast line. It's always been a favorite place for me. It strikes me as a beginning of a new world and the end of an old.
We made a few low passes over the bay and then turned down the coast for a moment. I was soon pretty familiar with the controls and began to feel at home in the cockpit of this beautiful craft. a short time passed and we turned back north and then east again heading back to the strip at the old grain mill. We crossed over the runway on a high-speed low pass just below the tops of the young pines on the west side of the strip. I pulled back on the yoke and climbed out until the air speed dropped to just shy of a stall. I banked right, slid out and done a text book (Bob Hoover) recovery as if he was setting next to me giving instructions. Old man Dixon seemed a little uncomfortable with my technique, but hung in never the less without a word. We brought it around and lined her up for landing.

"Chop the throttles, give her flaps, gear down, fuel pumps on, and here we are safe and sound just as if we had never left the ground," I rattled on.

We rolled to a stop, killed the engines, and popped the door.

"Where'd you learn that move? " The old man asked.

"I been practicing that for quite some time," I said. "I saw Hoover do it at an air show in Sarasota, a couple of years back, had to learn it… looked like fun," I said.

"Not bad for you being such a young man," said the old man.

"Thanks," I replied.

"Well, you gonna buy her?" said the old man.

"Oh yea" I said, it's a done deal."
"I have to go to the plane and get my bag, I'll be right back."

I walked over to the Cessna, unlocked the door and grabbed the satchel from the back, closed the door and headed back towards the hangar where everyone had migrated. I laid the satchel on a work bench that Denny had cleared. I began to pull out the cash for the transaction, asking if cash would do, and laughing at old man Dixon as he said "hell yea!" with a large grin.

We finished all the paper work and discussed me leaving the Cessna behind for a short time until I could drop Casey by to fly it back home. He agreed and we said our farewells. I remembered the weird way that Mr. Dixon said good bye. Emphasizing "Buddy Ray," as if to say "like that's really your name." But what did he care, he got cash, I got a plane and we all parted happily..
So off to Cameron Town we go in search of a good time and to meet our next rendezvous with the man who knew where he could get a dead body for my big plan.

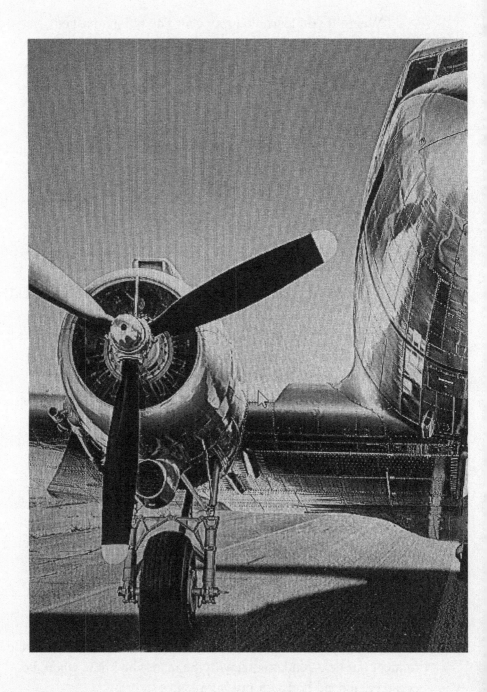

16.

Body Parts

Cameron Town

The cab driver cruises across the bayou road that was barely wide enough to pass the oncoming traffic. I had the back window down on the gulf side, the wind generated from the moving car rushed across my face. The salty sulfurous air reminded me of home. No one spoke a word for a few moments. Lucie knew what I was thinking and did not want to interrupt my reflection. The cab rolled down the old two lane, oversized aggregate highway, bouncing up and down occasionally from the sunken dips between each street crossing in the road. It was only a month away, that is the court appearance for the latest bust I was involved in. If only I had listened to Clance, and stayed inside of the circle, not messing with the boys from down south. Clance had warned of what the possibility of exposure could be, and the ultimate consequences.

The driver soon spoke up, "here we are." as we rolled up in front of Nate's.

Lucie opened the door as I paid the driver, and thanking him

for the ride. I stepped out of the car stretching my arms and legs, leaning my head back looking up at the large dusty neon sign in front of the weathered building. The neon glowed orange while the street lights cast an illuminated haze on the damp night air, each light appearing smaller in the distance. The sound of the juke box seeped the melody of blues through the cracks in the walls. There were quite a few people in the joint for a Thursday night. Lucie stood at the door, with it half opened, as I slowly walked towards her, looking down the old Cobblestone Street to my left that led to the bay.

I finally turned and headed inside. We were supposed to receive directions where to meet the man who could direct us to the body connection. Word on the street was that you could get anything from this guy, including a body or two. He supposedly had a connection with a group out of Idaho Falls that homesteaded in a militant compound deep in the mountains.

Only a few minutes had past when I saw Jim coming through the front door. He had a bit of a serious look on his face, and walked at a concerned pace as he headed towards the booth that we occupied. It was the one beside the Hemingway shrine in the corner.

Jim was wearing a heavy over coat, it was black and red plaid, a bit aged from the nights of sea air exposure and running the lines on the shrimpers deck this past season. The half high white rubber boots made a clogging sound with an almost musical beat as he hurried across the old saw dusty concrete floor.

"I'm surprised to see you here," I said, "I thought you were shrimping with the Bowden boys for a while."

"Oh, I am said Jim, I just needed to relay a message for Casey, he called the marina and had Johnny come get me off the boat while he sat waiting on the line."

"I don't know just quite how to tell you this but here it

goes!" Word on the river is that the Feds made a big bust this morning. They got Clance, and several others. They also seized your shrimp boat," he said.

"Oh no, daddy! said Lucie," as a tear began to stream down her face.

I sat silent, didn't say a word, I just sat and stared off in the distance.

"Don't cry baby," I said to Lucie. "It'll all be alright soon."

"Casey said that Dersch, his lawyer was getting Clance out now," said Jim. "Well, I hate to be the barer of bad news and run, but I gotta get back to the boat, we're pulling out in about an hour."

"No problem, hey thanks for finding us and letting me know what was going on," I said.

"You're welcome," said Jim as he leaned over, hugging Lucie as if to try and comfort her while bidding her farewell.

Jim shook My hand, turned without another word spoken and walked out the screen door. He turned right and headed up the street disappearing into the damp darkness beyond. Lucie watched, paralleling her life with what she had just witnessed.
Just as Jim had left a strange looking character slowly made his way to the bar. He made no eye contact with anyone. He wore a worn-out green Army jacket, a buck skin beaver hat, and carried a large Bowie knife strapped to his side. The tip of the sheath hung past his jacket tail at least six inches.
He asks Nate's boy behind the bar a question, I assumed he was looking for me. A few minutes past as the stranger sipped on a cold draft beer and peered around the room. I watched him

carefully without being too obvious.

The juke box was playing *"Bad Leroy Brown"* by old *Jim Croce.* The sound filled the room. Back at the pool table the young men were singing along and playing their pool sticks like guitars. The rest of the crowd was focused on the drunk pair, laughing and pointing.

A few more minutes past before the man moved towards our table. He walked past the first time; he was merely getting a closer look at us.

He made his way to the juke box and dropped a quarter in and pushed a few selections. The room soon bounced to the tune *"Sweet Home Alabama"*. The whole room lit up as if the man had hit them with a cattle prod. Drunk folks danced right where they stood.

The stranger grinned and turned heading back to our table.

He walked up and said, "you the people looking for the stiff?'

"That would be us," I replied.

"What you plan to do with it?" the man asked.

"Is it really important that you know?" I asked.

"Well yea, because I can get the whole body or just parts. You see if you are gonna just blow the mother fuckers to bits then you really don't give a shit about what shape they're in, you know, missing hands, arms, legs etc.," he went on.

"Well, I guess you gotta point there," I said.

"How many you looking for anyway?" asked the man.

"I need one," I replied, going down in a plane crash, shall we say.

"Okey-doke, then since your faking your death, we better remove the hands and head... no finger prints and no dental work traceable," said the man as he made a few notes on a little pocket note book.

"You can save a few bucks if you remove the hands and head, if you like," said the man.

"No way, you take care of that," I said with a disgusted tone in my voice.

"Ok, ok just offering," said the man.

I looked at Lucie she had a look of shock on her face from the discussion that had just taken place. She didn't say a word just stared at me. I had not shared all of my plan details with her, thought it would be easier to give it to her as we went along. Hoping that would make it easier to digest... guess I was wrong.

"Ok, just hang in town till tomorrow night... I assume I can find you here?" the man asked.

"Yea," I replied.

The man stood up, turned and disappeared in a few seconds out the door into the night.

Dead Man Bay, Florida.

The agents boarded the Miss Linda at the dock protruding out into the river moored at the crab plant. It's an aged frame work building covered entirely with old galvanized corrugated

tin. The time shows from the random rust streaks on its walls and roof. Its bones were made of peeled cypress poles. It looked like a good place to build an open-air bar someday, maybe call it "Who Dat."

The sun had only been up for a couple of hours, but the old man could feel it warming the right side of his face on the cool October morning. He stood in a pool of sadness, as he watched what he'd worked so hard to build for his son being stripped from his feeble grasp. The agents turned the boat inside out, looking for any sign of drugs so it could be confiscated by the United States Government. After a few minutes one of the men onboard yelled out that he had found what they'd come for.

The agent held up a few seeds and some flakes of dried marijuana, it was all they would need according to U.S. law. The old man turned and walked away, severely crushed by what he'd witnessed at the docks end. The lead agent began the seizure process, ordering each man to a specific task. The old man made his way through the middle of the crab plant, reflecting on his past, and how he had created the successful business around him. He knew this would all be levied to try and save his son. Looking back over his shoulder one last time at his shrimp boat to see the drug agents un-tying it, they started the engines to prepare it for a final trip down the river. Never to return to the dock it had moored at many times. The boat had been a symbol of his growing success, but was soon to be only a memory.

The river was covered with agents. "There was over fifteen arrest this morning alone," said the man into the receiver of the pay phone just outside of the Jiffy Store. "They even got Mr. Don's shrimp boat, and word is they got Clance too!" The man quickly hung up the phone, jumped in his old pick up and headed off down the road towards the Pool Hall.

Things were hot, the coconut telegraph was singing a song of its own. People scurried around the river roads, nosily watching the early days event, and reliving them in conversations over

coffee at the diners and bourbon at the bars. Some were trying desperately to warn others, some were trying to hide money, and others hiding their stash of personal use as well as a few hiding large quantities they had boldly kept on their property. The whole thing took place while Me and Lucie lay sleeping in our hotel after a late night of partying at Nate's several hundred miles away.

Tallahassee, Florida

The agents continued to question Clance without his lawyer present. Clance knew this would be used to his advantage as this was not his first visit to the federal building, likely not his last. The two F.D.L.E. agents were as green as the rolling hills of North Florida. Clance continued to string them along a little at a time, he knew he was going down eventually, but not today.

He could only hope that Casey could get a hold of Remy and Lucie to warn them of what had went down. Things were going to be ugly from here on out. It was time to put the last hurrah together, go down in flames, or be free forever from the grip of the long arm of the law. The thing is, you can't catch somebody that you can't find or better yet never existed. If only he could get his phone call, he could put it into play.

It would start by getting the fuck out of here. The lawyer would have to do that first, and then he could do the rest. Dersch would go to the safety deposit box to retrieve the cash money for the half a million-dollar bail. This way no bondsman would ever be on his trail. So, he wouldn't have to constantly look over his shoulder, not that any bondsman could ever find him as deep as he was going.

He hoped that Remy had remembered what to do in the event that he was ever taken in to custody. There was a place that the crew were all to meet, it was out west.

The front door of the holding cell was pulled open, Clance

had not noticed anyone approaching as he had his back to it, deep in thought. He turned to see his lawyer to his pleasant surprise.

"How did you know I was here so quick?" asked Clance.

"Word travels fast when you're involved," Dersch said.

"You gonna get me out of here today?"

"Already done, they're just finishing the paper work."

"You herd from Remy and Lucie?"

"Not yet, I sent word out to Cameron Town to see if anyone has seen them lately," he said. "Supposedly that's the direction they were headed, haven't heard anything yet."

"They didn't have a warrant for Casey, or Cole?" asked Clance.

"Yes, both, but they hadn't found them last I heard," he said.

"I think Remy boy's already working up a scheme to cover his trail from the three previous indictments, I hope he's careful. I hear he's talking to the Cobey Boy's, about what I don't know, but you can bet when they're involved it ain't about church on Sunday," said Dersch.

Cameron Town, Louisiana

The day seemed to pass as slow as molasses. The waiting was driving me in sane. It was hotter than a fire cracker, with humidity as thick as butter.

"I'm going for a walk," I said to Lucie.

"Ok," she replied. "I'm gonna stay here beside the pool and have another cocktail."

"Suit yourself," I said, as I walked out of the short, weathered chain link fence that surrounded the pool at the local motel.

It was known as the Gulf Side Inn. The string of rooms faced the bay of Cameron, each door was a faded aqua blue. Their paint was beaten from years of summer sun and salty air. The building was that of a masonry block style, with sea shells in the mix. The walls were a salmon shade, it's paint tattered. The sidewalk met the aged large aggregate asphalt lot with little difference in heights. Its crack filled with beach sand tracked in by the many years of patrons, from which fennel weeds grew. An occasional palm scattered across the landscape cast its shadows in a northerly direction.

Lucie continued to lay in the hot southern sun. Beads of sweat rolled down her arm as she reached for the tall sweaty glass of Bacardi and seven. It was setting on the old hand made cypress patio tables. The tropical oil glistened on her darkly tanned body with the small sea foam green bikini leaving little room for imagination.

The water splashed in the pools shallow end and the voices of children filled the air as Lucie leaned back closing her eyes under the pilot style Ray Bans. The mirrored lenses reflected the bright blue sky with tall clouds miles high.

I could hear it all in the background as I crossed the exhausted highway running east to west in front of the hotel.

I headed down the sidewalk, turning down the road that led straight to Nate's. Nate's is my get away from reality, my place of security it felt like home away from home.

Walking thinking of my mother and father, and how the recent events must be taking its toll on them both. I had gone my

own way.

The other direction was my father's plans and it all was quickly coming to a head. I pushed the old screen door open, it creaked to the tune of *"Garden Party"* a favorite Nelson song.

The air was a bit muggy, but the ceiling fans were doing a fair job in their struggle to cool the place. Nate stood behind the bar looking up at the one tv. The Florida - LSU game was on. He watched it for a few seconds and turned when he heard the door.

"Remy!" he yelled. "My boy, how's it going?" you come down to argue with me about the game?" he asked.

"Yea, I figured you could use a little company."

"Well grab a seat, and here's a beer!" he said as he slid a cold one towards me and then walked around to join me on my side.

"So, Remy Boy what brings you here this trip?" asked Nate.

"I gotta get some help with my legal problems."

"Well, you best watch out about that character you and Lucie were talking to last night, word is he's a pretty unscrupulous fellow."

"Ah don't worry pops I can handle him."

"I know, I just don't wanta see anything bad happen to you kids," said Nate.

"I understand and really appreciate your concern for our welfare... now how many points does your old coon ass need on today's game?"

"Points, me needing points, you gotta be kidding me, I was gonna be gracious to you and those pansy ass Gators!" said Nate.

"Yea right, put your money where your mouth is old man," I said as I threw a "Grant" on the bar.

"Bring it on big boy!" said Nate as he matched the bet.

The game was barely in the first quarter with no score. The two sat and watched the whole game till nearly dark, drinking the afternoon away. There were cheers and ooows, throughout the day as each team gain or lost. it was a fun time Remy thought to himself, and oh how he would miss this place after it was all over. But he couldn't think of that for now, he had to stay focused on his final hurrah, after all it was the only chance, he had left at freedom as he knew it.

After the game I paid off my bet and told Nate me and Lucie would see him for dinner. Nate was still rubbing in the loss as I went through the screen door and headed up the street for the motel. You could hear it for a half a block bouncing off the olden down town brick walls lining each side of the street. I continued on up the sidewalk with my balance constantly in check from the seven or so draft beers I had drank during the football dual.

By the time I made it back to the motel the sun had dropped to the horizon turning the western sky into a beautiful painting. All its vibrant colors, purples, oranges and yellows danced a slow dance to the soft rolling ripples on a calm surface for as far as the eye could see.

I noticed Lucie had long since packed up from the pool side and migrated into the room. I could still hear the transistor radio crackling a tune with a common beat. I walked towards the door the motel, reaching in my back pocket I pulled out the room key and began to fiddle with the door lock. The dusk and the alcohol made the usually simple task a bit tricky. I thought about how my

head began to hurt, it usually did after an afternoon of drinking. Suddenly the outside light came on, and the door swung open. There stood Lucie with her top off and a smile on her face. I knew what was next and had no objections to her advances as I closed the door behind us.

Dead Man Bay, Florida

Casey and Cole quickly gathered their cash and guns from Cole's house at the beach. Neither Casey or Cole was nabbed by the long arm, as one was out for an all-night affair, and the other got a tip from a friend via VHF.

When the bust went down around the river simultaneously, the boys were luckily out of pocket allowing their present freedom. They knew they only had a short amount of time before the feds would be on to their whereabouts. After all the trip from the river to the beach is only about twenty-five minutes. Surely, they would quickly pick up on their trail, and further more why did they miss this obvious location in their planned round up?

Casey was jamming wads of cash into the large black duffle bag while Cole packed a few clothes in the gun satchels for each of them. Cole was constantly looking out the window for any unwelcome arrivals as he tended to the final chores for their big escape. He was concerned about the phone call Casey had made to Jim to pass the word to Remy about Clancy's bust. The phone had to be tapped, there was no way they were that stupid or careless, surely the feds were smarter than that. After the quick packing the two hurriedly ran out the back door of the house heading down to the dock where the float plane was waiting. They were in such a hurry Casey didn't even shut the door behind him. He knew their time was limited. And boy was he right! They had no sooner loaded their stuff before they heard the sound of a barrage of vehicles heading up the old lime rock road, the larger lime stone from the fresh grading were popping under the tires of

the heavy trucks.

"Let's go, let's go!" yelled Cole as he cut the lines loose from the dock.

They were taking the small plane for a quick escape as the goose would take too long to get out of the channel. Casey primed the fuel pump and began to spin her over, as Cole shoved them off.

By this time the feds had rounded the corner of the dense brush that lined the driveway. Several trucks and two cars parked hap hazard in the drive and yard. Out jumped more than a dozen armed agents, all of which headed straight for the dock. By this time Casey had the plane started and was taxing for the other side of the canal in an attempt to keep the feds from boarding the pontoons and stopping their escape. But this only bought him a minute or so. Three of the agents dove into the canal and began swimming towards the plane. Casey swung the tail around to line up with the length of the canal for takeoff. He had to go right back past the group of agents, but would be doing fifty or so by the time they reached them. The three agents continued to swim towards the plane closing the gap quickly. The others took position and began to fire warning shots trying to convince the pair to surrender. The bullets whizzed past the windshield as Casey aggressively pulled the throttle to ad power. The floats were slicing the glassy water as the plane gained speed, nearly enough now to lift off. The agents fired again as they approached the dock. This time they weren't warning shots. Several bullets pierced the left door, one barely missing Casey's shoulder. Cole had been preparing for this and quickly raised his shorty scattergun. He named it that because, every time he broke it out, everybody scattered!

"Lean back!" he yelled to Casey, as he brought it up to shoulder level and fired both barrels, blowing the left window out

of the door just before the plane lined up even with the dock full of agents. The blast rang out through the cockpit and led shot spread out to a fifteen-foot pattern by the time it reached the dock. Several agents took the hit and the others... well,... They scattered.

The plane soon reached lift off speed and Casey pulled back on the yoke.

"No need to reload... Huh?" said Cole as he grinned.

Casey just looked at him and nodded as they banked right and hugged the ground, meandering back and forth through the ten thousand islands before them.

"Glad I had on the headset!" yelled Casey.

17.

Rendezvous

Parker, Arizona

The engines rumbled, and the turbo props fluttered as the pilot changed their pitch to slow the King Air after touch down. The change in the pitch of sound woke Clance from his nap of an hour or so. He stretched as he peered through the thick, circular glass window on the left side of the plane. The aircraft rolled down the blacktop runway to the last place possible to cross. The desert rocks divided it from the small terminal against the hills.

Clance could see the dark blue suburban waiting for him on the tarmac.

It was a hired ride that he'd set up prior to leaving Tallahassee, and the confines of the small concrete walls of the federal holding cell.

The plane rocked slightly as the pilot applied the brakes. The engines silenced and the props slowed to a stop. The copilot popped the boarding door and dropped the steps. "OK Mr. Clancy, she's all yours," he said, as he stepped down to the ground.

Clance rubbed his eyes and stood to a crouched position and climbed off the plane, heading directly to the suburban without

hesitating. He was met by young man of Mexican descent, sporting long hair pulled back into a pony tail. The young man wore faded Levi's, a black t-shirt with a Strum Ruger logo on the front. Over that he wore a light weight jacket to conceal the large caliber pistol in his shoulder holster. He opened the back door without saying a word, only nodding as he made eye contact with Clance.

Clance quickly ducked into the vehicle, where he was out of sight of any leering eyes that may place him there at some other time in some other court room.

The suburban was cool inside from the AC running while it waited. Just seconds after the assistant tossed his bags in the rear doors, the vehicle began to pull away.

They drove for about five or ten minutes, paralleling the Colorado River. It was now late October and the boat traffic was minimal, most had left for the winter. Only the snow birds were evident from the northern license plates parked in the drives of the trailer parks that banked the river. They made their way down the sloped gravel drive towards the last trailer on the right. The ground crackled from the crushing weight of the tires as it slowly rolled forward. Clance stepped out to look around at his new surroundings. The sun had begun to sink behind the rocky hills on the California side of the river, casting long shadows across to the Arizona side. The shadows mimicked large jagged teeth spread over the ground. This gave Clance an eerie feeling as he gazed at it for a moment, thinking of what his next move would be, and when it would be.

He soon went to the front door of the old mobile home. Watching his step on the metal stairs, he grabbed the cold silver door knob and twisted it to the right. The door popped open from the warped aluminum hinge which had seen a better day. The years of the desert winds had taken its toll on the door, whipping it back and forth like a flag in the wind. He stepped inside with his bag in one hand, and pulled the door closed behind himself with the other.

The last of the day's sunshine was glaring through the dusty glass, half blocked by the dingy mustard yellow drapes that hung just below the bottom of the window. The suburban pulled away disappearing up the gravel drive, the crunching gravel sound went with it. In the middle of the living room was a shin high coffee table made of a cheap pressed board layered with water damaged cherry veneer. The room was sparsely furnished with only a couple of pieces for setting.

The walls were a dark paneling with a few pictures from a local yard sale in the neighborhood. The table in the corner had two levels, the top covered with a doily and on it sat a relic of a hurricane lamp. On the wall were two built in lights with small watt bulbs casting little light when on. The kitchen was in the end of the trailer that faced the main drive. There were windows spanning the entire end but were covered with aluminum foil to block the light and view from outside. Clance sat down at the round table still wearing his windbreaker, pouring himself a stiff drink of Jack Daniels. The crystal brought back the memories of his late wife, how he missed her and how he seen her in their daughter Lucie. The beaten trailer was a little musky, it lacked a woman's touch and it had been several years since he and Angelina had visited. The last time was just before she died. Oh, how he missed her so.

The more he thought the more he drank. An hour and a half, had passed before his deep thoughts were disturbed by the ringing of the phone. It sat on the bar top that divided the kitchen from the living room. It was a rotary dial with a long cord that suddenly twisted one loop the opposite direction about half way down. It was canary yellow, a color of the times. The phone rang several times before he got up to answer it.

"Hello," he said.

A voice on the other end quickly said "Daddy is that you, are you all right, how long have you been there?"

163

"Hold on little girl!" he said, "one thing at a time, yes, I am OK, and I just got here a couple of hours ago. Where are you guys?"

"We're in Cameron town for just a quick stop and then we're heading west to see you, have you heard from Cole and Casey yet?"

"No... not yet, I hear they were in a bit of a scuffle with the FEDS, I hope they made it out OK," said Clance.

"Yea and those bastards confiscated the shrimp boat too," said Lucie.

"Yea, that's what I heard sweetheart," he said.

"You Know we can't stay on the line but a few more seconds, so say good bye for now, I love you and be careful on your way out," he said.

"OK daddy I love you and we'll see you in a few days," she said. Then she heard the line go dead on the other end.

Cameron Town

Lucie lay the receiver down in the cradle. She turned to me and said, "we gotta get out of here I need to see my daddy, I can tell he's very lonely and needs my company."

We'll leave in the morning I said, right after we get our pick-up instructions from that fucking lunatic, so get ready we're supposed to be at Nate's at about nine," I said.

"Ok." said Lucie as she stripped off her panties and threw them at me, turning and walking for the bathroom door.

I turned and watched each sway of her perfectly round ass as I drank the last swallow of the brown sweaty Michelob I held.

As always, she bent over grabbing her ankles exposing the full view for her man, as she knew I loved to see it. And she loved to do it.

After the shower started and a few minutes passed, I got up and headed into the bathroom. I opened the door and undressed quickly. I reached over and pulled the shower curtain open slowly. Lucie was deep into her own self-satisfaction. She was slowly moving her hand in and out from between her legs, moaning with every stroke. I climbed in the shower behind her, wrapping my arms around her and working my right hand in place of hers. She smiled big as she felt me from behind, anticipating my advancements. I reached over and pulled the shower curtain closed as I brought her to a climax. She fell to her knees and began to repay the pleasurable favor. I hardened with excitement with each stroke of her hand, holding back as long as I could, until it was over in a flash. I sat down in the tub and lay

back, enjoying the past few minutes in my mind. Lucie rose from her kneeling position and soon straddled me. Slid down onto me and began to hump me up and down until I was hard again. We made love for a half an hour or so. Until each had gotten our fair share. We then rinsed off and began to dress for the evening's events.

The night air was fairly warm for this late in the year. I gripped Lucie's hand tightly as we crossed the main road in front of the hotel. Not wanting her to lag behind, as the oncoming traffic was moving a little faster than I first thought. We walked towards Nate's with few words being said.

There was a slight breeze coming from the direction of the coast, it blew the hem of Lucie's dress as we walked. The neon glowed, lighting the immediate area. Its hue painted the white walls of the building across the street. Changing from green to red each time the lights would blink.

I reached out with my left hand and pulled open the screen door I had so many times before. The creaking of the old door spring could be heard across the quite room. There were few people in the bar and the juke box wasn't playing at the moment. Nate stood behind the bar in usual fashion in his favorite bar apron staring at the TV. Lucie walked in ahead of me and headed to the bar. I followed grabbing one of the wooden fossils of a bar stools that swayed a little from its age. The man we had met the night before, sat at the end of the bar. He quietly sipped his beer under the brim of his felt hat. Nate carried on about the hostage crisis in Iran. It had now been almost a year and everyone was sure it would end with the election of Ronald Regan.

Lucie ordered a couple of beers and struck up a conversation with Nate about the goings on as I moved over towards the man.

The man picked up his beer and motioned for me to follow. We walked over to the other side of the pool tables, where he pulled a folded piece of paper from his jacket pocket. On it was a phone number with an Idaho area code. I quickly knew the

direction I was headed. The man only said " George Riley." and nothing more, as he turned and headed towards the door.

"Wait." I said "what about paying you your fee?" I asked.

The man said " don't worry I'll get mine from Mr. Riley", and kept on walking.

Lucie was cautiously watching as he passed the bar. Nate kept an eye on the man as he drew another beer from the tap for Lucie.

"I meant what I said last night about that character said Nate, he's a dangerous man."

"Don't worry Nate, Remy's got everything under control," said Lucie.

In a few minutes I joined them at the bar. "Give me another one," I said as I sat down on the rickety stool.

Nate bent down reaching into the refrigerator under the bar top. He looked at me over his glasses as he pulled out the frosty mug. I had seen this father figure look more than once, and I knew what it meant without a single word. It was obvious to me that he disapproved of any dealings with this guy. I knew that Nate felt it was a risky thing and wanted me to have no part of whatever it was that the man had to offer.

"Aw stop it Nate," I said.

"Stop what ?" said Nate.

"That look you're giving me, that's what," I said.

"No look here," Nate quickly responded, as he slid me the cold draft, along with the cold shoulder.

I turned to Lucie and said, "we gotta leave in the morning for Idaho."

"Idaho! " Said Lucie, "is that the best he could do, thought you said he was gonna get something between here and Arizona?"

"Not much choice," I said. "It's a little out of the way, but we gotta do it".

The conversation continued, and Lucie filled the juke box with quarters punching up some of her favorites. The old building soon lit up with joy.

Nate broke out the tequila shots and the race was on. there was only a couple of other people around and with Lucie's outgoing personality, she had them at the bar joining in on the shots. The place was alive in a special little quaint way. Even Nate had begun to have a shot or two.

The evening continued to a late hour completion and the few patrons stumbled to the door. Only Nate, Lucie, and myself remained in the bar. We began to say our goodbyes. Lucie was somewhat emotional as she wept on Nate's shoulder, it wasn't really apparent weather it was the booze talking or not. But it didn't matter as Nate looked at the two of us as his own children. He knew that she meant all that she was blubbering.

I spoke in a tone that he'd never heard. It was almost distant, with a hollowed sadness. I could see he had a weird feeling. He somehow got the strange notion this was the last time he would ever see the two of us. It was as if a portion of his life ended, or sort of died. He felt a feeling of morbidity, it came upon him like an unexpected swoosh of humid night air. It was as if the grim reaper had flown down and stood before him. He was frightened

nearly sober as he watched almost in slow motion as I turned and looked over my shoulder. It was as if I knew it was coming; Nate could see the somber acceptance in my eyes. I waved, and the screen door I had opened to a warm friendly atmosphere so many times before, slammed closed for the last time in my life, and we both knew it.

Dead Man Bay, Florida

The early morning sun cast long shadows of the palms that hung over the river's edge. It was hauntingly quite as Mr. Remington stood on the crab house dock admiring the pale pinks that accompanied the ball of fire on the eastern horizon. He sipped his coffee as he soaked it all in. He found himself here more lately than normal with all that was going on with his son. He had run it through his mind a million times, where did he go wrong, what could he had done different that would have changed it all? It bothered him so, that he was caught up in his own hell of this all, and felt there was no way out.

He could hear the steps of someone making their way across the wooden dock. Turning to see the two federal agents headed his way. He knew what it was about, just not which event. Remy obviously had a new warrant out for his arrest. When would he learn to give it up? and when would this all end?

The two men exchanged words with the old man of the sea and spent no more than a few moments at his side. Then turning and leaving him as they had found him.

He found himself feeling over whelmed and sat down on a fish crate. He continued looking up river at the beautiful sunrise. The warmth of the rays removed the fall chill from his cheeks. Weathered from the years but each line had a story. A story of love, of anger, of death and most of all, of life. He sat there most of the early hours, almost in a trans.

Up the coast

Cole and Casey had been in the air now for some three hours or so. The two had managed to dodge bullets and the long arm one more time. Each knew he was soon to run out of luck. You can only beat them for a while, and frankly that period had past some time ago. They continued up the coast just above the tree line. It was nearly sunset and the tattered float plane was needing fuel in the near future. By now they had made Panama City Beach. As so many times before Casey flew across the mouth of the canal that curved leading back to the east. It was only a mile or so to the marina that he had fueled at many times before. Casey eased back on the throttle and circled the marina one time. As he made his way around and began to lose altitude, making sure the canal was clear of any boats, and lining up with the trees on either side. Full flaps and less throttle, this made the old boy sink into the late evening shadows cast by a heavy line of pines and palms. Soon the floats parted the water and slightly rumbled from the cascade pounding on their bottoms.

The shadows were darkening by the moment, making it harder to see what was lurking beyond. The two were a little gun shy to say the least. They could only hope no one knew their routine stop. Cole continued to stare into the shadows looking for any sign of trouble. He could see a couple of guys on a fishing rig unloading their gear. They had stopped to watch the appearance from out of nowhere. It looked like they were a little too interested. Casey reduced the power once again as the bird came off the step. Cole reached down and grabbed the scatter gun, and began to load it as they idled towards the dock. He popped the door open to just a crack in case he would need to fire. The two strange fishermen on the dock continued to unload, but seemed to do so in slow motion as they attempted to discreetly watch the

moves of the plane and their occupants. Casey looked at Cole and without a word between the two, they both checked their weapons. They had been down this road before and knew what each other's thoughts were at most any given time. Casey reached up and killed the power to the engine. The bird slowly drifted to the dock, with only the sound of the water slapping against the floats. The quite was deafening as they watched closely as the two-fisherman reached down, and picked up their ice chest and turned looking over their shoulders at the plane as they disappeared into the dark shadows in the distance. There was a bit of a sigh of relief from Cole as he removed his hand from the stock of his shot gun. The sweat on his palm turned cold, an icy cold unlike any time before. It sent a haunting feeling straight to his gut. It scared him and he turned a bit pale as he looked over to Casey. Casey had sweat dripping from his forehead as he sat now with his hand tightly wrapped around the yoke. He stared straight ahead as the dock attendant stepped on the nose of the float with one foot, stopping it from bouncing off the dock as it came to a rest.

"How yall doing?" A voice said from outside the cockpit, seaming a bit louder than usual for someone standing outside.

Casey looked left and realized that he had gotten so use to the tomato can sized hole that Cole had blown out of the side window, that he had forgotten it was there. He reached up popped the door, swinging it open he quickly responded to a familiar face.

"Fine, fine!"

"How's it been going with you Kelton?"

"Oh, not bad, not bad at all, the old lady just had a little girl day before yesterday."

"Well, I guess congrats are in order huh Cole!" said Casey.

"Huh...?" Cole said as he stared at his hand of ice.

"Oh yeah," he quickly said as it registered as to what Casey had said. "Congratulations," said Cole as he turned his head and looked toward Kelton.

"Want me to fill'er up Case?" he asked.

"Yes sir," he responded. " We gotta long way to go."

Kelton filled the tank and told Casey what the total was as he noticed the holes in the side of the plane's door panel. Kelton was a bit slow and only had mastered the seventh grade in his academic studies as a young man, and was very naive to boot.

"Looks like you got a hole in your door Case." said Kelton.

"Yeh, we had a small accident with Cole's scatter gun," Casey said as he stretched his legs on the dock.

The sun was completely gone by now and the boys were getting anxious. They needed to move on.

Now the tank was full, the money changed hands and the good byes were exchanged.

The two flying cowboys were in the plane and on their way.

They idled out to the center of the canal that was dimly lit by the few dock lights that were scattered randomly along the tree covered shore line.

In a short time after the preflight check the plane leaped on the step splitting the dark water beneath its floats. Then as mysteriously as it had appeared, it vanished in the dark night sky heading south and then west until the sound of the bull frogs and crickets drowned out the sound of the engine in the distance.

Somewhere Over Texas

Lucie and I had been flying for about three and a half hours.

I could see in the distance off to the southwest a thunder head was building and could begin to feel some slight turbulence.

I told Lucie to make sure she was buckled up as the plane bumped along.

I figured a heading for the nearest V.O.R. to the north and soon began a turn in that direction. I backed off the air speed to about 130 knots to ease the stress on the plane and its occupants.

The turbulence increased as we flew through the edge of the outer rim of the weather. Soon the sky lit up above the twin Commander from the upper-level lightning strikes. The cockpit glowed from the random electricity making us uneasy to say the least.

The further we flew the worse things got. I continued to turn north and then northeast until we could finally see a possible hole in the quickly deteriorating weather. Lucie pulled out a chart and began to look for a place back towards the east to put the plane down until the weather cleared. With the red of the cockpit light and occasional interrupting flash of the lightning she finally spotted a small strip about twelve miles more towards the east. The strip ran parallel to a main highway through the west Texas desert. I took a heading and corrected the plane. About halfway out I began the descent following the main road using the headlights of the few cars scattered up and down it in both directions until I spotted the small strip. After a few minutes of preparation, the plane was ready for the landing attempt. Calling to let any other plane in the area know of my approach, I made the base turn, and then final. With the weather still in disorder and the serious cross wind this was going to be quite a busy landing. I reached for the landing gear switch, flipping it in the down position I kept an eye on it to make sure the gear locked in place while keeping one eye on the end of the runway as it

quickly grew larger in the wind screen. The wind was whipping and throwing the small plane about as it grew closer to the ground, and I knew this was the danger zone as there would be little time to recover from any drastic change in the attitude, or a down draft this close to the ground.

The landing lights began to glow on the runway. Shortly the plane bounced off of the strip a couple of times before I could keep it safely on the ground. Long enough to chop the throttles and complete the roll with the whipping wind pushing us from side to side. The weather was worsening by the minute. I taxied over to a nearby tie down next to the exit of the tarmac. Lucie reached into the back seat and pulled a light wind breaker jacket from her bag; it was powder blue with dark pin stripes down the sleeves and a Piper logo on the left breast pocket. I shut down the engines one at a time. The props slowly come to a stop one after the other until the plane sat motionless like a paralyzed bird in the pouring rain. We decided to wait it out for a break in the thunder clouds before we would head to the little cafe across the small two-lane street that ran east and west through the flat Texas desert. The neon light in the distance was blinking in a pattern almost like a drum keeping a perfect beat to a song. It wasn't long before the rain subsided and we were able to make a break for it. The wind was still whipping around a bit as I was fiddling around with the door latch, attempting to close the door. Lucie had managed to get out ahead of me and had started in the direction of the street. There was still a small bit of large drops pelting us and the ground in no certain pattern or form. I caught up with her just as she reached the road. Looking out for any possible traffic we held hands as we crossed.

I thought of how close of a call that had been, and was thankful to be on the ground and safe for now.

I reached out in front of Lucie and pulled the old wooden door open. It had a single window in the upper half partially obscured by a single curtain pulled to one side. I noticed that there was only one old timer setting across the dining room at the

end of the lunch counter, gazing off in the distance. I wondered what the man was looking at, or was he at all. maybe he was lost in his own world unaware of the subtle change in his surroundings. We walked across the room and sat at the counter several seats away from the man in space. No one from behind the counter showed their face for a few moments, as we waited patiently. But before long an old woman came from behind a makeshift curtain door that covered the entrance to the small kitchen. She was like every grandmother from the south that we'd known. She beamed with life which she credited to God. She wore an old faded cotton dress with no sleeves and bore the print of a small flower arrangement of light blue and green on a white background. Her hair was gray and kept in a spiraling wrap around the perimeter of her head. She wore a pair of old bifocal horn-rimmed glasses that magnified the cataracts on her aging eyes. Speaking in a sweet old voice as she welcomed us in from the weather and offered us hot coffee. Pointing to the menu board leaning against the wall at the end of the lunch counter. It was displaying a few options of fried this or that with a few sides of the bean origin.

Off in the distant sky, filling the large window was another building storm. The glow filled the pane glass window for a flat second. Each time the lightning struck it was like a picture being snapped with an old strobe bulb Nikon camera. The man finally spoke only a few words, words that were not really meant to be heard, he repeated them again only once more as he continued to stare into the night.

Lucie got up from the stool and walked over to the pay phone tucked away in a corner near the small door that led to the bathroom.

She had decided to try and reach her dad to see how he was holding up after the latest events. After dialing the number, she waited for a few seconds and she began to hear the clicking tone as it rang on the other end in Parker Arizona. It rang seven or eight times before someone picked up the other end. There was

silence for a couple of seconds and the clearing of a voice on the line and then a dim "hello."

"Hi dad it's me Lucie," she said.

"Hi honey," he replied, "how are you?" he asked.

"Fine, we're in a little town in west Texas. I think it's called Sundown, or something like that, we had to put down because of bad weather," she said.

"You guys, OK?" asked Clance.

"Yea, we're fine, just waiting it out and then we'll be heading out; but it looks like tomorrow at this rate. We're getting a bite and I think probably a room for the night; there's a motel next door," Lucie went on.

"You guys still heading for Idaho?"

"Yea, and then we're coming to Parker," said Lucie.

"How are you doing Dad?" she asked.

"I'm hanging in there honey. But I'm too old to run anymore," he said. "You guys have your whole lives ahead of you, and should find a way out of this."

"I think Remy has a plan from all I can gather," she said.

"I hope it's not too dangerous," said Clance.

"I'm sure he's got it covered Dad, stop worrying," she said.

"I can't help it you're my little girl and I don't want to lose

you, baby girl."

"You won't Daddy, I gotta go for now, I'll call from Idaho, I love you Daddy."

"I love you little one," he said.

And then she heard the line go dead, leaving only a crackling dial tone humming in her ear. Lucie hung the receiver in the chrome cradle, turned and headed back to the counter where I sat sipping my coffee.

"How's your dad?" I asked.

"Ok I guess, he seems really depressed though."

Your dads a tough man and always seems to come out of whatever it is he's in, unscathed."

"Yea, I guess you're right."

The two just sat quietly for a few minutes staring out at the latest shower moving across the lightning lit night sky, only thinking each their own thoughts, sharing only an occasional glance and nothing more.

18.

Getting the Slip

Tallahassee, Florida

Agent Maveric slammed the phone down and begin to curse attracting attention from the rest of the office. They all were looking in his direction but cautiously as they knew how volatile he could be when he didn't get his man.

He had been on the force for better than twenty-five years and usually didn't fail at his attempt to collar someone breaking the laws that he so proudly enforced.

He was particularly disturbed from the phone call. Not only had the perps gotten away but they had shot and seriously injured two agents in the process. This really angered agent Maveric and made him that much eager to pursue the group he had warrants for, Hutch Remington aka. Casey, Cole, Remy Remington and Trent Clancy aka. Clance. as well as a whole slew of other humps, helpers and boat captains.

Maveric picked up the receiver and began to dial the number from the card in his rolodex. He was trying to reach agent Swanston about a lead they had on where the two gun slinging cowboys that had taken down his boys, were headed. He stared out the window from the second floor of the Federal building watching the morning traffic on Government Avenue. Each car

creeping along from the grind. The sun cast long shadows on the building he stood in making it feel earlier than it really was.

The phone rang on the other end but there was no answer for some time. He almost hung up but then someone picked up on the other end.

"Division Six Tampa," the voice said.

"Hello I'm looking for Swanston," said agent Maveric.

"He's not here, this is agent Goodman," can I help you?

"Yea, agent Maveric here, I understand you guys have a tip on my perps that shot it out with my boys yesterday down in Dead Man Bay," he said.

"Yea we heard about that, how's your team?"

"They'll make it but their pretty banged up," Maveric stated.

"Well, we got word from an informant that they were spotted late yesterday in Panama City, at St. Andrews Marina in the bay. The informant couldn't tell for sure but said it sounded like they were heading west. We got word they requested a weather briefing late yesterday as well.

Apparently for a heading in the direction Biloxi Mississippi," said Goodman.

"Is that the last sighting you have of the two?" asked Maveric.

"Yea, that's it, gone again," said Goodman.

"That's the two luckiest bastards I've ever chased in my entire career. It seems as if every time we get them cornered, they

disappear into thin air right before our eyes."

"I'm sure their luck will run out soon," said Goodman.

"I sure hope so; I'm getting tired in my older age."

"Well, I'll let Swanston know you're looking for him."

"OK, thanks for the info, I'll be in touch soon," said Maveric.

The receivers were tossed in the cradles at each end of the line, each man heading off in a hurry to attend to matters at hand.

Sundown, Texas

The early morning sun peeked through the crack of the thick motel curtains.

The thunder from the night before had subsided and the skies were clear for as far as the eye could see on this chilly fall morning. Lucie stood in front of the window as she slowly opened the curtains. She stretched and yawned, and rubbed her eyes clear of the night's sleep. She looked out at the flat countryside of Sundown. It was brown and flat. The parking lot had puddles from the evening rain storm. Everything was gray, no leaves on the trees and dead grass, where there was grass. The morning sun gleamed around her creating a silhouette that I admired as I scratched my head and sat up in bed. She turned, run and jumped on top of me before I knew what had happened. I grabbed her in my arms and we wrestled for a few minutes before she jumped up and ran off in the direction of the bathroom. I stood up out of the hard bed and walked to the window to see the newly cleansed world I hoped to be a part of for at least one more day. After admiring the beautiful sun rise and feeling its warmth

on my face I turned to the overnight bag on the low wooden dresser and fumbled for a fresh pair of under wear and a clean pair of jeans. The lava lamp shed little light on the subject when it was turned on. I made the best of it. Lucie had finished in the shower and walked out to turn up the heat on the little window unit. I reached out and ran my hand across her smooth soft ass and she grinned and continued for the heater. I sat on the edge of the bed admiring her. She had been the dream of my life, and it had come true the day I met her. I thought of her so often and how she made me whole. Lucie was a bit more mystical; she knew she had me wrapped around her finger and loved to play around with my mind. She had a way of keeping my interest at peek nearly all the time.

She turned and dropped the towel only to parade in front of me, running her fingers through my hair as she walked slowly, sexually past me. I was still a bit sleepy but was ready for the calling. I reached out and pulled her back towards me by the hand. She walked up to me; we were facing now. She put her arms around my neck and gently pulled herself to me pressing her breast against my face and slowly straddling me putting one knee at a time onto the bed. She reached down felt my excitement, soon we were one.

We made love until we were exhausted, showered together, dressed and headed out the door for the cafe. It would be coffee and breakfast as we planned the next leg of our flight in the direction of the western sky.

Biloxi, Mississippi

Cole sat with the plane while Casey went to the convenience store. It was just down the street a couple of blocks away from the small dirt strip they'd managed to put down on late the night before.

Casey needed to find a phone to try and locate the aviation

mechanic in town. They needed to repair the wheel strut they had damaged from the rough landing. He had found a flyer stapled to a makeshift sort of bulletin board. The board was nailed to a light pole at the only exit through a weathered chain link fence that bordered the east side of the strip. Cole killed time planning the next flight while he waited for Casey to return, hopefully with some help.

It wasn't long before Casey came running back towards the strip. He was waving his arms and yelling at Cole to start the engine. Cole could see in the distance down a side street a police car closing in on Casey quickly. Cole immediately began to prime the fuel pump while switching seats, then he hit the starter switch and the engine quickly came to life. He ran it up to warm the engine before this outrageous take off attempt.

Casey had just made the fence when Cole spun the plane around to line up for the take off. Within a few seconds the cop car had skidded to a stop stirring a cloud of dust that drifted over the car hiding it for a brief moment.

The deputy jumped out and drew his weapon. This was the last thing the two cowboys needed, another shooting match!

By this time Casey was able to clear the tail of the plane and jump on the step of the float. Cole had pushed the door open for him and was handing him the sawed-off double barrel when the first shots rang out. The deputy had taken aim at the engine cowling, piercing it with a couple of shots.

Cole was ducking with each sound of the gun fire. Casey cocked the scatter gun and stuck it under the fuselage of the plane while hanging on with one hand, he pulled one trigger and then the other. The bird shot pelted the side of the police car riddling it with holes and sending the young deputy heading for cover. Soon you could hear the waling of another police car in the distance. Casey climbed aboard laughing as he latched the door. Cole pushed the throttle to full and felt the lunge of the craft as it gained speed.

He could hear the popping of the small caliber pistol fade as

the plane sped down the runway. He pulled back on the yoke, the bird lifted away from the earth and floated off into the distance. Soon the whole event was only a recent memory.

It wasn't long before that would change. The engine began to sputter and they began to lose altitude. An altitude that was much needed as they had only managed to get to a thousand feet before the problem began to unfold.

Only minutes past but it seemed like an hour as Cole fought to keep control of the falling bird. The plane began to sink at a much too fast of a rate for either of the experienced pilots. The wind screen began to fill with foliage, and it was becoming easy to make out the dense forest below. It wasn't looking good for the moment as they couldn't see any immediate possibilities for a safe landing, much less a bare strip of dirt to put it down on. He had only one chance and that would be it. This could be the end for them both. He thought after all these years of running together I'm gonna kill us over a god damned simple engine problem. Just to think of how many times they had taken on fire from pissed off feds, deals gone bad, or how they had managed to limp a DC 3 back from Belize just fifty feet off the deck, in poor weather and badly wounded. This can't be ending here. He knew he had to do something. Just then he spotted a hole in the tree tops.

Cole had a death grip on the yoke, his fists shook in fear and determination. He was looking for the horizon to appear any second or for the reaper to call out to them both. He could only hope it to be the previous.

Finally, after what seemed to be an eternity the old boy began to nose up and the horizon never looked so good in all the years they had flown.

The plane leveled off and was scooting along now at about seventy-five knots. In one last glance around they still could not see any possible place to put it down. Cole reached overhead and started cranking on the trim to keep the nose up as the speed bled off. Casey looked out into the cypress swamp below, he knew it was going to be the roughest landing they'd ever go through and

hoped to live to tell about it over drinks. Drinks maybe at the thatch bar on white sandy beaches of Belize, or down on the dock at the river house. He had to focus he couldn't day dream it could cost them their lives.

Cole watched the air speed; it was getting close to the threshold of stall. He went through the motions in his mind. just as it got within fifty knots, he would pull the flaps to full, this would push the nose over further so he would have to compensate with pulling back on the yoke, but not too much that would cause the plane to climb and stall too high above the trees.

Casey scanned the wind screen for the perfect spot to put it in the stall while Cole continued to fly the plane. few words were past as the two had flown for many hours together. They knew each other's thoughts and movements, so few words were ever needed. They both had a job to do and both knew their part and played it well.

"There it is," said Casey.

He was referring to a spot about five hundred yards out, a place with the fewest trees, it only appeared as a dark shadow in the distant morning light, but was the best possible chance for survival at this point. Cole reached down and pulled full flaps, and just as he had expected the plane began to nose over but he quickly corrected it. The plane began to sink quickly as it approached the hole in the dense thick forest of cypress trees. They now were barely staying aloft at about fifty knots as Cole heeled back on the yoke to put it in the final approach, so to speak.

Just as they reached the edge of the black hole the plane fell well past stall speed and sank like a rock, Cole fought it all the way to the ground, keeping the nose slightly up. Then the cockpit filled with a thunderous sound as the bullet riddled floats hit the muddy shallows of the Mississippi swamp. Collapsing from the impact the floats tore away from the fuselage. Water flew over

the windscreen like a dark blanket of molasses as the plane slid for about a hundred feet or so. They finally came to rest just short of the other side of the clearing.

Cole could not tell for sure how much time had passed since they had crash-landed as he was knocked unconscious during the event. When he came to, he could feel the cold swamp water around his legs. The water had filled the floor board of the cockpit as it sank into the gassy swamps mud bottom. He looked over to see Casey, only to see the empty seat and the door partially open. He unbuckled his seat belt and began to crawl out towards the cracked door on Casey's side. The plane had tilted slightly to the left jamming the door. He lay on his back and pulled himself towards the high side, sticking his head out he felt the warm high noon sun on his face. He squinted, and turned to look in the direction of the tail of the plane. He had to focus for a minute but soon could see Casey wading back towards him. He had someone following him. The man looked to be some sort of wilderness man with an animal skin cap and wearing flannel long sleeves over long handles. He carried a short brush rifle in one hand and a long walking stick in the other. Cole managed to sit up but soon realized that he had a broken leg as the pain shot through his veins when he swung his legs into the sitting position. he let out a yell as Casey reach the end of the plane.

"Hang in there buddy I got some help here," he said.

"I'm hanging," said Cole with obvious pain on his face.

The two men began to help Cole from the plane and set him in a small skiff the wilderness man had been towing behind himself, the line tied around his waist.

"Cole this here's Clevis Larose, he's gonna help us out of this mess."

"How's your leg buddy?" Casey asked.

Hurts like hell, but I been worse off. Remember the last trip to Belize?" Cole asked.

"Yea, but I'm trying to forget," said Casey.

Soon they were on their way sloshing through the brackish water with the small skiff sliding across the muddy shallows. They were headed to a nearby camp house. A place that the local trappers used to sleep during their seasonal gator hunts. The house was about a half an hour of tough hiking mostly in knee deep water and a few spots deeper.

Cole lay back and said little, only staring into the soft blue fall sky. He thought about where he lay once again, when would it end would they ever make Mexico? He wandered.

Casey held one side of the harness looped through the bow of the skiff and Clevis the other. They would stop their progress to maneuver around an occasional cotton mouth or alligator. Clevis was as sharp as a razor when it came to his surroundings, he sensed every move of everything in the trees, on the ground and in the water. It wasn't too long before they could hear the popping of the rotor blades of the police helicopter that probably was dispatched from Biloxi after the recent encounter. Cole could now only see the sky in brief spots as the Spanish moss and tall cypress tree canopy was swallowing them whole like a python ingesting its pray. The sound grew closer and soon it sounded as if it was circling. Casey and Clevis marched on deeper into the swamp until the sky became dark with the foliage of the thickening cypress from above. Cole could no longer see a way out above, feeling as if they had moved into a cave.

"There it is," said Clevis, pointing to the old tattered building in the distant shadows.

In a few moments they were pulling Cole from the skiff onto the porch and hauling him inside to lay him on a pile of blankets.

Casey went back outside to the porch to listen for the chopper. He could still hear it faintly in the distance. It wouldn't be long before they were on the ground to investigate the damaged plane and look for survivors. Clevis began to work on Cole's leg, making a splint with a couple of hickory sticks and strips of torn up blanket.

"What kind 'a shit you boy's into?" Clevis asked Cole.

"A little of this and a lot of that," Cole responded.

Clevis continued to work on the leg and kept his thoughts to himself.

Soon Casey walked back inside to inform Cole of their short time at the bayou Hyatt. He removed the duffle bag from his shoulder that he had retrieved from the skiff. Dropping it on the floor he quickly went through it checking the cash, guns and ammo.

"You boys can hang here till dark and then if you like I'll guide you out to the edge of the swamp and show you how to get to the main road, then you're on your own, cause I don't need no trouble with the law man."

"That would be great, you've helped us a great deal as it is," said Casey.

Clevis warmed up some vittles and made a hot pot of coffee to warm their bones while they all quietly waited for night fall.

19.

New Identities

Parker, Arizona

Clance stood at the end of the dock with the morning
sunlight gleaming across the peaks and through the treetops on
the sloping terrain of the trailer park.

He patiently waited for the gentlemen that were to meet him
there this morning. The two would be delivering his new identity,
his new life and a plan to leave the country. He would be residing
deep into the heart of Mexico not far from the coast. He knew
that being near this coastal town could bear some risk of being
discovered. But he must be near the gulf as it was in his blood.
He grew up in a small coastal setting and knew nothing more. He
stared down at the water moving slowly south towards the U.S. -
Mexican border. He was contemplating how he probably see the
same water again in the near future, as it passed across the back
of his new cattle ranch in the expatriated southern surroundings.
Before long his wandering mind and drifting thoughts were
interrupted by the sound of the tires on the large four by four
crunching the gravel drive of the park. The truck was green, army
green and was covered in a film of clay dust. The windshield was
caked with dust, the wiper tracks barely leaving any visible path
through the arches they had left.

The truck came to a stop just short of the dock entrance. In a minute a short man of Mexican descent stepped down from the trucks pipe shaped running board, closing the door behind himself. Another man stayed put in the truck and waited. He seemed to be paranoid, but patient.

The man in the truck watched as his partner walked down the dock, keeping his hand on the rifle that lay against the seat. A few words were past between Clance and the unidentified man. He handed Clance some papers in an envelope and clearly demanded something back. Clance slowly reached in his jacket pocket and pulled from it a tri folded stack of papers and stuck it out at arm's length. He did not let go on the first tug from the man. The man looked up and the two exchanged expressions. His of understanding and Clance's of reluctance. The man knew it must be hard to give up your existence in one quick exchange of lives. The man needed this information so he could be convincing with the extinguishing of Trent Clancy's past life.

Clance let go of the papers and watched himself disappear down the dock and into the eyes of the warm Arizona sun.

He stuck the envelope without looking at it into his right jacket pocket and began his slow walk back towards the mobile home a few hundred feet away. He only heard the steps of the new man as he walked slowly thinking of his daughter, and how this would all affect her life.

He made it back to the trailer and poured himself a stiff double and downed it. Then he pulled the envelope from his pocket to find out who he had become. He slowly opened it with a pin knife he had pulled from a small catch all basket on the cheap Formica table in the kitchen. In the envelope was used driver's license, a tattered social security card, a couple of credit cards and a pass port that tagged him the nationality of Argentinean, as it was previously determined he could speak fluent Spanish.

"Benicio Alvarez" he said out loud, reading the name on the

license he held in his hand.

His plan was to fly from Parker to Puerta Vallarta and then would travel by truck to a small village about forty miles away into the thick rain forest.

He would live the rest of his years on a small ranch just on the other side of the forest. In a valley with a small creek running through the back acreage. It was only an hour from the coast, but close enough to visit without having to live exposed to any possible detection by accident.

Somewhere in the hills of Idaho

I walked around out front of the small mountain cabin. The snow was only splotchy at this elevation but the air wouldn't tell it.

The night was creeping up, as the sun sank past the tall pine trees. I could see my breath in the cold and could hear myself think in the quite evening dusk. I looked at my watch again it was now a quarter after six and the connection was late by a half hour.

I thought about the call I had placed earlier, the voice on the other end seemed confused about receiving the call at all. When I asked for Mr. Riley they said, " who? " As if I had dialed the wrong number and hung up. Maybe it was just a cover in the event someone was listening that should not be. Or maybe it was really the wrong number. I had checked it and dialed it again to get the same voice again. I went on to explain why I had called.

The man said "wait out front" and hung up.

The sky grew darker as I paced the rocky driveway. Man, it was getting colder by the minute. I had told Lucie to keep inside

and I would be back later tonight. She was concerned about me going off by myself with some stranger we'd never met. But she knew that it was part of the life we led. Sometimes you couldn't question who, what, or why.

Lucie sat in front of the fireplace watching the flame as it rolled around the large split logs, disappearing into the cold thin night air above. She held a cool glass of chardonnay in one hand while setting on the floor in one of Remy's T-shirts, leaning one arm against the oversized sofa, the other wrapped around her knees. The warmth of the fire eased under the edge of the blanket draped over her legs, caressing the back of her bare thighs. She was listening to Otis Redding on the radio, playing *"Sitting on the Dock of the Bay"*. She lightly sang along.

In a moment she could hear a car running in the drive, but only for a minute and then it faded into the cold distance. She knew she was now all alone for a bit. She thought to herself how lonely it was being on the run. No real permanent friends, no place to really call home. She thought about her father and his situation and how he would probably spend the rest of his days behind bars when they caught up with him. She thought he was probably too tired to run. She wondered what was in store for her and Remy, what would be their final destination. Remy wasn't sharing much these days. he kept a lot to himself lately. He would change the subject when she would bring up their future and what roll she played in it. She had become just a fixture on this trip and was getting bored with it all. She poured another glass of wine and continued to think about how she would demand to know everything when Remy returned. She thought about how He made her mad but she loved and lust him all in one thought. The time passed and she finished the wine a little at a time. Soon she found herself feeling warm and bubbly inside, she was thinking she sure could use her man. The wine and warm fire had her in that special place laying on the blanket in front of the hot fire in the night. The amber hues glowed on the rock walls of the cabin. It turned the heavy wood accents to a dark red that faded to

black. She lay and thought some more as she drifted off to sleep.

The Jeep Cherokee rattled down the dirt road and into the night. They were headed to the local marina on a nearby lake. It was the only place in town with a freezer large enough to facilitate a body. Riley drove and said few words, I kept quite as well. I knew it was the best thing to do in this case as I needed little background on a man, I hoped to never see again.

The lamps lit the road only a hundred feet or so reflecting from the brilliant white snow piled high on each side. It was obvious we were headed to a higher elevation.

Riley spoke up. "You got the money?"

"Yea twenty-five K , right?" I asked.

"That's right," said Riley.

We drove for another twenty minutes or so before reaching the marina. I could see the sign ahead. It hung from a pole so it could swing in the breeze if need be.

It marked a cut off and nearly blended in with the trees if you weren't looking for it, you would certainly miss it. The moon cast barely enough light to make out the sloping terrain to my right. It rolled down to the edge of the lake.

Riley turned on to the side road at the marina sign and headed down the hill, the lake now ahead.

As we approached the parking area there was a red glow of tail lights. It was that of another truck setting at the entrance of the boat ramp. There was a man in a long duster type trench coat wearing a black snow hat. He had one hand in his coat pocket and holding a glowing cigarette down by his side with the other. He'd been standing there for several minutes and two cigarettes from the pace marks in the thin layer of recent snow.

Riley said, "remain quite I'll talk to him."

"No problem," I replied.

We pulled up alongside of the dark blue Ford pickup and shut off the engine.

We got out of the Cherokee closing the doors behind us.

Riley walked around the front of the vehicle and pulled out a cigarette and lit up while standing in front of the man. I stayed near the door of the truck and just in hearing range of the conversation. I could not hear every word but could clearly tell the man had the cargo I was looking for.

There was some debate for a minute about the price but it apparently was quickly resolved and the two shook hands.

"Follow me," the man said.

Riley looked at me and motioned for me to follow. We headed around the side of the main store of the marina. Then back to where there was a large cooler door where ice would probably get delivered during business hours. The man pulled a key from his coat pocket, not on a chain, so it probably was a borrowed key for this very meeting. He fiddled for only a second continually looking over his shoulder and then popped the lock open. He almost seemed surprised. But then quickly pulled the door open and waved us inside.

He flipped a light switch on the left as he entered and then continued towards the rear of the box. The air inside was foggy but I could make out in the shadowed refrigerator, a black bag. The bag was big enough for a body so this must be it, I thought. I almost got sick when Riley yanked open the top exposing the stump of a neck, the head was really gone, I couldn't believe I was doing this. But I knew it was this or prison for a very long time. I decided to toughen up and shook it off, thinking only of freedom in a southern hemisphere.

Riley spoke up, "where did you get him?"

"He's a drifter from down Corda Lane way," the man responded.

"So, I take it he ain't gonna be missed by many huh?" said Riley

"Yea that's right," the man said.

Riley tied the top of the bag and motioned for me to grab the bottom half. Still squeamish I grabbed hold and then we worked our way to the door, me walking backwards till we cleared the doorway. The man held the door for us as we made our way out. The bag was heavy and inconvenient to carry. We managed our way around to the Cherokee. The man was gracious enough to open the hatch on the vehicle and helped get the frozen stiff in the back. After closing the hatch Riley told me to get out the money. I reached into my breast pocket and pulled out a large bundle of cash. The man added that there was a couple of other random legs and an arm he thought. Going on, that it sounded like I needed it to appear to be more than one person on the plane. I nodded and said thanks as I passed Riley the money… wow I thought.

"Get in the car I'll finish this," said Riley.

I headed for the passenger door without a word, opened it and climbed in pulling it softly closed. I was glad to get in out of the cold night air. As I sat patiently while they finished the business at hand, I could see through the hazy window him handing over the cash, shaking hands with the strange man and turning towards the car. He walked around the front keeping an eye out for his back. He opened the door climbing in, quickly starting the engine and briskly pulling away from the scene.

"Well, that went well," I said.

"Yea," replied Riley without taking his eyes from the road.

We drove back the same way we had come. Few words were exchanged, other than the discussion of our destination. This would be the small air field where I had tied down the plane.

After a forty-five-minute ride, the airfield slowly appeared in the hazy distance ahead. It was a small field and was unprotected by any official law enforcement. Riley headed for the narrow passage that once held a gate that now lay to one side half off the hinges. It led to the grass field where three planes were securely held in place by tie downs in the cold dark night. Two with a foot of snow on their wings and one with hardly any. It was the newest visitor. I thought is someone following me? While looking over the new arrival.

Riley pulled alongside of my plane, several spaces away from the others. He put it in park and killed the head lights. I slowly got out and looked around for any sign of activity on or around the field, but there was none to observe. Riley climbed out and walked to the rear of the Cherokee and opened the back. Meanwhile I opened the cargo door on the side of the plane and arranged a few items to make room for the newly acquired package, finishing with a layer of plastic sheeting on the floor.

By the time I had come back to the car Riley had the body by the top of the bag and was waiting patiently for assistance. I grabbed the bottom end quickly as he dragged it out of the car, catching it before it hit the ground. We briskly walked it to the cargo door on the left side and slid the frozen body into the plane. I closed the door and locked it down.

"Well, that's that," said Riley.

"Yea I guess so," I said as we headed back for the car.

195

Moments later we were roaring down the wet road back towards the cabin where Lucie awaited my return. I asked "how long do I have before the body thaws?"

"You got a good two days in moderate weather and probably almost a week in this cold ass shit," said Riley.

"Good I'll need it to get everything in place," I said.

A short time past, and then we were looking at the driveway in which it all had started only a few hours earlier. I stuck out my hand to offer my thanks for Riley's assistance as I stepped from the passenger's door of the truck. No words were spoken only looks past, each knew the meanings and that was good enough for both.

I walked up the drive and climbed the three steps to the cabin porch, glancing back to see the vehicle disappear into the night as mystical as it had appeared.

I put the key into the door lock and turned the knob pushing my way in. Closing the door behind me I called Lucie's name. I could hear her soft voice in the direction of the fireplace across the room. I walked over to find Lucie on her back lying naked on top of the warm fuzzy blanket on the floor. She was smiling at me as she caressed her breast with the warm palms of her hands, lying there just waiting for me. I said nothing, as I kneeled beside her. I leaned down and kissed her. Removing my shirts, I pulled a blanket from the back of the sofa and joined her on the floor in front of the hot blaze in the large stone fire place for the rest of the evening.

Morning came faster than we'd expected, still on the floor in front of the fire place where the blaze had lessened to a mere ember. I got up and pulled on my pants and began to add wood to

the fire to warm up the small mountain cabin once again. Lucie stayed rolled up in the warm blankets on the floor watching as she rubbed the sleep from her eyes. I proceeded to the kitchen to start the coffee pulling on a flannel shirt as I walked.

Looking through the window at the frozen future, I filled the coffee pot with the ice-cold mountain water. The snow had fallen several inches through the night while we had slept off the wine and love. I started the stove and sat the percolator on the flame.

By this time Lucie had started to dress while asking "when we were leaving for Parker."

I yawned and responded only with "today."

Lucie wandered towards the shower and said " I'll be out in a few."

I put on my boots and walked out onto the front porch to see how cold it was, and quickly returned cursing about the whole experience while slamming the door. Rubbing my hands together, I headed for the fireplace. Just then the coffee pot began to bobble the glass cap on top releasing the warm aroma inside. I went to the kitchen and poured two cups of life and headed for the bathroom where Lucie had just stepped out of the shower. Tapping on the door with one hand as I held the cups in the other with one finger looped through both handles, the hot cups began to burn my knuckle. Lucie opened the door to find me trying desperately to get the hot cups off of my finger without spilling them both and possibly burning myself worse. She chuckled, commenting on how graceful I looked in the process.

I handed her one and began to sip on the other as I leaned against the doorway while she began to get ready. We spoke about the daily plan for our flight south, neither bringing up the third passenger as it disgusted her, and simply assured me of my freedom.

Shortly after breakfast we headed for the small airport. Winding down the narrow mountain road we passed a sheriff's car headed in the opposite direction seemingly in a bit of a hurry. I didn't say it out loud but the site of the car made me uneasy at best. I was easily spooked by law enforcement due to my checkered past. My heart raced as I sped up to distance myself from the long arm.

Lucie asked me, "why are you going faster?"

I responded with "I'm not going that fast, relax we're almost there."

She looked to be uncomfortable with the increase in speed as she gripped the arm rest and pressed her feet on the floor as if to put on the brakes. The ride only lasted a couple of more minutes as the strip appeared in the windshield not a second too soon for her liking.

I pulled into the same drive as last night, passing through the same broken gate and pulled the truck alongside of the plane. Stepping out, I took a quick look around as I popped open the cargo door making sure passenger number three was still safe, sound and solid. All seemed to be in order and I tossed in our bags. Some contained clothes and others contained cash, guns and marijuana, which I often used to bargain with certain locals in certain cases such as the use of the truck we were currently driving. Lucie walked around the front of the truck and climbed in the plane.

I took about two thousand dollars cash and a two-pound bag of dope sticking it under the driver's seat. This was payment for the use of the truck. It would be retrieved by the owner later that morning. After a quick walk around the plane, I then climbed aboard and began the preflight check list. Lucie folded a chart as I started the engines in normal sequence. First the left and then the right. I continued my list as the engines warmed the cold oil.

The skies were clear and cold, nice for flying. I went over my route and marked it clearly on the chart. After a few minutes I run the left engine up and then the right to check for maximum power while I looked over all the instruments for correct function. All seemed well as I released the brake and began the taxi for the downwind end of the small strip. I checked for other possible traffic and then pulled onto the runway lining up for takeoff. One last look for free and clear before the roll, pulling and pushing, and turning the yoke in both directions. All looked good, and we were off. The big engines came to life, rumbling the cabin as the plane bounced down the small narrow strip. The heart pounded in my chest as always, each time I took off. Soon we were at lift off speed, I held it to the ground for a few extra seconds for safety's sake and with one smooth pull on the yoke we were up and gone once again. Another place and another time.

Lucedale, Mississippi

Casey could hear the cars on the main highway as he paddled quietly through the swamp, towards the faint tone of the traffic. Cole sat in the back of the skiff with his leg in pain as he watched the other two. The night seemed darker than usual as the tall cypress blocked any star light from getting through the dense canopy above. Cole listened intensely to the rhythmic swirls of each paddle as it parted the black waters under them. The drip from the end of the paddles gave way to the sound of the passing cars ahead. Occasionally Clevis would shine his headlamp off into the night only to see the large half dollar size eyes of an alligator that lay in wait for the mistake of the unknowing evening meal. The night was filled with smells. The smell of the stagnant water this far from the bay, the smell of an unfiltered, self-rolled Prince Albert cigarette hanging from Clevis's lip, and the smell of time on all three men.

They paddled on until they had reached the shallows only a

hundred yards or so from the main road. Casey stepped out of the skiff into the boggy bottom of the bayou sinking up to his ankles. He walked to the back of the skiff, where Cole was already half way into the water to assist him and his banged-up leg. Clevis gave them some simple directions to the local municipal airport, and local motel, which happened to be just across the highway and two chain link fences. The plan was to get cleaned up, dress up Cole's leg, and barrow someone's plane during the night. Casey threw their bags over his shoulder keeping them dry. He put his arm under Cole's arm pit to help him through the boggy hike ahead. With a thank you, and a few words exchanged, Clevis disappeared again into the darkness as the two sloshed towards the road.

After reaching the road Cole and Casey lay against the embankment of the raised passage that meandered through the middle of the wet lands. They rested for a few minutes after the tough walk.

"You, ok?" He asked Cole.

"I'll make it."

Soon Casey stood to get his bearings and spotted the Marsh Grass Motel only several hundred yards north up the pavement. Once again, they were up on their feet walking in the ditch following the road. Looking for the best place to cross without any detection from passersby. It wasn't long before they found a good spot to cross, almost directly across from the motel. They could see a small path at the end of the fence, probably worn from the local school kids crossing the road there to get to the burger hut up a short piece. Casey waited for a couple of cars to pass before they made their run for it. After getting to the other side, he struggled with the bags containing the cash and guns. It was becoming harder and harder to carry the bags and assist his limping partner.

The two managed to make it into the parking lot of the motel before collapsing onto a curb to rest for a minute. After catching his breath Casey headed for the front office to pay for a room. He was glad to see the front desk lobby was closed for the night and he would have to use the night window. After all it would be hard to not stare at his pants soaked up to the nuts and sopping wet boots tracking that aromatic bayou mud across the carpet in the front lobby.

By now it was midnight and the clerk would have to be summoned by the buzzer at the window, as he could not see anyone through the glass.

A short time after ringing the bell, a small framed man appeared in the window. He wore a shirt and tie that did not match and a pair of brown pants to boot. The black horn rims on his nose were cracked and held together with a piece of white surgical tape, dirty from age. His hair a bit messy from a recent nap. The name tag pinned to his pale shirt was crooked and the letters on the label maker tape was faded. The name on the raised letters spelled Delbert. He opened the small window and asked if he could help, as he looked up and down Casey. Imagining only what he had been involved in this evening. Casey explained that he needed a room for the night and laid the cash on the little Formica ledge, and slid it towards the clerk. Delbert reached for the money but Casey held onto it for a couple of more seconds to force eye contact.

"There's a little extra for you there, and you have not seen us, ok?"

"Yea, no problem," he replied. "I haven't seen you, I got it." as he pulled the money from Casey's grip.

He handed him the room key and said "room 109, it's around back in the corner all the way to the end."

Delbert looked at the money seeing that there was an extra two hundred-dollars. He asked if Casey needed a hand with getting Cole to the room or could he manage.

Casey said "We'll be ok."

He turned and headed over to where Cole sat on the curb. Casey noticed that Delbert had made his way outside in no time flat and began to assist him with lifting Cole from the ground. He was tired and did not refuse the help. The three walked slowly to the rear of the motel and down to room 109. Casey put the key into the door turning it and pushing it open with his left foot. They helped Cole to the bed closest to the bathroom setting him down on the end. He dropped the bags between the beds and sat down to rest.

"Can I get you guy's anything else?" said Delbert.

"No, but thanks for the hand," said Casey.

"Well ok then I better get back to the desk before someone misses me," he said as he pulled the door closed hearing the latch click as it met the jamb.

After a few moments of rest Casey helped Cole to the shower to clean him up from the day's events in the swamp. Cole undressed and Casey helped him into the tub, he sat down, grabbed a bar of soap as Casey turned on the shower. Soon after he sat dressed in the clean clothes, he had wished for all day long. Casey began to bandage Cole's leg using two wooden hangers he pulled down from the closet bar. It would have to do for now. He used them to make a splint on Cole's leg. He added strips of sheet he had torn up from one of the beds. It would be better than the sticks from the earlier splint thrown together in the swamp.

"OK my turn to get cleaned up," said Casey as he headed for the bathroom thinking how long the day had been, and how bad he needed the rest soon to be gotten.

Clearwater, Florida

Maveric stood in the door way waiting patiently for the rest of the agents to muster in the briefing room. The others were making their way down the hall with no apparent excitement in the recent knowledge of the upcoming raid. Maveric sipped his coffee and pursed his lips while he waited, watching the sluggish bunch drag their feet. It was a day he had worked so hard to get to. The years of undercover work had taken its toll on him in the usual way. Making him appear older, more hardened and exhausted. But he was running on adrenalin, knowing that he would head the raid that would probably bring down as many as sixty or seventy people. Some being of high profiles in the small communities of North Florida. The last agent filed in the room pulling the door closed behind him, smiling at Maveric as he walked past him at the doors edge.

All the major law enforcement heads were present, ATF, DEA, and FDLE.

This was to bring the ATF and the DEA up to speed on the raid as to avoid interference, or accidental cross fire from other agencies in the field. Maveric wanted this raid to go off without a hitch. The last thing he needed was one more shot up agent, his or anyone else's for that matter.

Maveric started the briefing explaining their objective was to arrest the list of people he was passing out to each person on the front row. The list showed a family tree of sorts. It identified all involved starting from the king pin, to the lowest men on the pole. It was a complex web of leaders, to workers compiled over the years, seven in all. It covered the entire southeastern United States. These were big players and Maveric knew they were not

going down without a fight. He explained the history of the group and went on to note specific details of the primary players, including their general day to day habits, naming favorite restaurants, bars, and so on. After a good half hour of details, he stopped for questions from the agents involved. Answering them as best as he could and then continued on with the layout of the raid to take place in the early hours of the morning in only four days. They would hit the unsuspecting bunch on Saturday morning while they slept. They would never expect another raid so soon after the last, only taking place a month or so ago. That was the one that haunted Maveric. One of his agents was put out of commission in the shoot-out down at the beach house while trying to apprehend Cole, and Casey. They had narrowly escaped the attempt.

This raid would take place simultaneously at the major players homes first.

Somewhere Over the Ruby Mountains of Nevada

It had been some three hours or so since Me and Lucie had left the small air field of Challis. A beautiful country side with the Salmon River bordering its edge. This time of year, the river was partly frozen on its edges and the hillsides were blanketed with a deep layer of fresh snow. As pretty as it was, I thought how glad I was to leave it behind. Now its purity was tainted with the memory of the recent events. I knew I could never visit this place again. What the hell I didn't like cold weather anyway. Where I was going was warm, sun shining, and sandy beaches for miles. There would be drinks with umbrellas, people with tans. I would become another statistic in the files of the expatriated Americans.

It was now about Eleven-Thirty the warm sun beat on the wind screen, it seemed brighter at this high of an altitude. The

visibility was twenty-five miles, clear as a bell. I loved it up here it was my escape from the rest of the world, and sometimes myself, or maybe my self-inflicted pain below. Whatever the reason it was a great place to be. Lucie quietly read her book; both of her feet propped up on the dash panel with the seat pushed back as far as it would go. I looked at her wondering how would she go on without me. Would she remarry, and have the kids we never did. I knew this was the only way to get out clean without any chance of being tracked down. I could have no possible connection to my past, family or friends. It had to be a clean break. I tried to change what I was thinking about by looking at the chart and figuring the fuel consumption. Lucie laid down her book and stretched her arms. She unbuckled and stood up asking Me if I would like a cold soda. She had temporarily forgotten about the passenger in the back and was briefly startled when she looked in the rear of the plane. She could see the black plastic sticking out from under the corner of the blanket that covered the large hump in the rear cargo area. It made her shiver a bit as she reached for the sodas but she quickly got over it and closed the lid to the cooler. Passing the cold coke to me, she smiled when we made eye contact. It was the smile I cherished so. She sat back down in the right seat and put her headset back on.

She put the mic close to her lips and with the crisp popping of the audio, asked "how much longer before we made Parker?"

I responded saying, "about an hour and a half, tops."

I asked "how's our passenger?" and chuckled a bit when Lucie rolled her eyes at me and launched into the story. Talking about how she had forgotten about it. Shortly after the few laugh's things were quite again between the two of us. Lucie went back to her book and me to my task of flying the airplane.

I had begun a slow descent from eleven thousand feet over the last twenty minutes or so to about six thousand. I was headed for the Colorado River basin. I liked to fly low over it through the Needles area to the Topock Gorge.

It's a beautiful thing I thought to myself, how the turquoise water meandered through the green plush slopes of the valley, that abruptly turned into shear rock walls hundreds of feet high. I continued the descent until I had the valley in sight. Passing just over the last peak of the mountains that backed the Indian reservation, I pushed the nose over and dived towards the riverbed. Lucie looked at me as she always did when I would make moves or turns of more than a few degrees. The large engines increased in rpm as the plane headed for the earth. Airspeed increasing, I carefully watched for any oddities in the instruments, and the attitude of the plane. Keeping it in the safe range of speed I began to pull back on the yoke to level off at a predetermined altitude not far above the water. The windscreen began to fill with the brilliant shades of the valley, doubling in size every several seconds, until we leveled off and banked right to line up with the river itself.

"Won't be long now!" I said smiling with excitement as I gripped the yoke.

The large engines roared as the twin Commander ripped the air only feet above the turbulent river. Few boats were on the river this late in the year so I knew I could get away with the unusually low pass without chancing a complaint to the FAA., As if I gave a shit.

Lucie began to get a bit anxious with the low flight at such a speed. She was also feeling the excitement of seeing her father. She loved him so and wanted to be with him in this troublesome time after his recent arrest. She knew deep inside he would have to leave the country as all of his get out of jail free cards were used up. She could count on her father unlike Remy who rarely

shared his thoughts of it at all, the last bust, why the strange goodbye at Nate's, why was it really necessary to have the dead body in the plane with them and many other unanswered questions. It didn't change her love for him, but she felt deep inside that it somehow would change their future together.

I saw Lucie squirming in the seat so I pulled up and leveled off at five hundred feet without a word.

She smiled and said "thanks." looking at me with her large brown eyes I so admired.

Only moments had past when the left engine began to lose rpm. I looked at the fuel gauges in comparison only to see that the fuel pressure was quickly diminishing. The plane began to dip left and lose altitude as the slower rpm was working as a plow on the left. I began to feather the prop and shut down the left engine. We were now only four hundred feet above the river basin and running on one. I plan to try and make it to the Parker air strip and avoid any explanation to any lawman, especially with my various cargos onboard. I decided to keep it over the lake until we reached the end. Then over the dam, crossing Buckskin state Park at big Bend and following the river to the approach of runway One Nine. I managed to keep control of the old girl applying right rudder to correct its yaw from the left engines drag. I knew I had enough altitude to clear the power lines at the end of the lake. the dam was in sight now, just avoid the small peak just southeast. Lucie asked if she could do anything to help me.

I only responded with, "watch for other traffic around the lake." as I was pretty busy flying the plane.

We continued across the lake and across the dam. Thought that the loss of the left engine was due to a failed fuel pump. I

pulled back on the yoke, though a bit mushy and slow to respond the plane began to climb. Not to stall the underpowered machine I pushed it back slightly, watching the air speed. Lucie kept scanning the sky line and only spotted one small plane off to the west, towards the Needles airport on a somewhat northerly heading, and well above us by five hundred feet or so. I began a right bank, careful not to dip the wing tip of the crippled bird and roll to a fiery death into the rocky hillside below. Leveling off as we crossed Big Bend, following the river now over Parker Strip, we could see the airfield straight ahead. I called for clearance to land, advising of our status. I was given immediate clearance and the controller held any other traffic that was inbound from other directions, what little there may be. We headed just north of Blue Water and started the last turn left, very gradual as not to dip the unpowered wing. We lined up with the runway on a long final approach. Dropping the gear and applying a little more power to compensate for the drag. I checked the air speed one more time for comfort. I'd never actually landed with one engine out and was scared to pull back on the power as much as usual, and rightly so. This changed some things. I knew that if once I got too slow, with the one engine out there was not enough time to get the airspeed back, and that could be disastrous. I decided to do a high-speed landing with no flaps. There was probably enough runway, but if not, it was only gravel and sand for another two hundred feet beyond. The plane sank slowly as we reached the approach end of the field. I corrected the yaw a slight bit just before we touched down. The plane floated for some time as it was only inches from the runway and was feeling the ground effects at such a high landing speed. Chopping the throttle to idle, the bird softly chirped the tires and then the nose gear softly made contact with the ground. And then everything changed in the cockpit, it was now time to focus on the high-speed roll, and the short amount of runway left in front of us. I began to apply the toe brake as I diligently feathered both props to drag in the wind, we needed all the help we could get and quick. I felt we

had slowed enough to begin applying the flaps for a little extra drag, but not too quick it could cause the plane to nose over and become hard to steer, after all I was already fighting the odd drag on the left side.

Finally, the plane began to slow enough to tell it would have a little runway to spare. It slowed to a speed that was now controllable with the nose gear.

Bringing it to a complete stop at the last turn out before the runway turned into desert, I looked at Lucie with relief.

Smiling I said, " Welcome to Parker Arizona Ma'am."

And then throttled up and headed back to the small terminal building where Lucie spotted her Daddy. He was standing at the fence line near the tie downs. It made her smile from ear to ear. I pulled up to the nearest spot available and shut down the tired engine.

20.

Hot Bonanza

Lucedale Mississippi

Casey turned the door knob of the motel and pushed it open with his foot, balancing the coffees with his hands and a little help from his chin. Cole had managed to get himself dressed since He had left, and now was sitting in one of the two arm chairs on either side of the round laminate table that mounted to the floor. He sat with his boots off, in a bit of a daze enjoying the shag under his water cracked feet, pulling at it occasionally with his toes. Cole was tired to say the least. The question, was it tired from running or tired of running. He tossed it around in his mind once again as he sipped the hot coffee Casey had sat in front of him. He didn't say anything, he didn't have to, it was more than obvious and had become so in the past few years. Casey knew that Cole was slowly losing his fight, his will, and his love for the run, the being on the lamb. It was more apparent this morning than it had ever been since he had known him for the last thirty years. Casey sat across from him and just stared into the blankness of his face. He was saddened by what he was witnessing and felt lost for the first time in his life. Cole had been there for him all that time... but now it seemed he had slipped away somehow. Casey knew it was now time for him to be there

for Cole.... and he would. Maybe if he got him heeled up, he would be like the neighborhood Tom Cat, back on his feet again and back to his old self. Well, that was his plan for now anyway. Not many words were exchanged for the next half hour or so as the two sat and reflected. The time soon came for their departure via whatever airplane that wasn't securely chained down and was out of the site of the cafe, and general traffic. Casey made sure they didn't leave anything behind as Cole managed to put on two socks and one boot, tossing the other in his bag with the cash and guns. Cole was managing to get around fair with the cane that Delbert had left by the door in the night. The break in his leg was surely not a compound fracture, but still it hurt like hell he thought. Casey threw the baggage straps over his shoulder while Cole started his slow journey across the parking lot heading for the gap in the fence. Casey pulled several hundred dollars out of the cash bag and left it for Delbert under the phone. He called the desk to thank him and to let him know that he should stop by before the maid to pick up a little something more they'd left. He then pulled the door closed behind him, leaving the key inside. He turned to see that Cole had a pretty good lead on him for a fucking cripple. He was nearly to the edge of the gravel trail that led to the airport, an obvious path beaten by recent visitors too lazy to go around the end of the fence near the highway. It wasn't long though before He caught Cole. The two exchanged a few humorous words about their situation and Casey continued ahead to ready the plane for takeoff. He was careful to pick a nice-looking Bonanza on the corner nearest them to limit their exposure from the cafe occupants of the morning. He watched in the direction of the tower as he moved across the tarmac towards the plane. The V-tail was a beauty with its tall cabin, three blade chrome prop, and tall landing gear. He was quick to pull the wheel chocks and remove the tie-downs. Casey could hear Cole mumbling something in the background as he popped the passenger door open, staying on the opposite side to shield them from the tower. Casey quickly tossed in the bags he had set

down, and stepped up on the wing to enter the cockpit. Cole wasn't far behind; he was soon crawling up the wing while Casey done the pre-flight. He had to bypass the key switch being he had no key under the circumstances.

He reached over and assisted Cole into the cockpit with his right hand and then started the engine with the lose wires hanging from under the console. Casey had put on his headset he had brought with him; it was about all that was left from their recent venture in the swamps yesterday. Cole pulled the door closed but didn't latch it yet. Then he pulled the other pair of headsets from around the right yoke that Casey had hung there for him. Casey called the tower requesting clearance for taxi calling his tail number, 3 8 Poppa. The tower promptly responded advising him to taxi to the south end of the runway, and advising him to let him know when he was ready to go. There was one ahead of him and a 172 Cessna on final. He repeated his direction finishing with the tail numbers and call letter. He could feel his heart beating above normal rhythm as a bead of sweat rolled down his forehead towards his nose. All hopes were that the person manning the tower today didn't know where the real owner of the Bonanza was this morning… everybody knows everything in a small town. Cole seemed to be in good spirits for his condition as he made note of the pilots perspiring and dampening brow. Chuckling and referring to a past experience in the Bahamas of them being in a similar situation. They taxied and held for clearance, to depart. The controller advised the landing Cessna to depart the runway at Charlie, and then cleared 3 8 Poppa for takeoff.

He acknowledged the transmission and began the roll onto the runway and pushed the throttle to full. The Bonanza came to life as its large engine rumble the cabin and built speed aggressively as it began the repetitive bounce. Casey checked the instruments and put his eyes back on the runway. Soon Lucedale Mississippi was just a memory, and likely nothing more. The tower told them good day and to contact Sotex for further

instructions. Casey said good day and banked left heading for the western sky were the next step of their escape and their rendezvous awaited them. They climbed out to four thousand, cleaned up the trim and set the auto pilot for a heading of 270 due west for El Paso, their next fuel stop, before they could make Parker Arizona. For now, the sun, the law and their past were over their shoulder. It appeared to be a clear blue sky in their face... or so they thought.

Tampa, Florida

Agent Maveric gathered his things as quickly as possible, as the chopper waited for him on the helipad at the Tallahassee headquarters of the FDLE. He had confirmed a sighting of Bushard Remington and Cole McCabe just outside of Biloxi Mississippi. He grabbed his Colt and shoved it in his shoulder holster, then turned towards the door picking up his coat off of the metal gray chair arm and headed out for the pad. Two other agents, Jones a big lanky guy with horn rims and Jackson a stocky man in his mid-thirties with a hardened look, his face weathered from the Florida sunshine. Jackson insisted on wearing shorts all of the time with hiking boots and a button-down safari shirt. He wore a double shoulder holster with a pair of cold steel .357 Magnums with black Pachmayr grips. He was proud of the pair, they once belonged to his father a retired agent from the force in the very same division. Jones was the keep to himself type with Jewish nose to hold up the glasses and always a tooth pick in the corner of his mouth. Blue Jeans and Khaki shirts were a trademark. Jones favored the M-16 and a large snub nose revolver. The men came from different directions but met at the pad. Jones was first and opened the door in the back, shoving his rifle in first, he climbed in hunched over more than the normal frame due to his height. Maveric opened the front door, threw his case of files and the latest pictures in and onto the front right seat.

The pilot reached over and pulled the case off the seat clearing it for the agent as he stepped up onto the rail and swung in. Jackson was only seconds behind and the pilot run it up for takeoff as they strapped their belts. The chopper was quickly airborne leaving behind only a trace of its recent presence with the whipping wind against the tall stems of the seed grass that lined the edge of the concrete helipad. Soon the bird was out of sight and sound, heading west down the panhandle.

Parker, Arizona

I sat out front on the picnic table bench while Lucie and her dad caught up inside for a while. It wasn't that I didn't want to visit but I was waiting for the arrival of an acquaintance that would help put the last piece of the plan in place. Only moments passed before an old Mexican rolled up in a Dodge pickup. It was brown, rusty brown with mud flaps and large rear tires. The truck was older but well maintained. The interior looked a lot like a disco, curtains in the rear window with dingle balls lining the perimeter of the cab. The dark-skinned man stepped out and said hello in Spanish and then began speaking perfect English. One would never expect it from his appearance. He looked to be from the deep heart of Mexico, but obviously spent much time working on his languages. His name was Julio Hernandez, from Mexico City, Mexico. He would help us blend with the natives when we reached Sonora for the first stop. The plan was coming together. I put my hand out and greeted him with a big smile, "Ola' amigo" he said as we shook hands.

"Glad to see you Julio, buddy," I said.

"Same here," he replied.

Julio went on to ask how the plane was, how much room for the cargo, and a few other details. We talked a while outside and

moved inside where Lucie and Clance were catching up. I introduced everyone and made a few Jack and Cokes to toast the newly formed friendship with the family. Now if only Cole and Casey could get here unscathed.

El Paso, Texas

Casey pulled the Bonanza next to the fuel tanker and shut the engine down. Cole pushed the door open to the feeling of the fall breeze and brisk winds from the desert town. Casey rubbed his eyes and removed his headset hanging them on the yoke as he peered through the left window looking for anyone who may help them with the refueling. But only seen the gust of wind tumbling the weeds against the chain link fence that divided the planes from the public access. The sky was pale and the deserts burnt oranges faded to light browns. Cole managed to get himself out of the seat and slid down onto the wing and then the ground. He needed to take a piss and began his hobble with the cane to the cafe only a rocks-throw away. Casey stepped out onto the wing and stretched again, raising his arms over and behind his head. he now had noticed a young man heading his way, and he was exchanging words with Cole without missing a beat in his pace.

The young man asked, "can I help you?"

Casey replied, "fill'er up with one hundred, I gotta get a weather bulletin."

The young man went right to it. Casey headed for the public access bulletin room just right of the cafe. Cole passed him inside the corridor coming out of the restroom heading into the cafe.

"Let's eat," he said.

"Yea, let me check the weather first," Casey said, and continued walking.

"Meet you inside the Café," Cole said.

Cole slowly made his way to the nearest table beside the window so he could look out at the plane while there was someone near it. After all there was a lot of cash and guns on board.

Casey checked the weather and found that it was going to get a bit better as they moved west. They had seven hundred and fifty miles left. Three and a half hours if all went well... it never did. There was a front moving across northern New Mexico in the late evening. if they were to get moving, they could probably miss it, they may have to deviate a bit south, but what the hell it beat setting still.

He joined Cole in the cafe and filled him in.

"How's the leg?" he asked.

"Ok, long as I keep the valium level up in the old blood stream," Cole replied.

"Hang in there, looks like we can make Parker by nine or so, if we get moving, maybe sooner." said Casey.

A waitress came to their table, she carried two ice teas, with lemon on the edge. She was for sure Indian, long dark hair, weathered face, and heavy set. They placed their order for cheese burgers and fries. Casey shortly after, stood up from the table.

"I'll go call, and let Clance know how far out we are. He's probably wandering since we haven't called in a while. I'd like to know if Remy and Lucie made it yet anyway. They should have arrived yesterday I think," he said as he walked away from the

table.

Cole sat quietly as he watched the fellow fueling the plane through the large window talking to someone that was walking across the tarmac. In the background the sky was darkening with the setting of the sun and the building of the anticipated storm. Casey was standing at the pay phone barely in his sight through the end of the large pane of glass dividing him and the elements. The wind had picked up since they had landed, it was now blowing hard enough to erect the faded orange wind sock occasionally. Cole sipped his ice tea as he peered out the window in the red cedar slat wall.

Casey was only a moment and then he headed back to the cafe. The order was just arriving as he made it back to the table. He sat down and rejoined Cole, picking up his tea glass, nearly drinking it in one tilt.

"Well, they made it," Casey said.

"All the cargo get picked up?" asked Cole.

" Yea, they got it."

Casey picked up his burger and took a bite, reliving the phone call and eating between comments. The two of them finished their dinner, Casey paid the bill and Cole headed for the plane. The wind was blowing steadier now as Cole leaned on the cane into the wind. The fuel truck driver met him at the right side of the plane and told him how much they owed. The young man was kind enough to help Cole back into the right seat. He then waited for Cole to reach in the back for some cash to pay him, making small talk about the weather and asking where they were headed. Cole answered him with a bogus destination as he handed him a Hundred-dollar bill, and told him to keep the change. The young man seemed pleased with the twelve-dollar tip as he thanked him smiling as he pushed the door closed.

Casey had managed to get to the plane shortly after and climbing across Cole, holding a couple of bottles of soda to put in the cooler in the back seat. He made himself comfortable in the left seat and put his headset on, and adjusted the mic.

He reviewed a chart and planned his route around the prevailing weather by the blood red cockpit light in the evening twilight. He thought to himself how they had only Seven Hundred and Fifty nautical miles to go, about three and a half hours. That would put them in Parker about nine thirty or so. Good he thought, the desert wind will have died down by then. This would make for an easy landing in the dark, one less thing to worry about on approach, it eased his mind as he hit the starter and brought the large engine to life. Soon they were rolling down the runway under full power and all lights lit. The bird lifted away into the dark southwestern sky bucking a bit of a breeze, but soon to be smooth sailing as He banked south towards the Mexico border.

Biloxi, Mississippi

The rotor blades of the helicopter kicked up a flurry of dust as it settled on the tarmac of the small dirt strip airport. Agent Maveric popped the door, his feet nearly hit the ground at the same time as the chopper. He walked briskly in the direction of the Sheriff standing beside his patrol car, one hand on his hat and his eyes squinted protecting them from the dust. The other hand out stretched in preparation for the anticipated hand shake. The agent shook hands with the Sheriff, and they exchanged names at the informal meeting. The helicopter was winding down and the audible was now to a point the two could speak without yelling over the whine of the engine.

"They shot up one of my cars," the Sheriff said.

"Did anyone of your men get hit?" asked Maveric.

"No, he was able to take cover in time, but I believe my man landed a shot in the plane," said the Sheriff.

Maveric said "Yea, I think your man done enough damage to it, that it had to be put down in the cypress swamp between here and Lucedale. We got word from Division two out of Panama City Beach, that they were spotted refueling and we were able to get a bird airborne to track them for a while. Then we lost them so we called Biloxi Police Dept. to see if they could get a make on their direction based on our tail. Apparently, they managed to pick them up just shortly after they shot it up here with your man. But then they lost them in the swamp flying low. Now we think they went down in the swamp yesterday afternoon. The P.D. called and said they've spotted a crash site in the deep brush about twenty miles Northeast of Lucedale, but it could be an old site they stumbled on to, and the only way to tell is go in by skiff, or drop in from the air."

"You fellows going in tonight"? asked the Sheriff.

"No, we'll wait till first light, it's too dangerous at night." Maveric said.

"Where can we bed down for the night?" He asked.

"There's a small motel just around the corner here down from this strip," said the Sheriff. "Jump in and I'll give you boy's a ride."

"Sounds good" said Maveric as he motions for the pilot.

The County Sheriff car pulled away leaving the lone chopper on the tarmac for the evening.

The Sheriff, in good southern nature took the agents to dinner at the local diner, a place for all black-eyed peas and cornbread lovers. They all had large helpings among other home cooked delicacies, and lots of ice tea to boot.

The sun sat in the western picture frame diner window as Maveric thought of how they would do it all over again tomorrow.

Parker Arizona

I was pleased to hear from Casey. I now knew it was just a matter of time to permanent freedom. It would only be hours before they arrived and in the meantime Me and Julio could complete the final details. We could set up the scene and make it obvious that we were in town and soon to leave.

It was now around seven-thirty pm. as we drove through the small town, following the river road on the Arizona side. Looking occasionally over to California, thinking of how close the last western state really was. The opposing roads came close together. It seemed as if we could reach out and touch the other side in some places, but the roads pulled away again like a cautious dolphin shadowing the bow of a boat, staying just out of its passenger's reach. I road shot gun as Julio quietly steered with one hand, hanging his arm on the door with the window down. The cool evening air swirled around in the cab of the truck. We listened to a song on the radio, it was without doubt fitting for the moment. It was so fitting that nothing was said only expressions were exchanged, each felt the same.

Julio pulled off the road in front of the café, just a short piece from the entrance to the airport gate. We both got out to make a showing here, it would be important to our plan later to confirm our whereabouts. I opened the old lime green, raised panel door

of the cafe. It had a small cracked window in the upper half, the crack continued from the bottom right corner to the top left in a sort of silver arc. A curtain covered one edge.

We moved on inside and made ourselves at home at a corner booth near a window and away from the door. The red Naugahyde fluttered and squeaked as I sat down. The waitress was soon over to take our order. Julio struck up a conversation with her. He told her a friend said she could help us with our plan. She told him to go on with what he was saying. I picked up at this point and told her that we only needed her to take pictures of us getting on the plane tomorrow, and to take a roll of film of other planes. This would make it appear that she had an interest in airplanes and would have only coincidentally have gotten them in one of the shots. It would also be important to make her presents known to a few employees at the airport. This way when the feds came looking for information, they could be led to her for the pictures and her statement. It was a crucial part of the plan because she would be the last person to see us... alive.

I went on to say that it would be worth five thousand dollars cash if she would do it.

"The names Stella," she said with a smile, "and it would be a pleasure."

We placed our order with her and folded the menus putting them back in the rack, a metal wire circular shaped deal. It was obvious that it was from the fifties. Stella brought the glasses of ice tea, with a rather large smile. Me and Julio spoke a bit about the trip tomorrow evening. Julio was interested in the weather as it was looking a little rough from the evening news playing on the small black and white. It sat on the end of the counter near our table in the dining room. There was a sizable front moving through northern New Mexico currently, and a larger one right behind it threatening to arrive by tomorrow night late. Weather was not something we needed; it was bad enough with the other

things we would have to contend with. We surely didn't need bad weather. I told Julio not to worry, we would be ahead of the front and that it may actually help to cover our trail. After all we were trying to disappear for a while and elude the feds. It may make for a better cover for the plane to hit bad weather and be forced down. It would appear more suspicious for a perfectly good plane to go down in clear weather.

We finished our dinner and had coffee. Stella joined us on her break and discussed quietly the details of the plan. After finishing, she stood up and swiped an envelope from the table discreetly as she cleaned up, sticking it in her top.

We finished our Joe and bid farewell as we headed for the door.

Back in the truck and off we were for the airport to load the plane and check on our frozen friend, hoping he had not thawed much in the cool weather of the Fall season. Julio drove through the gate and onto the tarmac to the end. It was a bit of a ways from the gate, away from normal traffic, and curious eyes. I looked over the window covers to make sure that they all were secure. They appeared to be just as I had left them. I was a bit relieved, the sinking filling in the pit of my stomach slowly disappeared. After the inspection I opened the cargo door and made sure the stiff was still there, He was. And He had begun to thaw, there was a small puddle of water on the floor. I dried it up with an old oily towel that I kept behind one of the back seats. Then spreading it out on the spot where the water had previously dripped, attempting to catch what was to come.

Julio began to unload the coils of wire for the short-wave radio, the large bag of quarters, and then the dirt bike. We would need this to trace us to the plane by paper trail. I laughed, and me and Julio joked about the bike being the only thing I'd had ever bought on a credit card, and here we were going to destroy it, and how it would probably ruin my credit.

We loaded some canned foods, sodas, and bottles of water as well.

Our job was done for now, all we could do was sit and wait for Casey and Cole, and that should only be about an hour and a half now. So, we headed back to the bar for a couple of beers to kill the time and ease the pain of anticipation.

Painted Rock Res. Arizona

Casey had flown a Northwest heading since they had left the border around Tombstone. With only an hour to go he was feeling a bit of excitement, thinking they had foiled the plans of the long arm. Just a little longer and it would be margaritas, Senoritas, warm sunshine, and aqua blue seas rolling against the brilliant white sand. Cole was feeling ok for a man with a broken leg on valium. He rambled on a bit about how he loved Mexico. He spoke of his plans for the beach house he planned to build and how he would find himself a young well built, Spanish lady. He went on about how he would shave his signature beard making his face as smooth as Robert Redford's. He planned to wear shorts and Hawaiian shirts for the rest of his life, and sandals when he went to town in the evening for dinner and drinks with his new lady. Oh, how he imagined it all. Casey added a few comments about how he would only be just down the beach, and building his hut with a revolving door for all the young pretty senoritas to come and go. Casey didn't like the thought of commitment beyond how he made his money, that was the only one he'd ever make.

Checking his heading one more time and calculated the location, he used the charts to figure the time they'd left El Paso. They seemed to be on course as he had determined earlier.

21.

Bad Men in a Bad Bar

Parker, Arizona

Me and Julio sat quietly at the bar having a cold beer and a shot of tequila. We were killing the time as we patiently but anxiously waited for our comrades to arrive later in the evening. Julio had noticed an odd-looking man across the bar, one he'd never seen before in the small river town. He knew everyone for the most part, but had never seen this fellow, and was a bit suspicious of him. Especially this close to our departure. The bar was dim lit and a few people meandered near the balcony exit on this silent night. The juke box was turned down lower than normal it seemed, as *"Black Beauty"* played below the few conversations being held around the bar. The stranger sat across from us and just to our left at the large horse shoe. The ceiling fan swirled the smoke from his filter-less Camel into an almost vortex column as it rose. He peered over his thick lens glasses that covered the better part of his tan face as he sipped on the bourbon.

I was taking most things in stride lately, and was less concerned about the new visitor; how could he possibly affect my future as long as he kept to himself and didn't bother us? There would be no harm. After all we would be long gone in twenty-

four hours anyway. The most I made of the whole thing was how out of place the man was with the plain white long sleeve shirt and black tie in a bar like *'Foxx's by the Water'*. But Julio made much more of it. It was becoming more apparent that he wanted something with us. But what could it be, we had never seen him before? Could it be a mad dealer from one of our pasts, someone who had been shorted on a pay off. Who knew, but Julio was determined to put the uncertainty to rest once and for all, he was going to talk to the guy to find out what business he had in this one-horse town.

He slowly walked around the bar with a sweaty beer bottle in one hand and a Cuban in the other. The stranger paid no attention to his movement towards him as he quietly sipped from the short bourbon glass that dripped it's sweat with each tilt. The three cubes of ice nearly gone now. I watched in amazement as Julio made his way around the end of the bar. I could feel that he was about to pull his pistol, as he put the cigar in his teeth, gripping it tightly. I stood up and quickly followed behind him, trying to catch him before he drew the gun. Julio gripped the pearl handles under his shirt tail, continuing towards the man. I had nearly caught him by now and was calling his name repeatedly, walking briskly as I knew I only had a few seconds before the ruckus broke out. I was too late. I watched as Julio pulled the .357 out and pressed it to the man's temple. The man didn't even flinch. Julio watched him take another sip of the bourbon, A bead of water fell from the bourbon tumbler in slow motion and was heard all over the bar when it hit the shiny lacquer surface.

I reached up and wrapped my left hand around the gun and slowly pulled it down, putting my other on the man's shoulder and whispered… "sorry".

Julio was stunned from the lack of reaction from the stranger. Both he and I slowly turned and headed for the door. The juke box was quiet, not a word was spoken from the

bartender, or anyone else. The sound of the cowboy boots was nearly deafening, as we walked across the bar's hardwood floor and into the darkness of a quite night.

I drove to the airport in the old brown Dodge as he sat silently in the passenger's seat. It was about ten o'clock now and it was much cooler than our earlier ride. The windows were rolled up and the heater blasted the floor board of the truck. He told me that he was sorry for the display of ignorance and stupidity back at the bar. But he was certain this guy was trouble for us.

I just said, "don't worry about it." and continued down the river road towards the airport, passing the cafe we'd eaten at earlier.

Shortly after we turned right onto the airport road and slowly progressed to the gate at the far end where the plane sat, I stopped outside of the fence and killed the engine. It was very quiet, I noticed as we sat. I cracked my window and zipped the wool lined brown flight jacket that Lucie had bought me recently for my Twenty-first birthday.

We sat quietly as we stared through the wind shield looking for the landing lights of Casey and Cole McCabe. It wasn't more than ten minutes before the twinkle of light broke the darkness in the direction of the approach end of the air strip.

I got out of the truck and walked around the back end, leaning over the side with my arms crossed, I peered down the runway watching the approaching planes light grow larger by the second. Julio sat in the truck and smoked a cigarette pulling the air threw the hand rolled Prince Albert, till the end glowed a brilliant orange. He then held his breath for a moment and exhaled a long plume of smoke into the night. The plane touched down and rolled out to the end of the runway where we waited. It was a Bonanza V tail, I didn't recognize it as one that Casey or

Cole had flown before, and rightly so since they had borrowed it
back in Lucedale a couple of days earlier, I later found out. He
killed the engine as the craft came to a stop. The door popped
open and Cole yelled for me to come and help him out. I quickly
ran to his assistance, climbing on the trailing edge and pulling the
door open in it full swing. Casey jumped down from the wing
and let out a yelp.

"Yea, it's almost miller time!"

Cole and I had managed to get out, we were sitting on the
wing as Casey slid down to greet Me and Julio.

"Well, it's about time you got here," I yelled. " I thought
there was gonna be a killing before you got here," I went on."
Old Julio here got a little cross threaded with one of the patrons
at ' *Foxx's*,' the man looked at us or something, I guess."

"I don't wanta even here about it," said Casey. "We been
chased, shot at and missed, shot at and hit, crash landed in the
swamp, Cole broke his fuckin' leg, and on top of all that, we
were charged too much for fuel in El Paso!"

Soon they could hear a vehicle turn in on the airport road. It
would be only a few seconds before Clance's head lights would
appear in the distance. The group of guys quickly gather their
things and tied and lock down the airplane.

I took a look at our passenger on the Aero Commander to see
how he was keeping. The puddle that had begun earlier on the
pavement that day was masked by the light evening shower on
this end of town, removing any question of what might be the
cause.

Clance rolled up and stop the vehicle, opened the door and
stepped out to join the bunch. He had a few words with Cole and
Casey and told Julio and me to help Cole into his truck. Casey

walked around and climbed in on the passenger's side, closing the door behind. Clance climbed into the driver's seat and started the engine. He told us he would see us back at the trailer, and drove slowly away as I headed for the Dodge. Julio followed behind. I started the brown truck and fell in, following close, the tail lights glimmering in the mirroring puddles on the wet pavement interrupted only by the ripples of the night breeze.

A half an hour later both vehicles rolled up in the drive of the mobile home. Everyone was tired from the day's events and most wanted to retire, with the exception of Casey. He had always been a diehard and love to party till the morning come. Retiring was not on his mind at the moment. Julio struck up a conversation in an attempt to bond with Casey, so to speak as they had never met until earlier this evening. He figured they best get to know one another since they were running from the same law. Still a little spooked from the happenings at the lounge, Julio just couldn't shake the feeling that the man was up to no good on their account.

There were some big hugs exchanged between the boys and Lucie. She was excited to see them, and told Cole so as the local doctor in town was setting his leg in the living room of the trailer while he sipped a Jack on ice. It soothed the pain. Clance said his good nights to all and headed for the back room. I had a couple and wasn't far behind.

I had a few last-minute things to handle in the morning before the flight to freedom. The rest of the bunch would sleep in as usual and rise late for breakfast rubbing their eyes and nursing their heads. I needed to call the weather bureau for the forecast for tomorrow before I turned in, as the weather appeared to be getting slightly worse in the direction of Albuquerque. Hoping it would hold to the north, as we were planning our escapade around the border near El Paso Texas. I would wait till morning to contact my uncle EJ who was already in hiding in central Mexico, he would play a part in the plan.

22.

Cold Mississippi Morning

Biloxi, Mississippi

The morning sun broke the cricket chirping darkness in a
split second, piercing the single paned window of the agent's
room. Rising with the same excitement this morning as he did
with every morning in the past twenty-five years on the force. He
thought more lately about what he might do with all the free time
on his hands, after his soon to be retirement. But not as much to
day as usual. He had to catch his man today. He rang the other
rooms of Jackson, Jones and Darwin the pilot to get them
moving, telling them to meet him in the cafe across the street for
breakfast. Quickly showering and dressing, he put on his
shoulder holster and made for the door. The cool November
morning caressed his face with it's opening. He walked across
the aggregate exposed surface of the two-lane road that ran North
and South through the west part of town. Being careful to dodge
the few early travelers on this sleepy Saturday morning. Noticing
the steaming exhaust as each one past, pushing a brisk breeze in
his face that chilled him in a way that he was almost paralyzed
with anticipation of the next. It played out like a childish game.
He laughed out loud after the third car passed. The barely frozen
ground crunched under his heavy frame of six feet three inches as
he stepped from the street to the muddy parking lot. It was

covered with small puddles from a recent rain. Making it to the door steps of the cafe he blew his warm breath into his hands, rubbing them together he reached for the weathered brass knob. It was ice cold to the touch. He held it until the burning sensation came before he could let go. The weathered gray painted door was pulled open to the smell of fresh brewed coffee and warm sourdough toast. The aromas filled the air as he stepped in out of the cold. The cafe had only six or eight tables and several counter stools, most were filled by the local counter rats carrying on about politics, baseball and the local jargon of fish tales and hunting lies.

Maveric went for the booth across the room in the corner. He hated to sit beside the door as it would chill him at each opening. He also like to keep his back away from the door and against the wall. It was a trait that he knew he shared with the men he hunted. The waitress brought a coffee cup and a pot full of coffee to the table and asked if he was alone today, or was he expecting company. He acknowledged the latter and she went for more cups setting his down first and filling it.

Moments later Jones opened the door, entered with a jump in his step from the cold morning, Jackson and Darwin fell in quickly behind. The waitress met them at the table with coffee pot in hand. The three worked their way into the u-shaped booth, Jackson started right off with the morning chit chat that he always did. Maveric was one cup up on the others and it didn't bother him as much, after all he was thinking about the case. The others began to chug the first cup and ignored Jackson's banter about the hockey game on the night before. Going on about how the old black and white with rabbit ears had snow on the screen for the better part of the game. The waitress broke into his story to ask if they were ready to order. Each gave their preference as she went around the table. Leaving the coffee pot in the middle, she headed to the kitchen.

The four agents finished their breakfast and gulped down

the remainder of the coffee. Maveric passed the bill to Jackson, telling him it was his turn to pay as he got up from the booth. Jackson could be heard from the door complaining to Darwin the pilot, with little success. Darwin nodded and smiled as he walked away. He met the rest of the crew out front. They stood and talked until Jackson joined them and entered the conversation Discussing the final details for the day, planning to fly out over the recent crash site to see if they could find any trace of the two fugitives.

The sheriff pulled up just as their discussion ended. Maveric had called him earlier to join them for breakfast and coffee but he was unable to make it. There was some last minute paper work to be completed for a booking from the evening before that he had to attend to first. Apparently, some old country boy had shot his brother in some argument over a game of cards.

"Morning," he said as he rolled the window down with the crank handle, leaving it half way up to shield the cold.

"Good morning to you Sheriff Pickings," said agent Maveric. "Did you get the family squabble resolved"? He asked.

Well, I don't know about it being resolved, but I definitely got it cooling off for a while anyway," he said.

"You boys need a ride to the strip?" he asked.

"That would be great," said Maveric.

"Well get your asses in and let's go, we got criminals out there to catch today," he said with a flat style toothpick hanging from the left corner of his grinning mouth.

The four men loaded into the car, and he quickly pulled away, spinning the icy cold mud against the pale green fenders of

the low riding back end of the 82 Impala. Warm exhaust bellowed from the tail pipe as they faded into the morning sunrise, crossing the double yellow lines to the opposite side of the street.

Darwin started the engine of the chopper after a thorough preflight check. There were two puffs of dark smoke and then it lit. The rotors began to spin slowly but persistently gaining momentum with the passing of each second. Maveric was reviewing the chart of the area and showing Darwin where he would like to begin the search based on the info, he'd gotten from sheriff Pickens the day before.

Jackson and Jones loaded their weapons as they waited for departure.

Darwin called for any traffic in the area on 121.9, getting no response from any other aircraft, he pulled on the collective easing the helicopter in to the air. The craft rotated into the direction of their heading and slowly nosed over, accelerating as it gained altitude. Darwin took it to about eight Hundred feet and leveled off into strait flight. They were only about ten minutes from the supposed crash site. Maveric sat quietly as they whizzed across the southern sky not very far above the unforgiving swamp. He noticed several gators laying at the edge of the high grass in a pond. It was at the edge of a small dirt road, fading into tall cypress trees that smothered this part of the world. He glanced at his watch and gathered the time to be almost eight o'clock, tracing his morning over in his mind. The coffee was having the same effect it always did.

Just as he said to Darwin, "We should be getting close," the large clearing appeared before them.

They immediately spotted the plane keeled over on its left side, and a bit nose down. They could see the door was open on the right side, and obviously no one to be found dead or alive.

The two had slipped away from Him again.

Maveric dropped his head in disgust and began to mumble to himself, "son of a bitch."

Darwin settled the chopper down into the clearing without touching down, he hovered in front of the plane. It was clear they were gone, and unnecessary for anyone to get wet up to their balls for nothing.

Jones was scanning the edge of the swamp line and saw where something had caused an indentation recently. Visible in the tall weeds and swamp grass that disappeared into the thick dense swamp in a southernly direction.

"There!" he said pointing it out to Maveric over his left shoulder. Darwin brought the nose around to put the topic of discussion into clear view through the windscreen.

"Good job Jones," Maveric said, simultaneously signaling for Darwin to ascend and fly the tree tops in that direction.

The pilot eased into the air and slowly, accelerating to a pace only feet above the swampy terrain. All eyes were pointed down looking for any sign. It was slow go because of the thick mossy canopy with an occasional opening.

Knowing it was only luck that he spotted an old house in the middle of some high ground just west of their position, Maveric was excited again.

Darwin banked right and circled the dilapidated cabin. The roof was covered with years of leaves and moss that had clung to its surface.

It appeared that the place was occupied by someone, as the bow of a skiff was pulled up on to dry land not far from the cabin. A push pole and a pair of ores lay on the floor, visible

from the air. The canopy was too thick though to attempt any sort of landing, other than one like they had just spotted in the swamp. Maveric looked at Darwin and signaled him to head back to base, he knew that the only way in to the cabin would be by some type of boat. Darwin pulled on the collective, rose above the swamp, pushed the stick forward a bit and drifted over the towering cypress in the direction of Lucedale. It was only a few miles away where their outlaws had headed as well, unknowingly to the agents.

In only a moment the helicopter was nearing the air field. Darwin called the tower for clearance to land and was quickly granted to do so. After all, there's not much air traffic in Lucedale Mississippi.

He put the bird down softly on the helipad closest to the tower. The morning had begun to give way to the midday warmth of the sun, that tends to sag in the southern sky this time of year. The winter and low sun always seemed to rob Maveric of some of his oxygen supply, making him a bit slower and a mite tired At least compared to the rest of the year. Yawning and stretching, he stepped from the chopper onto the concrete landing. The pilot shut the engine down, and it slowed to a decreasing whine as the rest of the crew stepped out onto the tarmac. Maveric headed for the tower to speak with the controller in charge. He was met at the corridor of the entrance by a young man, short fellow with black hair wearing dungarees and a dark blue button down with a dark colored tie. Sticking out his hand he introduced himself as Coty Woodland, and he went on to explain he was in training, and was sent to meet them and show them the way to the controller in charge. Maveric exchanged greeting as did Jackson and Jones. They all followed the young man through the low chain link gate.

After reaching the control towers operations level, the crew was introduced to the controller in charge.

"The names Blake Ronald," he said, with a southern draw that's hard not to mimic.

"Please to meet you," said Maveric, as he shook hands with the man and displayed his government credentials.

"We're looking for a couple of guys, we've been hot on their trail for several days now. Wondering if maybe you might have seen any sign of them snooping around here?" asked Maveric.

"They bent the shit out of the plane they were flying, after one of the Sheriff's deputies got a couple in the cockpit. We thought we would find them in the wreckage, but as luck would have it their gone again, and it appears that they were headed in this direction." said Maveric.

"Well, we didn't actually see them, but someone stole a V-tail Bonanza from here just yesterday," said Blake.

"We even gave them clearance for takeoff, couldn't know the plane was being stolen at the time. They followed all our directions, appeared to be normal to us, of course till this morning when the gentleman that owned the plane showed up to complete his trip to Montana. He was here on a couple of days business trip, stayed right over there in that motel there." Blake pointed in the direction of the motel that coincidentally Maveric's outlaws also had spent the previous night.

Jackson headed down the stairs, and across the tarmac, to the edge of the fence line where the trail was beaten around its end, and towards the motel.

Maveric could see him from the tower as he glanced over Blake's shoulder, watching him disappear around the far corner.

Jones wandered down stairs and over towards the café, passing Darwin looking at the tail rotor for nicks.

In a few minutes Maveric worked his way down the spiral

stair case and headed for the motel where he found Jackson questioning the manager. They were looking over the records of the last two days for any possible duo that might fit the bill. One in particular caught his eye. The name "Buddy Ray" stood out.

"Looks like we got our boys right here, they stayed in room 109," said Jackson.

"That's around back on the opposite corner from where we are standing right now," said the manager.

"Were you on duty when these guys came in the night before last?" asked Maveric.

"No, that would have been Delbert, He comes on at 9:00 pm every night." said the manager.

"Any chance you can get him to come down here and talk to us?" asked Maveric.

"Yea, I probably can find him in town by now if he ain't at home." the manager stated as he picked up the receiver of the tan-colored phone and began to dial the number.

Jones opened the glass door of the motel and stepped into the corridor. He motioned for Maveric to step away from the counter to speak in private.

"I've spoken to the help at the cafe, and the bus boy seen our guys, he gave a perfect description of them both. The boy said he seen them getting into the plane. He walks the trail to the cafe, He said that one was injured and needed help into the plane.

The manager was still on the phone as Maveric told him to forget about the night manager, they had enough information to continue their pursuit as he turned and headed to the door, leaving the manager holding the receiver half way to his ear.

There was a voice on the other end saying, " hello, this is Delbert"!

23.

Expatriated American

Somewhere in the hills of Central Mexico

The musky smell of the burros always bothered EJ, as he had coffee at the small cafe. He sat at the same table in the corner of the patio near the exit, even though the wrought iron table didn't set level on the cobble stone patio. He would adjust it to suit himself every morning whether it be with a minor rotation until it no longer wobbled, or with a napkin from an adjacent table, folded to just the correct thickness and wedged under the short leg of the morning. The sun peaked through the overhanging tree branches filtered by the leaves of the ancient oaks scattered about the plateau. The morning was quiet. There was little traffic, only the noise of an occasional moped, bicycle or a wash woman on foot. The coffee was poured in the large mugs hand made by the locals, no two looked the same, each had its own design of a Mayan past.

EJ waited, and sipped his coffee. The steam rose into the morning chill, dissipating into the air well above his head.

He had spent so much time of his life in the hot Florida sun fishing away his younger years, the dark complexion and graying razor stubble certainly helped him blend with the locals. He wore a felt fedora, dark brown in color, pulled close to his brow, and

green lens aviators with silver frames to cover the eyes. Khaki was the choice of clothes in general. Another burrow past the cafe wondering aimlessly in the narrow stone street, and in no particular hurry. EJ tried to speed the animals passing with a shew and stomping of his feet, barely getting the attention of the dumb useless thing as it walked by.

Reading his newspaper while he waited for his appointment to arrive. Particularly paying close attention to the weather briefing on the back page of the local rag. They would pick up info from a wire service out of Ojo Laguna giving basic weather, temp., winds, and storm front information. He noticed a front moving out of the northwest, and pushing into northern New Mexico late last night. It would probably stall soon if the high pressure ridge out of Central America held its position. At least He hoped so, or it was gonna be a wet trip down the hill to the desert, for the rendezvous with his cousin, along with a few others making their way into the hidden community of X smugglers. Just then a young man, well dressed and well-mannered stood before his table. He was thin as a rail and about five ten. Obviously a local, just a well-dressed one. The light blue slacks and well starched white shirt represented a presence of power, over the less fortunate and more legal locals. He wore a white Panama Jack hat and white patented leather shoes with silver buckles. His dark hand looked like brown gloves against the white shirt, and shoulder length jet black hair sprawled from under his hat.

"Sit," said EJ.

"Coffee?" He asked the young man.

"Si," He replied.

EJ motioned for the waiter, and he came with cup in hand, placing it in front of the man.

"So, tell me Alberto, is the equipment and trucks ready?" asked EJ.

"Si Senor," as you requested, with three assistants, two drivers, and the best guide in these parts that money can buy." He said. "They will be at your casa at noon today. The guide says it's an eight-hour trip if all goes well."

"Good, that will put us in the desert about eight or nine tonight, giving us a couple of hours buffer," said EJ.

"Good, then it is done, now there's the issue of the rest of the money," said Alberto.

"Yes," said EJ, as he pulled out an envelope thick with twenties, passing it to the young man.

"Thank you, Mr. EJ. It's been a pleasure, please let us know if we can be of assistance to you in the future." Alberto stated. The reference to "Us," was that of the local organized crime group.

Alberto took one last sip of his coffee and slid the chair back scraping the metal legs against the stone floor. Tipping his hat as he turned to leave through the gated exit of the small patio diner. He walked around the closest corner and disappeared as quickly as he had appeared, leaving EJ savoring the hot coffee and cool morning air in the small village somewhere in the hills of central Mexico.

Parker, Arizona

The morning rolled in quicker than hoped by all. Me and

Julio were putting the last touches on the plane, after all it had a long journey. Lucie was doing some last-minute shopping in town, gathering a few things for the boys and for her father to take with him to Florida. He had one more piece of business to handle there before he made his exit. Cole just stayed put for the day, he would need all the rest he could get before he left with Clance this time. There was a change of plans for him, he would travel back to Florida and hide out for a bit and recuperate while Clance finished his business and then the two would disappear together.

I was watching the cloud cover build little by little, it bothered me and it showed as Julio was questioning me about my demeanor. He knew something was up, by the lack of dialogue between the two of us.

It was now getting late in the day and everyone was soon to part ways. Lucie was so very saddened to have to let her love walk away, for as far as everyone knew,… for the last time. There was the promise to let things cool down and for me to get things set up and in a few months, I would venture back across the border to get her. She had a few things to get in order back home as well. There was money to be retrieved among a few other things. This would be the hardest thing she ever done, but she knew she must or they could never be together again. The two of them stood on the weathered wooden dock down on the river's edge, arms around one another, fingers enlaced. The evenings air had cooled thanks only to the weather that Remy so dreaded but never let on. The sky was now grayer than either could remember, and seemed fitting for the silence of the river's canyon. The only sound was the breath against His chest and the rustle from the movement of their jackets against one another. Remy reached down in the dock locker pulling out a blanket, spreading it out on the end of the dock, He motioned for Lucie to sit. the grays of the sky were quickly turning to dusk. The two sat on the blanket and kissed, their cool noses touched. Lucie slowly

removed her pants, and then her panties, keeping wrapped in the blanket as much as possible. She unbuttoned Remy's shirt and pushed him onto his back. Then straddling him she bent down and began to kiss him on his chest, moving her way down, while undoing his jeans. Soon she could feel his warm excitement against her. Then they slowly began to make love.

Biloxi Mississippi, Municipal Airport.

Maveric had made arrangements for a twin-engine King Air to pick them up and continue their quest West, where ever that may be. For the moment He wasn't sure. But then a phone call had come in to the tower, where he patiently waited. It was from an agent in Parker Arizona. He had lots to say and Maveric listened closely hanging on every word.

When he hung up the phone, He knew he was closing in fast on the bandits, and he smiled, put his hand in his pockets and stood in front of the large window that faced Westerly,... His new direction, his final destination... at least he hoped.

The rest of the group waited it out in the cafe, drinking ice tea, shooting the shit, and watching the television. The hot topic was still the attempted assassination of President Regan's life. The static of the TV was soon interrupted by the rumble of the twin's propellers as they were rotated for stop power in the middle of the roll, on landing. Jones looked to his left as he sat slumped down in a lounge chair in the small bar of the cafe. He could see that their ride was here. Jackson was on his feet and headed for the door, and towards the tower. He was met at the bottom of the stairs by Maveric and Darwin.

The big King Air rolled to a stop only feet from the base of the tower. The pilot was Jim Macy, their usual. Darwin would copilot the remainder of the trip. Jim only flew alone from

Mobile, a short hop away. He would need the eyes, ears and hand if things got soupy, it's a handful alone in any kind of weather.

Maveric signaled for the pilot to keep the engines running as he pulled the passengers door open, it's latch, just behind the trailing edge of the wing. He climbed in and was followed quickly by the remaining crew, each taking their spot, Darwin in the right seat. He threw on his head set and begin to go over their flight plan giving Jim a heading, preferred altitude, and other related information.

In only a minute or so they were giving clearance for takeoff and were on the roll, taxing to the other end of the runway.

Jim run up the engines and released the brake, Darwin scanning the instruments and calling their speed as Jim focused on the end of the strip, it increasing in size with every second.

"sixty-five, seventy, seventy-five" Darwin continued to call as the large bird galloped down the pavement.

They reached eighty-five knots and Jim called out "rotating.... and we're up!"

"Gear up," said Darwin as he watched the green lights on the panel go amber.

"Tower, this is One One Romeo proceeding to twelve hundred at two seven zero." Jim called out.

"Proceed with caution there's a Cessna at six hundred on his downwind." the tower responded.

"We got 'em, One One Romeo," blurted Jim.

"Contact southwest control on 121.45, Romeo, Good day," said the voice from the tower.

"Contacting southwest control on 121.45, and thanks for all your guys help, we'll see you on our return, One One Romeo... and the radio was silent.

Jim pointed the plane in the direction of Parker Arizona, now on their last western leg of this chase... they thought.

Southern New Mexico

I thought of how devastated my parents would be when they got the news of my apparent death. But only for a second as the weather we were encountering was worse than I had anticipated. The front was moving faster than reported on the weather briefing I had called for in the afternoon. It has pushed down all the way passed the US border now and has worsened.

The night flying was becoming more difficult with the passing of each minute. I had little night time logged and even less in deteriorating weather. Casey was watching the instruments as I plotted our location, based on the last visible land mark and taking in to consideration our heading and air speed. We needed to be just north of highway Nine, east of Arena New Mexico. This is where we should begin preparation for making our jump, just over the US, Mexico Border.

"Casey," I called out. "We need to start our turn south now. We are somewhere around eighty-seven nautical miles northwest of El Paso Texas."

"Turning south," said Casey.

Things were getting bumpy so I pulled the throttles back in an attempt, to not over stress the air-frame.

We came around to 180 degrees and leveled off.

"Altitude nine thousand five hundred," Casey called out.

"Julio, get your chute on and ready the hatch," I said while looking over my left shoulder into the cabin.

I could see Julio in the low light just behind the dirt bike and just ahead of the now thawing body bag. Julio un zipped the bag, and began pulling the false floor panels up, accessing the hatch. We had modified the fuselage by cutting a two by three feet opening in the bottom of the plane between two of the structural frames. Then took the removed skin and built a hatch to fit the hole. We did this as it's not possible to bail out of the cabin door as it's in front of the left prop, which is too close to the fuselage. And the left passenger window was too small to exit with a chute on our backs.
As we continued for the border the weather worsened.

"Ready to go!" yelled Julio.

"We're about ten minutes out," said Casey. " It's time to take our friend out of the bag." Casey said as he looked my way.

I dreaded this for the last hour, knowing it had to happen, I pulled my headset off and hung them up, undone my belts and climbed out of the right seat. Casey looked at me and grinned. "Come on it ain't that bad," he said with a chuckle.

"Right, not from where you're sitting," I said as I ducked my head and went to the rear cabin to assist Julio.

Julio held up the headless body as I buckled the seat belt around our passenger. I removed my trucker cap and put on the neck, stood back and looked at the obscure figure.

Julio said to the stiff, "would you like some peanuts and a cola Sir?" laughing at the comment as he turned, he grabbed my chute and then tossed it to me.

I put my left arm through the harness and then the right, buckling it as I adjusted my shoulders with a shrug.

"Four minutes!" yelled Casey.

"Put it on auto pilot, get back here and get your chute on!" I yelled.

That's the last thing I can clearly recall.

Bam! A lightning bolt hit the tip of the left wing, the lights in the panel went dim, and then dark.

"Holy shit!" Casey screamed, what the fuck happened?!"

"We're completely black in the panel!" He yelled.

Casey wrestled the big Commander as he fumbled for the flash light that was kept in the seat pocket between the knees. The panel now glowed with a red hue.

We could feel the plane sinking fast, we just didn't realize how fast. Casey shined the light on the altimeter, it was clicking down seven or eight hundred feet a minute. He quickly shined it on the air speed indicator, it was now at two hundred and twenty knots and increasing. I was getting really scared, I'd never seen Casey so serious in his entire life. He told Julio, who he could hear praying loudly to pop the floor hatch and jump. Julio leaned down and simultaneously turned the handles. He let the handles go and the panel sucked off of the plane leaving a large black hole between us. The negative pressure was pulling at us from the gaping hole in the airplane floor. Julio looked at me, and then leaned down and dove into the dark. By now the plane had

reached two hundred and fifty knots. We knew the plane would break up if we didn't get it strait and level quick. Casey looked at the altimeter again, it passed six thousand in an increasing descent. He pulled the yoke harder, but it would not respond.

"Remy Boy," get your ass out of here, jump!" He yelled.

I knew better than to argue, as I stepped to the hole in the floor, I looked in his direction, it was a ghostly sight. He broke his concentration away for a second. Looking over his shoulder, he stared at me. I froze, and stared back. Seeing the absolute, red ambient light glow on his face made the hair stand up on my arms.

He smiled slightly, and said. "Go on, I'll be all right."

 I nodded, looked down into the abyss.

Suddenly there was another gigantic bang and the plane shuttered. Casey begins to scream as he was struggling to put his chute on while still sitting in the left seat. He yelled, " Jump, jump! It's gonna roll over!"

The left third of the wing had torn away from the plane and hit the tail section. It now was rolling left and nothing Casey did could right it... He left the cockpit; it was the last thing I saw before I fell into the darkness below.

Outside of Dale City Texas

The thunderstorm had passed. The sun now rises in the same eastern sky it did every other morning, over the mesquite bushes of the West Texas plains.

This morning there was something different about the landscape in one particular area. It was blackened and carnage lay strewn for some distance.

The sheriff stood at the front of his Bronco while he waited for the local paramedic crew to arrive. The raw smell of fuel nearly made him sick, but not nearly as bad as the flesh burning in the wreckage. The impact was so great that the engines of the plane were buried three feet in the ground. The fuselage was unrecognizable and the contents of the plane were scattered as far as the eye could see. Sheriff Walker stepped in the direction of what appeared to be cash flipping around in the breeze. It was nearly forty thousand dollars he would collect lying about the ground bundled with rubber bands. He continued walking and picking up the loot. He could hear the roar of the engine of the ambulance as it worked its way down the dirt side road, towards the crash. He stepped over a large coil of wire as he followed the trail of debris. Further away than anything else were the remains of a motorcycle. Only the frame and a piece of the front forks were left. It was only recognizable from the exhaust pipe sticking up into the air. The sheriff meandered around the crash site finding a bail of marijuana and an area covered in quarters, hundreds of them. The paramedics stood close to the ambulance, knowing that there were federal agents in route, they didn't want to disturb the site. They had heard the news on the scanner. The Sheriff walked back in their direction as he heard the buzzing of the rotor blades of the helicopter in the distance. The sound grew louder by the second, until it was visible slipping across the plains about a hundred feet off the deck. It was coming from the El Paso direction. The pilot picked a spot to put it down on the road behind the sheriff's truck. The passenger door opened as soon as the skids hit the ground. Out jump agent Maveric followed by Jones and Jackson from the rear door. Maveric headed in the direction of the congregation of people around the front of the few vehicles on site. The wind from the rotor fluttered his red hair like the wind of a winter storm. He

attempted to straighten it several times as he walked. He stuck his hand out and introduced himself to the Sheriff. The sheriff returned the gesture. The air was quieter now that the chopper blades had slowed. The men's breath fogged the air as they spoke.

The Sheriff told of all he knew so far. Apparently, there was one eyewitness. A young man on his way back from college for the Thanksgiving break. He said that the plane came out of the cloud cover, banked hard left and climbed again. There was an explosion, then it rolled over and dove at sixty degrees inverted, and crashed. There was a fire for about ten minutes after the crash.

Agent Maveric secured the site, sending Jackson and Jones to tape off the perimeter and begin cataloging what items they and the sheriff had found. Jackson motioned for the paramedics to follow him and begin to explain what to look for, body parts in particular for identification. The two men followed and listened closely to his directions.

The sheriff asked," how'd you guys know this was your boys?"

"We got a tip from one of our under covers in Arizona that our boys were heading this direction, then we were informed by the NTSB of the crash as we headed for Parker... So, we put down in El Paso, snagged a chopper and went on a hunch that it was them. The plane description was similar." Said Maveric.

"Well, it might be your boys, but the question is... Where are your boys?" said the sheriff. "I walked around a bit but I didn't see anything to prove there was anybody on board. So far, we've only found what appears to be human flesh, most no bigger than a half dollar, a few larger, not even a half of a garbage bag. Hell, I ain't even seen the first head, or even a hand

249

or a foot." The sheriff went on.

Maveric pondered for a minute and walked away from sheriff Walker in the direction of the crushed fuselage. He walked up to what once was a cockpit, now mangled beyond recognition. The tail section was doubled over and twisted a hundred and eighty degrees. He poked at the charred remains with a large stick from a dead mesquite he had broken off. He could see in the right window area that had a space big enough to put his head through. He was disappointed to find only a small crumpled empty void.

His focus was interrupted by the voice of agent Jones. Maveric pulled his head out of the tight confined space and look in the direction of the sound. Jones was waving for him to come over to investigate what he'd found. When he got to Jones, he could see him moving something around on the ground. It was a piece of flesh the size of a fist.

"Look Mav, it's frozen," said Jones. "What do you make of it?"

"Frozen?" Maveric asked.

Sheriff Walker stood across from the two agents.

"Sheriff, how cold did it get here last night?" asked Maveric.

"Barely freezing," said the sheriff.

"This is frozen through and through, " said agent Jones. "This didn't happen overnight," he said.

"What time did the witness say he seen the plane go down?" asked Maveric.

"Oh, about two AM, they said," said the sheriff.

Maveric stood from a squatting position and thought a moment without saying anything while the sheriff and agent Jones engaged in further conversation of the finding. He looked off in the distance toward the southern sky thinking that maybe this wasn't over just yet.

He turned and said, "anybody seen what use to fill that big opening on the bottom of the fuselage?" Pointing at the mangled wreck. There on the bottom side was a clearly visible opening, but no door.

The group that now surrounded the frozen flesh just all looked at him as he made eye contact with each. All responded with a nod or, shrug of the shoulders no sounds were made.
Agent Jackson quickly picked up on his trail of thought. He begins to look across the plains for any sign of the door, but soon resolved, this would take a chopper ride over the approach line of the crash. He motioned for Darwin to wind up the bird as he and Maveric headed in that direction. Jones would stay to command the scene.

Darwin took them in the direction from which the plane appeared to have come from, the west. They were only about a mile and a half when they spotted the left-wing tip. They continued on making a sweeping motion trying to cover plenty of terrain. It was only a few more minutes before they found the smoking gun. There on the west Texas desert plain, lay the make-shift cargo door. It was some two and a half miles from the crash site. Maveric thought this meant they were able to get the door off and possibly jump. Had they staged the whole thing? Where did the frozen flesh come from?
Why were there no heads or hands found in the crash? Surely out of four people on board they would've found something to

identify somebody. Maveric had more questions now, than he'd ever had since the beginning of this case some three years earlier.

"God dam it!" he yelled, " those bastards are gonna give me the slip for good this time!" Maveric shouted.

24.

Flight Gone Wrong

Somewhere south of Campo Volcanico Potrillo, Mexico

EJ paced the desert floor just south of the dormant volcano. They were only ten miles or so from the US border. This was the spot he was to meet the gang. The volcano made for an easy land mark. It could be seen for miles from the air. It was now about nine AM November twenty-first. He looked the charts over several times to make sure they didn't make a mistake in their location. He had not, and it was becoming more apparent that they were not gonna show. After all the were now twelve hours late. EJ tried to think positive. Maybe they put down because of the bad weather. He could see it north of the border last night and he hoped they didn't get caught in it. The guide was becoming impatient, and was ready to leave. EJ finally gave in, but first he was going to leave a sign that they had been there. He had some of the crew gather rocks and place them in a circle. He put two in for the eyes and several made the mouth. He laughed out loud at his signal. Then checking his map for a heading and placed several in the shape of an arrow in the direction of the hills of El Llanto. He looked one last time in the direction in which they were to arrive from, and then turned and climbed up into the dark green truck, pulling the squeaking door closed.

EJ could only hope that he was right, and the boys were safe somewhere in Texas. He hoped they would find his sign. It would be a while before he could get back to the village and attempt to make some sort of contact. By then they could be stuck in the desert waiting for their ride. But the rule applies, if you miss your mark, regroup and try again. Everyone knew it, it was unwritten but was well known among those who run in this line of work.

He had made the decision to stop off for a few days, it was only about ten miles from the location where Remy and the gang were supposed to parachute into. He wanted to be nearby in case they made their way following his sign. He thought that he would go back tomorrow to check and see if they had managed a later arrival.

When the truck rolled into the sleepy little town, EJ spotted the first cantina they would pass. He made the driver stop and let him out. Gathering his things, he paid the guide the second half of his money and bid him farewell, for he had kept his end of the bargain. He stood and watched the heavy truck bounce up the path leaving a pale orange dusty trail that drifted north up the canyon wall. The noise of the rattling motor of the truck gave way to the familiar sound of the clopping hooves of a passing burro. He turned away from the street and ducked into the lime stone watering hole. Removing his sun glasses, he then picked his hat up above his head, running his hand across the top of his hair. He waited for the pupils of his eyes to increase in size allowing him to see in the poorly lit bar. The air was filled with the smell of cigar smoke. The smell of tequila, and citrus from the baskets of limes that hung from the macramé' ropes, filled the room. The place was quiet, only the sound of the bartender washing beer mugs, and the low tone of two voices speaking the native tongue. It was now pushing noon, and EJ was craving a bottle, something he'd fought, for some time now in the past few years of his life. Each day it seemed that the bottle was gaining ground, but he kept it to himself, and most of the time he convinced himself that

he was winning the fight. However today he would give in, he thought as he pulled out the thatch woven chair, taking a seat and laying his hat on the bar. The bar tender, a short stocky Mexican with a scraggly beard and un-groomed hair, walked in his direction. He looked without a word, as if to ask what would he have.

EJ said "tequila."

The bartender put a bottle and shot glass beside it on the bar and turned back to tend to the beer mugs. EJ looked for a moment and then pulled the cork from the clear bottle. He poured the shot...and drank it slowly. And then another. He would spend the afternoon there, before looking for a place to spend the night.

The day wasted away in the cantina, and EJ was shit faced and tired. He managed to remove himself from the chair, leaving it with a ring of dampness where he sat. It had absorbed into the thatch. The evening humidity had pasted his brilliant red Hawaiian shirt to his back. He felt for his Ray Bans on his head as he stood up and headed for the door. The evening breeze that fell between the canyon walls cooled the sweat as he worked his way safely across the street. He spotted where he would bed down for the evening. It was a plaster slathered structure white washed with dingy highlights from the desert sands. An amber colored bulb swinging from a dangling wire in the entry way lit his way to the door. He felt sick for a moment but it passed as he burped out loud and laughed. EJ often amused himself with his own type of humor, most didn't see it. He walked through the door and rang the bell on the small wooden table. An old woman came out and assisted him, exchanging a key for cash, saying good night as she pointed the way down the corridor to his room. Followed the dim lit yellow wall sconce lighting, he found room six. The dirty door bore a metal number, different in style from all the others he'd passed. He let himself into the room, found

the light switch and closed the door behind himself. Falling face first into a goose down bed covered in blankets of many colors and shapes. The last thing EJ would remember tonight would be the flop of the pillow in his face, as his lights went out.

25.

Heavy Hearts

Tampa, Florida

Nearly four weeks had passed since agent Maveric stood staring across the Texas desert wondering if he'd ever see the modern-day cowboys again. Now he stood staring out of his tenth-floor office window looking across the bay, still contemplating the same thing. However, he believed his boys were still alive. He really couldn't come to terms with the thought of the crash being real. Maveric believed the whole thing was a well-planned escape. Plane crash kills outlaws, federal government drops the case.

"Can't prosecute a dead man now, can you?" He thought.

He wasn't giving up so easy, he'd convinced his superior to allow a tail on Lucie Remington. He had a hunch that she would lead him strait to Remy in due time. Assigning agent Jackson to the task for now. So far, he'd discovered the vary day the plane went down the house in Remy's name, was transferred into Lucie's name. Also, all of the banking accounts were closed, some four hundred thousand dollars was withdrawn.

And all traceable connections were no longer existent, it seemed.

And now Lucie was planning his funeral... How far would they take their plan? thought agent Maveric. There was one little piece of satisfaction for him. That was the fact that as soon as Trent Clancey landed, he was arrested on an outstanding warrant. Cole McCabe was expected to be on the King Air flight with Clance, but somehow had escaped them once more.

Dead Man Bay, Florida

The old man sat bewildered from the news of the death of his only son. The world felt as if it had come to a stop for him. He sat without feeling on his face or any emotion showing, only a blank stare into nowhere. His wife was in the kitchen trying to stay busy. She always did, whenever trying to keep her mind off the things that weigh heavy.

It had now been a couple of days since Lucie came with the news, and it just was unbelievable. The thought of it all. Remy was dead, and gone. The phone rang, He herd the murmur of a voice in the kitchen, and then the sound of the receiver being set in the cradle. It was followed by footsteps and the shuffle of leather soles on linoleum. After all she wasn't getting any younger, and getting around proved to be harder by the week. She walked to the screen door pushing it open only a small bit, enough for her face to peer through.

"That was Lucie, she says that the funeral will be tomorrow at four o'clock. She said she'd be by a little later today to visit with us."

The old man didn't say anything, only looked up at her as his eyes filled with tears he no longer could hold back. It was

becoming more real as time went on. The aged woman slowly walked over and sat beside him. They embraced as he broke down. She seemed stronger but really wasn't. Her grieving would come in time. But for now, the man she committed her years to, needed her more than ever. In all her years she'd never seen him in this state of sorrow. She only wished she could make it go away for him. She knew there was no answer, but hopefully in time he would be as good as a man could be with most of his heart, and probably all of his soul ripped from his chest. They sat on the porch together for some time as she tried to comfort him. He felt small in this world he used to control.

Across town

Lucie packed as many things as she could throw together, she had to get out of town for a while as soon as the funeral was over. It wouldn't do her any good waiting around here while waiting for word that Remy was safe. She knew he had to be; he couldn't just really have checked out that way. She began to cry as slung a picture of them onto the bed.

"Damnit, it wasn't supposed to happen quite the way it did!" she screamed as she cried with her head in her hands.

The not really knowing was eating her from the inside out. The irony of it all. It was supposed to look like he really was dead, even to her. she thought. Maybe Remy planned this part without telling her, yea he just planned it this way to make her really appear distraught, and saddened. But he wouldn't put me through this kind of pain. she thought.

She sat on the end of the bed hoping a signal would soon arrive in some manner, to let her know that he was alive and well. But today it never came, just as in all the past days. She would see Clance in a couple of days, he'd make his little girl feel

better, maybe he knew something he could only whisper to her quietly in the visitation hall of the prison.

Lucie tried to pull herself together so she could go see Remy's parents tonight. She needed to pay her respects. She picked up the picture of them and stared for a moment and then packed it away with the other things.

She made the few phone calls left to finalize the funeral arrangements. She was glad that part was done now.

Now that all the plans were complete and in place, she would be off to the Remington's for that last visit before the services tomorrow.

Lucie grabbed her few bags from the motel room and headed for the car. The sun was setting, she stopped to look for a minute. It was the calmest evening she'd ever experienced. It seemed fitting somehow. The gold was brighter than ever, and the pinks more vivid than memory served. The bay was very glassy. It was as if time stood still, and for her it did.

Tossing her bags in the hatch of the 280Z, she glanced once more at the site. Then closing the hatch and opening the door she slid down into the seat. Putting the key in the ignition and closing the door at the same time. She started the car, put it in gear and sped away down the river road, as golden hues filled the back window. An almost heavenly feeling came over her as she stared into the rear-view through her dark Ray Bans. The cool breeze of the fall evening whistled through the partially cracked window on the driver's side. Soon the noise above the cold bothered her so she shut the window and drove.

Her visit with the parents was sad at best. She forced herself to overcome the urge to just bolt. She stayed for a while until there was nothing more to say. Nor were there any tears left in the weathered couple or herself. Lucie discussed the funeral arrangements with them and bid them farewell for now. She walked out into the cold night and left them hovering at the door.

The sight was heart breaking to her. She broke down once more as she drove away. The pain they must feel losing their only boy at such a young age.

Lucie went back to the motel, stopping at the pool hall for a bottle of bourbon and coke. She decided to have a beer when Marge cornered her at the bar. Marge went on and on about how sorry she was for her loss. The beer didn't make it any easier to swallow. But it occupied her hands while she listened. Soon she stood up, took out money, laid it on the bar and told Marge she needed to go for now. Marge came from behind the bar to give her a hug, as she put the money back in her hand and made a fist over it. Now both in tears they comforted one another with kind words, Marge about Remy and Lucie about Marge's compassion for them both. She pulled away, put her hand on Marge's shoulder and said thanks with the tears still streaming. A few other people in the bar new Remy well and missed him so. They'd walk by and put their hand on Lucie's back with no words and with a pat they'd keep on walking. Remy was well liked in the community and would clearly be missed by many.

Lucie walked out the door with the brown paper bag tucked under her left arm. She climbed in the car and slowly drove away. Heading just down the street to the motel, where she'd drink herself to numbness once more. Hoping that tomorrow would never come.

26.

Sadness in the Air

Hills of Central Mexico

EJ sat in the small café garden dumb founded, clutching the letter. He'd received it late yesterday. But didn't get around to opening it till this morning. He'd been entertaining some business prospects for he and Remy. They still planned to keep a hand in the trade. Neither wanted to get rusty or give up the adrenalin rush. Even though it was a questionable life to lead. They were good at what they did and hoped to continue for many years to come. For EJ it no longer was about money, it was more about the rush, the excitement, the getting away with it.

He couldn't believe what he was reading. Lucie had gotten the letter to him via his friend from just across the Texas border. It had been hand carried for some time now through the flat land and hills until it reached him. She'd spelled out what apparently had happened and was hoping that it was all just part of Remy's big plan. Maybe this was the part he kept to himself for obvious reasons. In any event Lucie wanted him to get in contact with her to let her know if he'd seen or heard from Remy. EJ's heart sunk into his stomach. This likened the possibility of the plane really going down with Remy and Casey. He sat silent in disbelief for a moment. Gathered his thoughts and then left several dollars on

the café table. He walked out the side gated exit onto the cobble stone street, and headed up the hill towards the pawn shop. He had to contact Lucie as soon as possible. EJ didn't usually call from the town of which he now resided. But the circumstances and magnitude of importance outweighed the risk of being discovered by wary ears on the coconut telegraph. His head was still a little bit light from the booze he'd drank the night before. He opened the door to the pawn shop and entered into a small breezeway. This was the location of the only public phone in the entire village. There was an old Mexican woman on the phone. She was speaking very low to the person on the other end. EJ couldn't make out all of what she was saying but heard enough to know that it was her son on the other end. She'd told him something about coming back home to her and Papa to work on the farm, and she missed him much, or something to that effect. EJ paced the floor with impatience. Making it obvious to the lady in hopes to shorten her call. But this seemed not to work. This only made him more impatient.

EJ said, "Let's go mama, I need the Telephono." As he made hand gestures holding the phone to his ear.

The old lady looked in disgust at him, said a few more words, slammed the phone down and walked out, eyeing him as she passed. If looks could kill EJ was dead. He just smiled and nodded in appreciation as she passed. Then he quickly jumped for the receiver. Holding the letter under his arm he contacted the international operator to connect him to The Riverside Café. He gave her the number, and then patiently waited for the connection.

A few minutes had passed before he heard the operator say, "go ahead Sir."

And then heard the voice on the other end. "Hello

Riverside."

EJ paused and then spoke, "Yea, is a… TJ in there having breakfast this morning?"

"As a matter a fact he is, want me to get him?" The young ladies voice asked.

"Yea, if you don't mind, I need to talk with him." Said EJ.

"Hang on then.," said the young lady.

EJ waited for a moment and then.

"Yea, this is TJ."

"Hey, old boy, how's the weather on your side of the border?" said EJ.

"You're taking a big risk calling here." said TJ.

"I know." said EJ, But I gotta know what happen to Remy Boy.

"He's dead…," said TJ.

"Well, he very well may be." said EJ. I haven't seen nor heard from him, if you know what I'm saying."

The line was quiet for minute, and then… TJ asked, "nothing at all?"

"No, nothing."

EJ could since that there was something wrong with the plan

and he really wasn't sure what.

"Well, I gotta get, the meters running." said EJ, meaning he didn't want the call to be traced if any unwanted ears were listening. "Tell Lucie to call this number, 813-546-7878, tell her to leave a number and a time to call her."

Then he quickly hung up the receiver. The numbers were transposed, they all used a system to unscramble phone numbers, addresses and so on. It was quite elaborate and required a bit of studying to learn. It was one of the things that stumped the feds for so long. They never have cracked the code, even to this day it's as guarded as a free Mason's secret.

TJ listened to the line go dead, and to the dial tone for a moment, then handed the receiver back to the girl behind the counter. He walked back to his table where he'd left his coffee steaming the cold glass window that peered onto the river. He stared at the ripples on the water. They were made by the light breeze on this cold December morning. The morning fishing guides were taking their customers out to the mouth of the river, one after the other passing slowly by, methodically almost. This was the best Trout season the river had seen in ten years. The guides were doing good in putting their fares right on top of the big fish. They had brought in some the length of ax handles this year. This was not the case in past seasons. There was more than one story as to what the reason was, but no one really knew they all just talked as if they did. TJ wandered was it real, did Remy and the crew burn it in on the west Texas plain? His mind began to go ninety miles per hour. He had to find out what was really going on. He drank the last of his coffee and headed for the door, leaving some cash on the table for his coffee and a tip for the waitress.

TJ didn't know if he should mention the call to Lucie, He

thought he would wait till at least after the funeral. Lucie was an emotional basket case and he really didn't want to make things worse at a time like this.

TJ drove back across the old single lane turret bridge and down the lime rock road that led to his home in the edge of the swamp. He had to get ready for Remy's funeral. There was a sickening feeling in the pit of his stomach. He felt like he was going to puke, it was becoming more apparent that the likelihood of Remy still being alive was growing slimmer by the hour it seemed. He could only hope that Remy was held up somewhere that no one knew about and would eventually surface down south of the border, or maybe in the islands. It was all he had for now. He finished getting ready and made for the car, back down the same old road he'd traveled before many nights to meet Remy for a smuggling deal. It seemed odd to drive to the staged funeral, or maybe his real funeral after all.

The morning had come, it was the day. Lucie stood and stared in the mirror, not feeling much more than confusion. She still hadn't heard from Remy or from EJ who might know where he was. She had faith it was still the big slip he was giving everyone. But was He giving her the slip as well?

She didn't really know anymore. Only hope in a sick twisted way that was exactly what he was doing. She put on her long black coat, her hat and scarf. She then walked past Remy's picture on the night stand and took a good look at it, stroked it with her left hand as another tear fell from the corner of her eye. She walked out of the motel room and pulled the door shut behind. The cold December morning was chilling. No wind or rain just the still dead cold. She slid down into the car, started it and turned the heater on long before it could get warm. She sat revving the motor to warm it, bundled up and shivering, feeling very alone. She had to keep it together as she drove to the parent's house.

When she arrived, the old man stood in the drive facing the

eastern sky. The sun was above the tree line by now and Mr. Remington was warming his face with his eyes closed and his hands in his pockets.

There was a line of cars on each side of the main road and down the driveway. It was mostly family. Lots of people would be at the services later as well. The Remington family was well known and well respected.

Lucie parked her car off to one side of the lime rock driveway and turned the engine off. She gathered her thoughts and composure and then opened the door to the cold morning air. Mr. Remington walked in the direction of her as she moved up the long drive. She began to weep slowly the closer she got. All the memories began rushing through her mind and she began to cry almost uncontrollably. Mr. Remington petted the back of her head as the two embraced. And then he led her inside out of the cold. The screen door opened and the two were met by several loving arms that embraced her in an attempt to comfort her from the real pain of her loss. The screen slammed behind them as the consoling faded into the darkened shadows of the confines of the house. Then the heavy oak door closed to the outside world, trapping all its pain on the other side.

Late afternoon Deadman Bay

The funeral procession worked its way down the old Mount Olive Road leaving only a faint trail of dust with a few tracks, and sadness in the air.

The service was a short one and soon the young man was laid to rest. His parents still in a state of shock and disbelief, his bride devastated and lonely. The cold breeze moved through the branches of the lifeless trees pressing dead pine needles against the tired wire fence. The chill sent most of the attendance for cover sooner than normal. Leaving only a hand full standing around after the service to pay further respects and condolences

to the family. Lucie stayed the longest standing in the cold shivering, watching as they lowered the casket into its rectangle eternity. She was finally escorted to the limousine from the cold gray winter day. It now gave way to the early setting suns painted horizon. One last look as it drove away from the barren landscape of the small-town cemetery that held its place in this community for nearly two Hundred years.

27.

Last Chance

Gainesville, Florida

TJ hopped a flight to Houston and then a commuter to Las Cruces New Mexico. He then chartered a small plane that would take him to a destination he'd yet to share with the young pilot. He told him only to fly south-southwest for the time being. The young man dares not argue with his passenger, the pistol or his large sum of money, He was afraid he may not return, But the risk was worth the five-grand. His passenger didn't say much, He only looked out the window and then at the worn-out map in his hand calculating their position occasionally. The pilot spoke a few words to encourage a conversation to no avail. He offered his assistance in plotting their coarse and final destination. But the man wouldn't budge. He finally told him that they were nearing a half a tank of fuel and unless he told Him where they were headed, he would have to turn back.

TJ handed the pilot the map and said, "Campo Potrillo, the volcano."

"Ok." said the pilot. As he quickly calculated fuel burn and distance to the site.

He saw they were close now, and could return to Juarez for fuel.

Looking at the map for a minute more he realized the strip was dirt and obviously not monitored by a tower or anything resembling one.

By now it was late afternoon and it was becoming clear to the young pilot he would have to stay the night or fly back in the moonless night sky over unfamiliar terrane. He would risk being forced down by US Customs when entering back into the states under the cover of dark. They are not fond of unauthorized entry. And since he didn't file a flight plan it would be even worse if he was to get spotted flying low attempting to avoid radar.

"There it is." said the Pilot as he banked right and circled the strip.

There was no wind sock to be seen anywhere, but it was typical for the winds to blow from the west in the afternoon on the desert. He would look for some sign of this by watching the few shrubs at the end of the strip.

Turning from base to final carefully not to tip the left wing too low, as the breeze was a quarter wind to the strip. After the base to final turn was complete, he stepped on the right rudder pedal to retard the crabbing effect from the wind and eased off the throttle. Gave it one more click of flaps to slow it a bit, and eased the nose over to compensate. Soon the plane was sinking like a rock. The pilot was unsure of the runway length so he decided on a short landing. He eased back on the yoke as the plane slowly settled to the earth. Then the wheels touched the dusty strip leaving a puff, and then a trail.

Rolling a moment and slowly coming to a stop, then taxied to the far end of the runway, near a small building off to one side of the strip.

The structure was old and hadn't seen the end of a paintbrush in a decade, leaving the tin metal surface in a weathered

condition. One window was broken and all were covered in an orange dust. There were farm animals in the back, a donkey, and a couple of goats were in a makeshift pin and a pig roamed freely.

The pilot popped his door and stepped onto the dusty ground, adjusting the waist of his pants and re-tucking his shirt. The surface beckoned for the distant thunder cloud never seeming to come. Shortly thereafter a small framed man, dark complexion and weathered from years of the arid desert plains, stepped from behind the building. He appeared hesitant to approach the plane at first. Then TJ climbed out and began speaking fluent Spanish to the man. This made him more at ease with their recent unexpected arrival. The two spoke for a minute or so, the pilot could only make out a few words here and there. Soon TJ turned and waved for the pilot to come over. He did so. They discussed him having to refuel and that it only made since to stay the evening as the weather was to deteriorate over the next few hours. Not to mention it was going to be dark soon. This could make the return trip a rough one at least if not a deadly one. TJ went on about how there was a small village over the hills behind the strip and that they could bed down there for the night, get a bit to eat and a bottle for the tall tales.

In Agreement the young pilot walked back to secure the plane. He grabbed the bags, his, and his passengers. Then he locked the doors and tied it down, to the less than sufficient hold downs in the desert floor. He looked west to see the setting sun. Brilliant gold with a redder than usual sky, it almost appeared to be running from the darkness from the east. The thunder cracked in the distance and rumbled for several seconds. It was getting closer and they needed to move. The wind moved in quickly, cold wind from the east. The static in the air made his arm hair stand on end.

The old Mexican man waved for them as he pulled an ancient Willy's jeep from behind the shelter. At a quick trot the two men jumped in the ride and off they drove up a hill and

through a tight spot in the rocks. The walls jutted higher and higher as they drove down in the canyon. The lightning cracked and the thunder roared with anger as it chased them, barely missing them as the jeep rolled under an over hang on the side of the little tavern carved from the red deserts shear rock wall. The rain began to pelt its tin roof like bullets from a machine gun. The sound was deafening as the rain droplets pounded on the tin cover and the red dry terrain. All three climbed from the vehicle and darted inside to a dryer place. The room was lit by candles and lanterns, the light created the warmest hue anyone had ever witnessed. It was surprisingly well furnished for such a remote place. The bar was carved from a fallen tree from some other latitude. The walls were nothing more than the sandstone of the desert, the colors bled from yellows to reds and browns in some places. There was background music from a Mariachi band in the corner. The Tequila was flowing from since noon. The place was elbow to elbow, people danced, talked and yelled. It was a joyous place.

After they all dried themselves, they stepped to the bar for a warming of the gut. Each requested the same Mescal for their warmth, each gulped it down and ask for more. The young pilot began to try to connect with his passenger from the day earlier. The mescal made him braver than usual and it showed. TJ didn't open up at first but began to come around after several more belts. The old Mexican from the strip bid farewell for the time being and left the other two alone.

"They call me TJ." he said, "What's your name boy?" asked TJ.

Briefly stunned by the comment the young man stared and then said,
" Dana," he said it with disbelief in his voice.

"Nice to meet you Dana," TJ said.

272

"Yea, ah, same here," he said.

The two drank some more. This went on till the late hours of the night, until they decided it best to hit the hay for the evening. They would stay next door to the cantina at the small motel in the dead end of the canyon.

Tomorrow TJ would continue his journey further south across the plain and up the in the hills where he would find EJ and hopefully Remy, but for now it was lights out.

As for Dana he would leave in the morning for Texas asking no questions and never to look back. He was content with the cash that he was paid for his services and assured TJ that no words would ever be spoken of their meeting. The two said their good byes, shook hands and picked up their belongings and headed for their rooms in opposite directions, likely to never cross paths again.

The next morning Dana headed down the path that led over to a makeshift store of some type looking for a ride back to his plane. The sun had barely come up but he was an early riser anyway. Not to mention he really didn't want to run into TJ, for some reason he felt it would be a bit awkward, so he walked a brisk pace not looking over his shoulder and barely in either direction left or right. When he reached the store, he could see the jeep next to the cantina under the shed they had pulled under the night before, but the driver was no where to be seen. He continued inside to find an old woman setting in a chair drinking coffee. Man, he was needing a cup. The woman pointed before he could get a word or two out, to the back of the store where an old wood burning stove stood in the corner. On top was a porcelain coffee pot, steam lightly rolling from its spout. On a shelf covered with a hand knitted doily he found a cup. He poured himself a cup and slowly drank it, setting down on a nearby

bench made of wrought iron and deer skin. Dana began to think about the night before and the entire trip, come to think of it. The booze had taken its toll on his mind, making his thoughts a bit sluggish, however vivid. It wasn't long before he saw the old Mexican man that had given them a ride to the cantina. The man walked over towards the store across the dampened red clay street dodging a puddle on his way.

The old man managed his way into the store and walked in the direction of the wood stove. The two made eye contact and simultaneously and politely smiled.

Dana asked him, as he extended his hand, "how did you know I needed a ride so early?"

The old man smiled and said "small town," as he poured himself a cup of coffee.

Dana chuckled and said, "good point."

The old man said" I'll be waiting out front when you are ready."

Dana gulped a swallow and spoke quickly after "ok, I'll be right out."

"No hurry" said the man "I got all day." as he turned and scuffled out towards the door.

Dana finished his coffee and soon followed. He was met by the man with the jeep just out front. He climbed out and helped Dana with his bag. Then the two loaded up and sped away towards the opening in the tall rocks that led back to the other side of the moon, leaving the only marks proving he had ever been there deep in the red muddy road.

The hills of Central Mexico

TJ stepped off the rail of the old farm truck as it slowed, slapping it on the fender and waving to its driver in the side view mirror thanking him for the quick jaunt up the steep hills outside of the village. He pulled out a Winston and lit it up, looking around as if he didn't know his next move. Standing on the edge of the cobble stone street he watched the busy morning traffic at large. A truck loaded with crates and a mule pulling a wagon with a family perched around the wooden rail, all staring at the new visitor.

He turned and looked up the street, seeing what appeared to be the post office. Further up was a cantina, an open street market in the dead center of town and several inns and motels at its far end. He looked back South and saw a café with a nice open patio with a wrought iron fence, over grown with vines. It appeared to be quaint and just the type of place he would find his Arrogant cousin EJ. But he wouldn't have to look far as EJ had spotted him as soon as he stepped off the truck. Standing across the street chewing on a cigar and chuckling, He waved his hand in the air until TJ realized he was waving at him. TJ waited for the passing moped to clear and looking for other traffic he stepped into the street, then crossing to the other side. The two smiled and embraced as they hadn't seen each other for some three or four years. Slapping each other on the back they said their hello's and then the conversation became serious.

TJ said, "you haven't had any contact with Remy and the boys?"

EJ replied only with the blunt statement of "none."… and then went on about how they had sent word to pick them up near the border. "The message was something about they were dropping from the air, and they would like a ride out of the desert but I don't know who was left to fly the plane… didn't make

much sense to me".

TJ said, "well their plane went down about seventy miles from the border, there was bad weather on that night, they said… I done a little poking around without being too suspicious, heard they didn't find anybody in the plane, well anybody whole that is… apparently they only found enough to fill about a half a trash bag."

EJ pondered for a moment. He turned and looked down the street for a minute, and then back at TJ, and then He said, "They made it… they made it, they just ended up somewhere other than here."

EJ sure hoped so anyway.

He told TJ to follow him, and he turned for the Cantina. He needed that first drink of the day to calm his nerves, He needed to think about the whole dammed situation.

Clearwater, Florida

Agent Maveric's phone rang, it was Jackson. He found out that Lucie was headed for Texas to the small town where the plane had gone down. He wasn't clear why but he figured to follow anyway hoping to find Remy and the gang laid up injured or waiting for Lucie to deliver the cash, or join up and head, possibly South. Maveric was holding out for any hope that his gang was alive and well. He told Jackson to follow and he would meet him there tomorrow afternoon. He was adamant that Jackson was not to lose sight of her. And then He hung up the phone.

Maveric gathered a few things for the trip, He made one quick call and headed for the door. He had another one of his

hunches. He locked the door behind himself and was off.

Twenty Years Later...

Island of Anguilla

The coastal breeze filled the open window of this aging man's casa by the sea. I put the pen to the paper. Bleeding the ink from my soul, for I longed for the companionship of my friends and family. I missed my wife and thought of her often. The memories flooded my mind. I looked across the gulf to see the building storm on the horizon. The darkening clouds reflected the feeling of my heavy heart. The secrets, the lies and years of deception have aged me well before my time. The waves rolled more heavily with each passing moment from the approaching easterly. I write to my love only this one time. I hope she would only be happy to hear I had survived the crash many years earlier. I didn't expect her to understand but hoped she could try. Continuing to tell her of how I thought of her each day, but for fear of being detected, I could never contact her all these years. But now I am willing to take this one chance, as I feel I owe her at least this much. Our time together was short and I hoped that helped with her trying to go on without me. I knew this was nowhere near fair...if there were any fairness at all to the madness, I had chosen to live all these years ago.

I went on to tell her where I was, and hoped one day to see her again, at least one time even if it were only for a few moments. I told her, I hoped that she could find it in her heart to meet me here. I finished with ...Love always, R.

Folding the letter and slipping a prepaid round-trip ticket in the middle, then putting it in a plain white envelope, I sealed it

277

and addressed it Lucie Remington Dead Man Bay, Fla. with no return address. On the back I drew a small boat propeller on the flap. I stuck the envelope in the top pocket of my cargo shirt. Closing the window in front of the old desk, the swirl of breeze blew the white starched curtain in its opening and trapped its corner. I headed for the door. Determined to get the letter in the mail today, climbing on an old beach cruiser, pointing it down the rural road towards town. I looked right only to feel the blast of cold air in my face from the approaching storm. It was followed by a staticky lightning bolt several miles off shore. pulling my hat down tight, I stood on the peddles of the bike. Knowing I could beat the storm and almost in a teasing manor, allowing the bike to coast down the slight grade, as I watched the darkening cloud gain on me. It was only a minute or two before I reached the edge of town and soon had the postal drop in my sights. I felt the first drop of rain, large and cold as ice. It hit me on the left cheek and then rolled off my chin. Pulling the bike under the tin metal covered walk, I got off for a moment. I walked over, pulled the drop door open, looked one last time at the letter, held it to my face and then dropped it into the dark abyss, watching it slide out of sight. Turning and walking to the edge of the wooden walk, standing so I could feel the cold rain on my face, I thought, the irony, I was always running, even from the rain-storm. Now it was done so to speak. It was only a matter of time till she would receive the letter… Then her whole world could change, or mine could end. I waited for the thunder cloud to blow through. Setting patiently on the hard-wooden bench in front of the convenience store, I watched the large drops of rain pelting the dry ground, turning the lime rock dust into a muddy chalk. The smell was refreshing, it always had been since I was a small boy. I reminisced a while of my childhood when the summer rains of North Florida would soak the pavements in front of the house, leaving the clean smell in the air. An unmistakable smell, one like no other. It made me home sick and a bit sad. It wasn't long before the rain slowed to a sprinkle and then nothing

more than a drip. Off across the Gulf I could see a rainbow that had formed when the sun showed its face. The brilliant colors soothed my pain and sadness. Above all it gave me hope once again, that Lucie would see it in her heart to forgive me for the treacherous deed I'd done. Hope, that's all I had left, I thought as I stood staring at the beautiful creation.

Dead Man Bay Florida,

Lucie walked into the post office, its wooden floors were worn and creaked with every step. The historic building was cooler than normal for a summer day, and the musky smell lingered. She opened up the postal box and reached in to pull out a week's worth of mail. A letter from the pile slipped and fell to the floor. It lay face down. She looked as she bent down to pick it up, then she saw the single propeller.... Her heart began to beat a faster pace, and a cold chill came over her as she quickly picked it up and turned it over. It was addressed to: Lucie Remington PO Box 169 Dead Man Bay, Florida 32359

She stared at the hand writing She'd seen it long ago and recognized it to be Remy's... Her mind raced... how could it be? was it some kind of sick joke of someone's?

She opened it and expected to be sadly disappointed as she unfolded the letter and began to read it. She hung on every word, the tears welled up, she could no longer hold back, they dripped to the page she read smudging the ink in one spot. The letter made her happy, angry, confused all at one time, she didn't know what to do. She slowly walked back to her Rover and climbed inside. Closing the door, she then pounded on the steering wheel and screamed and then cried for a long time.

She pulled the airline ticket from the envelope looked at the date and said out loud "I'm coming to see you." Lucie started the

truck and sped off down the river road towards the marina.

A few weeks later…

It would have been only like Remy to book her flight on a sea plane out of Miami. It was an old Albatross, there were only a few left around and this carrier had most of them in their fleet. Lucie got out of the cab, paid the fair and closed the door. She threw her long-strapped bag over her left shoulder and fumbled for the ticket in her hand bag. Walking towards the small shack standing alone beside the gang plank. It led to the floating dock, from which she would board. The warm morning breeze fluttered the brim of her sun hat. She adjusted her sun glasses with her middle finger, while getting her bearings about her new surroundings. It was a beautiful sunny morning with the typical southern humidity for this time of year. There were several other people already on the dock waiting to board. She noticed a man in white slacks and a Haitian print shirt smoking a cigar. He peered through his green lensed Ray bans at her, as he tipped his hat. She was flattered at the greeting, maybe a little surprised. She blushed and gave a little finger wave and then turned and looked away off in the direction of a voice calling,

"Mam ticket please."

Looking down to see she still had the ticket in her hand, realizing she had managed to get past the shack and half way down the plank, she reached out and handed the ticket to the attendant. She apologized for the mistake and continued down. The plane was soon boarded, and taxied for the turquoise blue strip of water. She had made herself comfortable in her window seat under the left wing. She stretched out and stared off into the distance and watched some kids playing on the bank of the canal. They were skipping rocks counting how many times until they

sank into the blue water. The breeze blew the spray across the wing float as it built up speed. The large Grumman engines roared to life and soon the plane was on the step. The cabin of the big bird rattle fiercely from the percussions of the engines exhaust. Lucie looked around at the few other passengers, noticing that they all seemed to have made this trip before. She turned back to a magazine she'd grabbed from the shop before boarding, and began to flip through the pages. The big seaplane lifted away from the water below and seemed to float like a balloon, it reminded her of the many times she'd flown with Remy. Her mind began to wonder through the few years of fun they'd had together, to all end seemingly so tragically. It began to piss her off, this whole scheme that Remy had pulled was a big lie and she was going there just to tell him so. She'd decided that she was not going to let him get away with such a heartless act. Reaching down into her hand bag, she stroked the Colt forty-five, the very one that Remy had given her so many years earlier. He was going to pay for the pain and suffering, the grief he'd put her through once and for all. A tear streamed down her cheek as the anger built. Was it for the love she had felt that was so evilly stripped away? Or was it the anger that had built over the last month since she had received the letter on that normal day of her simple life, she'd managed to carve out of society for herself. Obviously, she still wasn't sure but she would soon have to make a decision. What would it be? She closed her eyes for a moment and leaned her head back.

The throttle changes awakened Lucie from the light sleep. She had dozed off half way through the flight not realizing she was tired, maybe from the anxiety or excitement which ever, she was now back.

Off to the left the brilliant blue waters filled the small window. The plane banked a few times to line up parallel with the beach in preparation for landing. The palms soon looked

double in size and were moving by quickly. The planes bottom settled into the island waters and the cabin filled with the sound of the small waves slapping against the aluminum hull. Shortly the large bird settled down and came off the step. It sank, and began to plow its way to the dock just in the distance ahead. The background was tropical, lavish, and dark green. There were locals awaiting their arrival at the dockside. The large engines rumbled once again to bring around the cabin door, the water spray covered the window Lucie was looking out of, it dripped away like memories and was clear again.

The man that had drawn her attention earlier was making an attempt to speak to her. He said, "Hey we made it safe and sound."

Lucie was only paying half attention to him and made a minor gesture with a nod and a simple, "yea, we made it alright."

Her blood rushed and she came to life once again. She thought of it all, how he'd pulled the big one on her and left her to deal with everything, the sorrow, pain, his friends and family. She felt for the gun, it was still there, it hadn't gone anywhere. She almost hoped it had.

By now the plane had docked and moored. Debarking had begun. Lucie just sat for a moment as the rest of the group unloaded, she couldn't decide what to do. Once she thought about staying on the plane and returning without a sound... but she couldn't, she had to do this. So, she stood up and reached for her belongings in the next seat, turned and headed for the exit. She was the last one on board. The attendant, a strapping young man, waited patiently for her to walk down the aisle. He made eye contact and smiled. Lucie was thinking how the young man reminded her of Remy when they were so young, but then most everything on this trip had somehow reminded her of him.

She stepped through the doorway with the young man's assistance onto the dock, saying goodbye as she walked away up the gang plank disappearing into the lush tropical back ground.

Island of Anguilla

Lucie checked into her room, overlooking the beautiful bay on the west side of the island. The sun was only an hour or so from setting. It glistened on the smooth water giving it a mirror effect. The surface was only interrupted with the few ripples from the swirls of fish. The water was gold and glassy, as smooth as mercury. The view was soothing. She stood on the patio with a Bloody Mary in one hand, and holding the railing with the other. The air was calm and clammy. She wore only her shorts and a favorite swim top. Looking down the beach occasionally, she noticed someone sitting on a bench a couple of hundred feet away. She didn't pay much attention as she went back inside to mix another drink. Noticing when she returned, he had stood and had walked a little closer and seemed to be watching her from the corner of his eye. When she looked, he'd turn away and pretend to be looking at something else. This game went on for a few minutes. The man eased closer till Lucie could make out his face. It really wasn't the way she thought they'd meet again…but then how did she expect to meet again? She had been so consumed with what she might say and do, till how, hadn't crossed her mind.

The two looked at one another and stared… He walked closer and closer until he was certain it was her. Lucie slowly walked down the steps of the deck onto the warm sand without losing his face. She didn't know what to say, everything she'd rehearsed slipped away into the deep dangerous part of her mind. All she could do was just cry. The tears streamed down both their faces, hers for all the years of not knowing and missing him. And his for all the pain he'd put her through. They walked to

each other, and embraced harder than ever before. Holding each other for a very long time and just cried.

The sun set, turned the clouds a brilliant orange and Remy just held Lucie's hand. A light breeze flipped her hair softly. They walked up the beach, the sand between their toes, the salty water washing it away along with all the bad memories of their past. Lucie struggled with her feelings, somehow finding that lost love safely stored away in her heart until now. And Remy felt he may have gotten back that once in a million chance to make it all right. He felt for the first time in his life, the coast is clear.

THE END

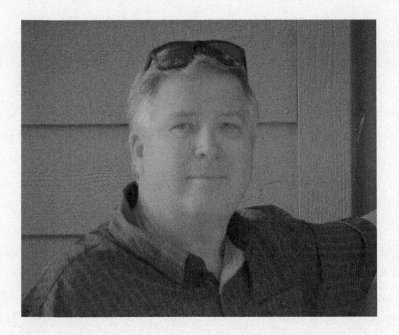

James Chewning grew up in a small coastal town on the panhandle of Florida. He walked the banks of the river as a child exploring for arrowheads and artifacts. James and his friends ventured the river and down the coast of Dead Man Bay, plundering the local islands. He still visits on occasion, and rambles with the same childhood friends today. He has sand in his shoes. He will always be drawn home to the deep roots of Dead Man Bay.

Made in United States
Orlando, FL
28 April 2022

17280552R00157